Images of Change

an archaeology of England's contemporary landscape

Sefryn Penrose with contributors

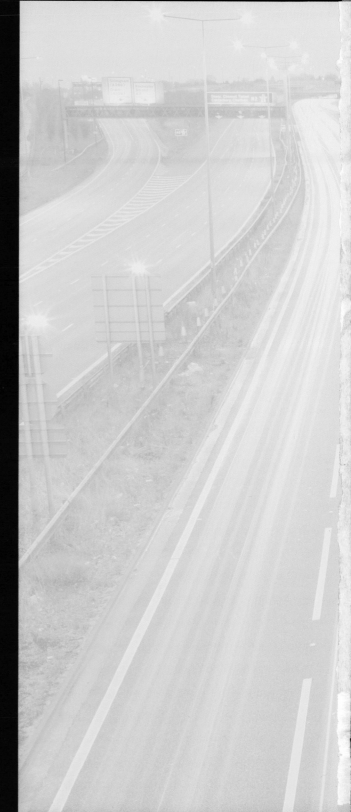

First published in 2007 by English Heritage, Kemble Drive,
Swindon SN2 2GZ

10 9 8 7 6 5 4 3 2 1

English Heritage is the Government's statutory advisor on the
historic environment. www.english-heritage.org.uk

ISBN: 978 1 905624 14 0
Product code: 51233

Edited and brought to press by Adele Campbell
Designed by Simon Borrough
Printed in Belgium by Deckers-Snoeck

For Joan and Eric Pearson

Images of Change

an archaeology of England's contemporary landscape

Sefryn Penrose with contributors

ENGLISH HERITAGE

ATKINS

Contributors

Migration: Zoe Khor (researcher, Opinion Leader)
Airports: Sarah Garrett Sonner (Centre for Cultural Studies, Goldsmiths)
Mental Health: Mary Gray (Department of Archaeology and Anthropology, University of Bristol)
Memorialisation: Anna Nilsson (Atkins Heritage)
Cemeteries: Julie Rugg (Centre for Housing Policy and Cemetery Research Group, University of York)
Defence Research and Development: John Schofield (Head of Military Programmes, English Heritage)
Defence Manufacturing: John Schofield (Head of Military Programmes, English Heritage)
Defence Infrastructure and Support: John Schofield (Head of Military Programmes, English Heritage)
Renewable Energy: Zoe Gardner (School of Geography, University of Nottingham)
Nuclear Power: Wayne Cocroft (Senior Investigator, English Heritage)
Metals and Industrial Minerals: Peter Claughton (Department of Archaeology, University of Exeter; Chairman, National Association of Mining History Organisations)
Farming: Jeremy Lake (English Heritage, Inspector, Characterisation Team)
Mobile Phones: Cassie Newland (Department of Archaeology and Anthropology, University of Bristol)
Offices: James Dixon (Faculty of the Creative Arts, University of the West of England)
Front Gardens: Angela Penrose
Back Gardens: Angela Penrose
Heritage: Rob Woodside (Atkins Heritage)
Golf: Andrea Bradley (Atkins Heritage)

Front Cover: Bedmond Lane, between junctions 6a and 10 of the M1, Hertfordshire © Matthew Walter
Title page: M1, Hertfordshire © Matthew Walter

Acknowledgements

The author and the Change and Creation project team would like to thank all those friends and colleagues who have contributed to the realisation of this book. In particular, our colleagues at Atkins Heritage, the University of Bristol, University College London and English Heritage. We are extremely grateful to Adele Campbell, Damian Grady, Liz Jenkins, Laura Maddison, Roger JC Thomas and Nigel Wilkins at English Heritage, to Simon Borrough, Marilyn Palmer, Matthew Walter and all those whose work and words are included in this book. The project was funded by the Historic Environment Enabling Programme (HEEP).

The Change and Creation team is:
Andrea Bradley and Janet Miller of Atkins, Graham Fairclough and John Schofield of English Heritage, Dan Hicks of Oxford University and Victor Buchli of University College London.

Picture credits

Andrew Crosby: 67; Forestry Commission: 142; English Heritage/NMR: 31 (AA03533), 32 (NMR17658/14), 33 (AA035336), 36 (NMR18693/02), 39 (NMR12636/03), 42 (BB97/07509), 43 (NMR 17190/09); 48 (BB97/01367), 51 (JEH22023/08A), 53 (BB93/23959), 54 (NMR15766/08), 57 (NMR17751/17), 59 (NMR23474/14), 72 (NMR4727/26), 78–9 (NMR 15578/08), 79 (AA96/04149), 82 (NMR23665/06), 84 (NMR21995/21), 85 (NMR21995/07), 86 (MAL_69031/0137), 87 (NMR21914/17), 88 (NMR21914/17), 89 (NMR23284/11), 94–5 (NMR15811/04), 101 (NMR18780/13), 109 (NMR4238/30), 111 (NMR235/12/11), 113 (NMR24002/16), 114 (NMR23914/03), 117 (NMR12911/13), 118l (OS93340/100), 122 (AA93/01450), 125 (NMR RXB3078/08), 127 (NMR23436/28), 130 (NMR21745/04), 136 (NMR4238/06), 137 (BB99/13805), 138 (BB96/10635), 139 (NMR21419/01), 140 (AA021161), 141 (NMR18722/08), 145 (NMR23322/08), 148 (AA047938), 157 (NMR23621/15), 162 (NMR18829/26), 167 (NMR17084/10), 171 (NMR21557/17), 172 (AA98/06311), 174 (NMR21380/30), 176 (NMR17658/21), 178 (NMR18795/21), 180 (AA98/06048), 183t, 184 (NMR259b), 185 (NMR23892/17); Lisa Hill: 144; Anna Nilsson: 90, 91, 121, 131, 154, 164–5; Chris Patrick: 166; Eric Pearson: 19, 20; Angela Penrose: 22; Perran Penrose: 93; Sefryn Penrose: 35, 37, 45, 47, 60, 61, 69, 77, 80, 92, 104, 105, 108, 118r, 124, 132, 149, 173l, 183b; Angela Poulter: 40, 55, 62; Graham Soult: 106–7; Cathy Stoertz: 64; Roger JC Thomas: 70–1, 73, 103, 159, 169; Julian Stallabrass: 134; Matthew Walter: 25, 27, 28, 29, 30, 34, 38–9, 41, 46, 49, 50, 58, 75, 81, 116, 120, 123, 126, 129, 151, 152, 156, 160, 161, 168, 173r, 175, 177, 181

Contents

Foreword 7

Introduction 9

People

Journey 19

Introduction 25

Temporary Housing 28

Social Housing 30

Privatopia 34

New Towns 36

Edge Towns 38

Migration 40

Faith 42

Homelessness 44

Airspace 46

Airports 48

Motorways 50

Roads 52

Car Parks 55

Motorway Service Areas 58

The Rail Network 60

Railway Stations 62

Politics

Journey 65

Introduction 69

Hospitals 73

Mental Health 76

Detention 78

Schools 80

Higher and Further Education 83

Defence Research and Development 84

Defence Manufacturing 87

Defence Infrastructure and Support 88

Memorialisation 90

Cemeteries 92

Crematoria 93

Protest 95

Profit

Journey 97

Introduction 103

Forestry 106

Farming 108

Metals and Industrial Minerals 110

Industry 112

Freight 115

Brownfield 116

Materials of Power 119

The National Grid 120

Energy 122

Nuclear Power 124

Renewable Energy 126

Water 128

The Office 130

Information 132

Mobile Phones 134

Out-of-Town Commercial Estates 136

Town-Centre Shopping 138

Shopping Malls 141

Pleasure

Journey 143

Introduction 147

Back Gardens 150

Front Gardens 152

National Parks 154

Country Parks 156

Heritage 158

Zoos 160

Television Landscapes 162

Theme Parks 164

Swimming Pools 166

Leisure Centres 168

Sports Stadia 170

Artificial Surfaces 172

Golf Courses 174

Cultural Centres 176

Art and Place 180

Holiday Camps 182

The Seaside 184

Afterword 187

Further reading 190

Bibliography 193

Foreword

What do we feel when we see the marching lines of pylons, the rising telecommunications masts, the slow-moving rotors of wind generators, the proliferation of huge, windowless plastic-coated distribution megasheds that are redescribing our chosen homeland? Are these presences alien or deeply ours? How much do we participate in the changing face of our landscape?

Ours is the most densely populated land in the European Union and our landscape is made, not found. And perhaps the least populated parts – those that are most vulnerable to cultural projection and resist the signs of change – are the ones with which we most fervently identify. It is important that we are participants in the evolution of our chosen dwelling place and recognise the change, rather than simply being inheritors of the fact and fiction of a place of birth.

The opening of the first sections of the M1 in 1959 confirmed the age of the car and as most of us now live in cities, landscape becomes more passed through than dwelt in: seen through the windows of our cars, we are separated from it not simply by distance but also by speed.

This book allows us to recognise the new networks of power and economy changing the face of the landscape. It is not simply that the car has overtaken the train, or that coal has been increasingly augmented by gas, nuclear and renewable supplies of energy. The new landscape is formed by the dominance of information and distribution taking over from production. The megashed, the mobile-phone networks' masts, the high-rise office tower, the proliferation of out-of-town shopping centres – this is the era of convenience, of service industries that ensure a comfort that separates us from time served in industry. In space/time terms the landscape has altered, but so have we in dwelling in it.

The spiral approach stacks that hang over Heathrow, Gatwick, Stansted, John Lennon and Manchester airports are our endless columns, so different from the monuments of the past. They are indications in vertical airspace of that same mobility that finds expression in Spaghetti Junction. This book helps us to engage with the facts of change: 'a landscape that grows out of social and economic decisions, a landscape that lives'. I think we should exult with our author in the recognition of large holding structures like the DIRFT (Daventry International Rail Freight Terminal), the large Ocado or Amazon distribution networks and the great spread of motorways which, since the opening of the M1, have become the most permanent unconscious memorial to the age of mobility.

The English national psyche has been a victim of the past, binding us to a reverence for the old things. But this acceptance of an imagined world, constituted and given value from the deeper past, also commits us to the role of victims; victims of choices made on our behalf by planners, architects and the government. This book encourages us to trace the lifelines of our territory – to see the somewhat hidden networks of power; power that we, as participatory democratic citizens, should exert positively in shaping our world. We can no longer be passive consumers: we have to take responsibility for the world we are making.

Another Place, Crosby Beach
near Liverpool

Antony Gormley

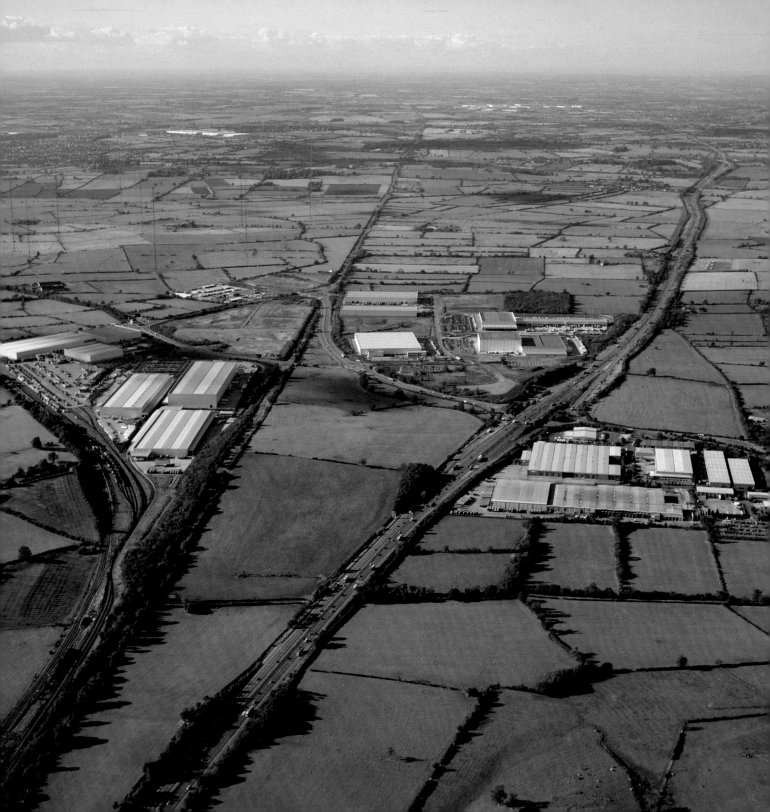

Introduction

There are some must-see sites on a tourist's itinerary of England: Stonehenge, the Tower of London, Hadrian's Wall, Ann Hathaway's Cottage – iconic images of the past that are inextricably embedded in the landscape of today. More recently: the Brighton Pavilion, the sadly damaged Cutty Sark, Ironbridge Gorge – all places that tell a story of a shrinking world and a time of unprecedented industrial and economic growth. It is likely that, at the time of their construction, those sites did not resonate in the way they do now. It is impossible to predict the values that future generations will ascribe to the material remains of the later 20th century but perhaps we can guess, and add the M6 Preston bypass, Greenham Common and Milton Keynes to the long list of historic sites that may attract future visitors to England.

Thinking about the heritage of our own lifetime, and that of our parents' lifetimes, throws up challenging questions. The landscape of England since the Second World War has been shaped by events and practices familiar to us. But in an era of rapid change that landscape fades fast, and is remodelled for new needs. The landscape of England is, and always has been, changing, malleable. The way it looks to us reflects what we create out of it. The tools of the later 20th century, and their impact, were bigger and more concentrated than ever before, but the 21st century will surpass it. The question is whether to address our own heritage while we still possess it.

Change and creation

In 2004, an English Heritage project set out to raise questions about the late 20th-century's contribution to heritage. In a short pamphlet, the project, called Change and Creation, asked 'why wait?'. It challenged the current orthodoxy within the heritage industry that places value, or assigns sites a designated protective status, only once a respectable 'cut-off' period of at least 30 years has passed. It rejected the notion of objective distance that underlies this rule. Indeed it celebrated subjectivity and personal engagement as important tools for exploring rapid, radical and, most importantly, recent change. It stressed that 'landscape' is a mental construct, an idea, a feeling that anyone can create. It is not 'out there', to be identified by scholars or experts in landscape: it is something that belongs to everyone. Change and Creation also rejected the common lament that recent landscape change is only loss: the removal of hedgerows, the hollowing-out of town centres, the concreting-over of the countryside. These laments mourn imagined landscapes. Landscapes have never been pristine, untouched or unchanging and the material of the long past is not better than that of the recent. On the other hand, neither should valuing the relatively new lead to a rush to

9

Daventry International Rail
Freight Terminal

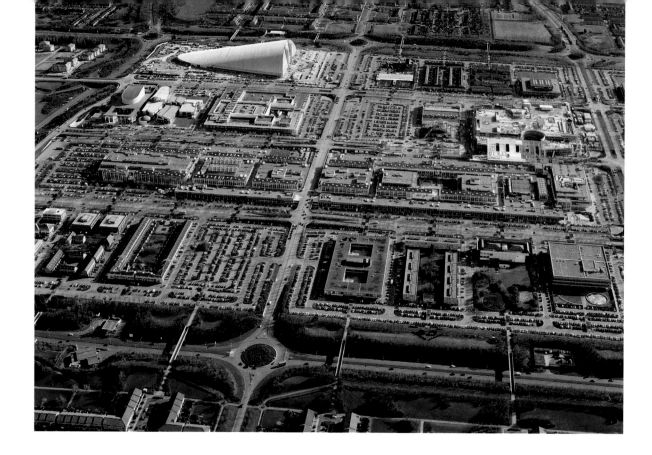

Milton Keynes town centre
with Snowdome

preserve things. Some things are transient. A thing's passing is sometimes its contribution. Heritage does not need to be defined narrowly as only 'that which we wish to keep'.

Modern landscape change has not always been, and is still not always, seen like this, however. Anxiety about change – the tentacles of urban sprawl – was a phenomenon of the inter-war years, for example. In 1955, one of the principal parents of modern landscape history, WG Hoskins, was moved to begin the final chapter of *The Making of the English Landscape*, with the words:

> *Since the year 1914, every single change in the English landscape has either uglified it or destroyed its meaning, or both. It is a distasteful subject, but it must be faced for a few moments.*

Hoskins regarded the landscape changes of his own time with distaste, but admired those remnants of what had gone before with a reverence divined from keen deductive observation. His book unravelled the landscape of the English countryside, its features and elements – roads, fields and towns – and tied them into a bigger picture of economic, cultural and social development from early times. Hoskins' new way of looking at the material

environment in order to understand it, its layers – stratigraphy – origins and foundations, inspired many now well-established disciplines such as local history studies.

Hoskins serves to remind us too of the origins of landscape archaeology, although even before the Second World War pioneers of aerial photography such as OGS Crawford, the first Archaeology Officer of the Ordnance Survey, provided another view of England's landscape, this time from the skies. Since then, English Heritage has collected images from the air in the National Monuments Record based in Swindon, a photographic archive of our changing landscape. At the height of the Cold War, Crawford wrote:

> Future archaeologists will perhaps excavate the ruined factories of the nineteenth and twentieth centuries when the radiation effects of Atom bombs have died away.

Since then archaeologists have indeed studied the material remains of the recent past – but not only of the industrial but also the technological and scientific revolutions, and not only the conflict and division of two world wars but also the unrealised nuclear war that Crawford feared. Some archaeologists have now begun the study of our contemporary lives.

Images of Change sits in this long tradition of landscape studies. It is an exploration, through words and images, of both the evolution of the later 20th-century landscape and the material expression of events and processes of the time which, to quote Hoskins,

> it is hoped will appeal to all those who like to travel intelligently, to get away from the guide-book show-pieces now and then, and to unearth the reason behind what they are looking at.

Journeys in the landscape

We are all travellers now, and we all have our personal and borrowed memories of the past 50 years. That period has shaped our identities and how we interact with the world, in short how we create mental landscape. But there is no reason why these views, these landscapes, should all be the same. Identities and experiences personalise our view of the world: age and generation, sex and gender, ethnic or cultural background, social and economic factors, access or subjection to power, regional differences, even which part of a town or even an estate we might live in. The intertwining of different narratives of the recent past is a part of this book's purpose as well.

Yet here we stand, the many authors of this book, apparently in the role of experts. So an early word is needed about authors and about authority. We know we cannot claim to be

representative nor typical of the wider population or of its view of landscape. We are describing housing estates for example, without living there, factories without working in them. And as archaeologists, many with inter-disciplinary connections to art or architecture or ecology or planning, we do not have an 'innocent' viewpoint. We mainly work in the realm of heritage and conservation, which gives a peculiar tinge to our perceptions of landscape and what we do with it. We are attempting to establish a new 'layer' of heritage and to contribute to the understanding of future heritage and landscape. It is a political as well as an academic book.

As archaeologists, we do not seek to identify the value of a particular site, building or place but to explore the processes and explanations behind the material culture that we study. However, in the study of the later 20th century we also think we should recognise and capitalise on our various 'biases'. After all, unlike the landscapes of prehistory, or the industrial revolution, this material culture is ours – in studying it, a lack of distance might be a virtue.

Much of this book is deliberate in the personal and subjective, merging object and subject (an illusory distinction anyway) to diminish distance. We emphasise this by beginning each section with an account from one of the Change and Creation team of a personal journey of their own.

Journeying is a leitmotif of *Images of Change*. Landscapes (unlike 'views') are not static but change as we move through them. Journeys are chronological as well as geographical, concerned with time as well as place, so the introductions to each section are also chronological journeys through the past half century. *Images of Change* also takes the reader to unpredictable destinations. It may appear at first glance to be unusually organised, and perhaps it is a book to wander around rather than to read sequentially. Its variety and non-linearity is a reflection of the diversity and complexity, and the unfinished character, of the world that we inhabit. As we said in Change and Creation, the answers to big questions such as which parts of the later 20th-century landscape matter most, or are disliked or appreciated, and how we should deal with modern things on their voyage into the future, are likely to come not from experts but from those who live and work in the wide variety of landscapes of England, of all generations, backgrounds and interests. This book consists of images and descriptions, evocations and reminders. They are to provoke questions, not to provide answers.

Structure

If the book does not provide answers, or a full picture, and if its arrangement reflects the daunting richness and intractability of the yet-undigested physical and intangible inheritance of the past 50 years, we can nevertheless explain the 'scaffolding' that we have used to create it. It has five levels, and it is worth describing them very briefly.

The first level is the interest, contemporary relevance and potential future significance of modern things and modern change. What people today see as modern and unremarkable will in future be seen as heritage, because of the patina that comes from the passage of time, because the older something becomes the more important it tends to be thought, but most importantly because with age comes familiarity as new things mature into being a natural part of people's landscapes. Cultural associations will have grown around them, people will have become familiar with them. We can all think of examples of recent structures whose construction was originally opposed, but whose demolition is in turn opposed. New perspectives and ways of seeing always emerge and *Images of Change* considers this phenomenon at a level above the anecdotal.

The second level is Characterisation, the English Heritage programme that contains the Change and Creation project. Characterisation is a relatively new way of approaching the management of heritage, aiming (as in historic landscape characterisation, for example) to rise above the level of individual sites, buildings or monuments and to look more widely at landscapes, townscapes and extensive areas. But it is more than a matter of scale. Landscape is a matter of perception; it links people to place in more powerful and influential ways than even the most important listed building. It allows space for the connections between things to be valued, for the overall essence of a place – what it means to people – to be valued, not just the mere fabric of its components. Once we reach the stage of thinking that all aspects of an area or place have a potential contribution to a place's future historic character and legibility, its link to the past, then we leave the realm of preservation and move into that of managing change.

The third level is the European framework that increasingly provides a solid philosophical foundation for character-based conservation, the European Landscape Convention. This Convention provides tools to link historical and archaeological interests – material culture, buildings, monuments that belonged to the past but now form part of peoples' mental landscapes – with present-day concerns. Landscape exists in the present, but the present-ness

of the past, especially perhaps the recent, contemporary past, ensures it makes a major contribution to landscape.

The fourth level in *Images of Change*, because it is written by archaeologists, is the 'evidential value' of the past 50 years of landscape change – what the late 20th-century landscape can tell us about our recent past. We do not have to value things only because they are seen to be beautiful, well designed or useful; we also value things because they explain the past (however recent). For earlier periods it is commonplace to hear landscape described as 'our primary historical document' and that is hardly less true for recent periods. Yes, we have a plethora of documents about the period, more than can be absorbed over several decades by historians. But the physical remains of the past tell their stories too, many different stories. The recent landscape, both materially and perceptually, offers us a tool for understanding the journey we've made as individuals and as a society since the end of the Second World War.

Finally, at the fifth level, is a concept of 'future heritage'. It seems fairly obvious, given the way that the 'cut-off date' for heritage creeps forward decade by decade allowing 'new' heritage into the accepted canon, that sooner or later all of late 20th-century heritage will be an unchallenged member of the club. In addition, though, in terms of landscape, we can also say that the most recent additions or change are not just the latest layer of landscape, easily removed if we do not like them. The latest layer is also the connection between older pasts and still unknown futures. If they are swept away after 20 years or so because we think we are tired of them and because they have not had time to become valued, or – worse – through a misguided attempt to go back to 'traditional' or 'natural' landscapes, we risk creating future landscape without roots. This book is therefore not just a description of the past 50 years of landscape change but part of a continuing debate about heritage, more specifically a shift towards progressive forward planning and design approaches to the future of landscape.

Having erected the scaffold, now for the structure. The fourfold arrangement of this book – landscapes of people, politics, profit and pleasure – helps us to order and group the 'entries' for each kind of landscape and pushes to the forefront a few of the major preoccupations that colour people's views of England's landscape. This structure provides a platform for us to look back on the last half of the 20th century, and to how we look forward to create the landscape of the 21st century.

People, politics, profit, pleasure

There is first a still solid conviction, that goes back to Beveridge and the post-war settlement, that some things should be provided by the State. Its legacy transformed English society: we have a social landscape of houses and movement. *People* examines the evolution of England's edge towns, the webs of roads that weave them together, and how we move through the post-war landscape.

The post-war settlement also provided for the health and educational security of the nation, as well as its defence. This belief not only created hospitals and schools, but it also allows us today to measure the world against that benchmark even with respect to post-Thatcher 're-settlement'. We have called this landscape of governmental machinery *Politics*.

Accompanying that, since the 1980s, is an almost equal public acceptance that 'the market works', and that it can provide for social good. This leads people to see the world through different lenses, and fuels the phenomenal rise in house prices which drives prosperity and new building. The technological revolution has shrunk England's manufacturing role, but the industries that replace it leave their own marks. This is the landscape of *Profit*.

The view from the car window has almost replaced all others in the perception of our own landscape. But we remain nostalgic for our agricultural past. Who in 1945 realised that the rustic myth would have so completely swept the board, shoring up conservation, biodiversity, attitudes to road building, provoking 'nimbyism' and objections to wind farms. It is an aspect of all landscapes but particularly relevant to the formation of our landscapes of *Pleasure*. For entertainment, we have reinvented our aristocratic and rural pasts, idylls that become more important to the imagination as we increasingly distance ourselves from any kind of pastoral identity.

The global picture

These are important factors that define our four types of landscapes. Behind them stand cross-cutting external factors, processes that shape England in a global landscape.

One of these is the ongoing process of urbanisation. We might see urbanisation as the product of other driving forces, but in practice urbanisation itself is now a factor for change. The landscape of England, it could be said, though unnoticed or denied by many, is in many ways a wholly urban landscape especially if urbanisation is defined by lifestyle and

networking, as well as place. We are all urban now, even if landscape looks rural.

Then there is globalisation. The physical face of the land and the city morphs with the impact of international geopolitical and financial forces, but more importantly the global media – internet, TV and cinema – and cheap travel, change how we perceive the world, opening up global not just local landscapes. If landscape is perception, then our landscape is global even when we gaze at local character.

Finally, there is the growing multiculturalism of our society which inevitably affects how landscapes are perceived. From the imported Americanisation of lifestyle to the home-grown multi-ethnic cultures and communities of our cities, none of the 'traditional' aesthetics of landscape, neither 'beauty' nor 'biodiversity', hold true for more than a minority of the population. Landscape is becoming pluralistic: not only do we all have our differing perceptions but our deepest, most unexamined taken-for-granted assumptions, whether based on class, religion, culture or gender, are becoming excitingly diverse. The associations, memories and aspirations that people bring to the 'construction' and 'reading' of England's landscape in the 21st century now come directly or indirectly from all corners of the world. If landscape is perception then our landscape is now more than ever multicultural and multi-vocal, even when looking at the same patch of land.

Absence and presence

Images of Change is the start of a national discussion about here, now, archaeology, history, memory and experience of the landscape. It can fit in your glove compartment as you drive the motorways and ring roads of the later 20th century. You might use it to spot landscape features from the train window on your commute to work. You might put it on your bookshelf alongside Hoskins.

It might provoke you to indignation both through its absences – where is Leeds? Where is the Stadium of Light? Where is the influence of immigration? – and presences – why Gateshead? Why that golf-course? What makes travel social and hospitals political? You could condemn it to landfill and the archaeological excavation of the future. *Images of Change* is a tool for understanding our own journeys in our own landscape, to understanding the recent past from within. So much of our lives is a journey through the landscape and infrastructure of our own creation. For each of us, the material of our contemporary environment embodies gradations of different meanings, sometimes monumental, sometimes

fleeting, sometimes solid, sometimes ephemeral. *Images of Change* gives an archaeological eye to this encounter, with which to excavate ourselves.

In the end, the structure and order, the fragments and divisions that *Images of Change* presents are false. Archaeologists break things down to put them together again, to better understand the whole. Landscape is a single, albeit eclectic, thing: there is only one landscape of England. It is multi-layered, richly textured and collectively authored; it is both changed and changing. Yet, well-travelled as we are, we move with ease from one place to another, enjoying 1990s entertainment centres and Chinese New Year as much as we do 18th-century Bath or a ramble in the Lakes. Is now the right time to engage in the discussion of our modern heritage?

There was a time when redundant quarries gave birth to 20th-century places, their boundaries offering ready-made perimeters to the self-containment required by the landscape features of the period: Thorpe Park, Cambridge Science Park, Springwell Industrial Estate, the Eden Project. Just as neatly, quarry sites lend themselves to disposal as well as creativity. The rubbish and rubble of the later 20th century becomes landfill. A fridge-filled quarry in Lewes is testament to our fast-lived lives, as are the long trains full of rubbish on its way to distant landfills, that hurtle out of London past waiting commuters. Durable forms are dismantled: 1950s Broadmead, Bristol's post-war shopping centre, ends its life in a Welsh quarry, disposed of without ceremony. As it always has been, England's landscape is reused, recycled, re-sculpted. It is a good time to look at what remains, review where and how we have lived, before we are left with just footprints, old photos and plans, memories and a sense of loss, and perhaps a future Hoskins writing that the later 20th century left no lasting mark on England's landscape.

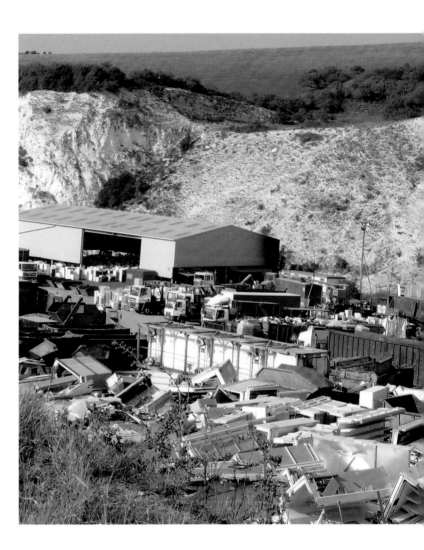

Refrigerator disposal,
Southerham Pit, Lewes,
East Sussex

People **Journeys North**

Sefryn Penrose

Driving north on the A34, we stop at Nether Alderley. A 14th-century corn mill, incongruously tangled with the 20th-century roadscape, sits squat against a banked contour as if shrinking from the speeding traffic. It is stooped under the weight of a stone-tiled roof and behind it a tranquil millpond is hidden from view. Across the road, the private church of the earls of Stanley, erstwhile lords of the north-west, is a stone's throw from the former home of the Beckhams: a converted barn in the heartland of the Cheshire Set. To an archaeologist, the juxtaposition is grist to the mill, but traditionally it is not the choice of brick, fixtures and fittings of the footballers' wives that are of interest. Instead, we seek out the minutiae of lives of a more distant era, high or low status; the deeper the finds in the soil layers of time the better. But sitting next to my mother, Angela, I begin to scrape back the layers of our own landscapes, the lives of the later 20th century, because they and their material record – apparently all-pervasive, all-encompassing – are disappearing too.

Angela is driving. She has moved Eric, my grandfather, into sheltered accommodation in Heald Green, Cheadle, and we are going to visit. The block in which Eric now lives is a few minutes from the house in which he and my grandmother, Joan, lived since I was born, the house that they moved to shortly after it was built in 1971. On our way, we stop outside it: Angela asks if I want to have one last look around the house. I don't. We work a couple of stray items into the car. The house is the first on a drive, oddly straight in a maze of closes and drives that wind quietly, residentially, around each other, so that every time my father came to visit he always got lost at the last minute in the labyrinth of identical houses. All the roadways are named after Cumberland landscapes – Buttermere, Grasmere, Eskdale – alien yet not too far away from this 1970s private estate. The house has three bedrooms, two storeys, generic. Rough grey brick is faced with white weatherboards, a strange appendage for '70s Wimpey-modern but indicative of the faux vernacular that has been so popular since. For the first time I notice they are peeling and cracked. The roof is pitched,

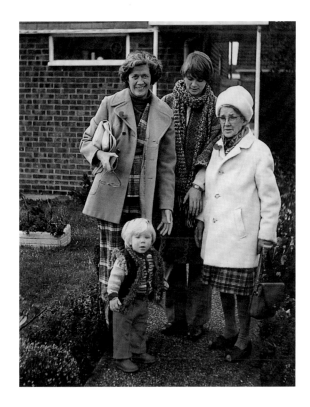

Four generations of the author's family, outside the house on Wasdale Drive

PEOPLE

19

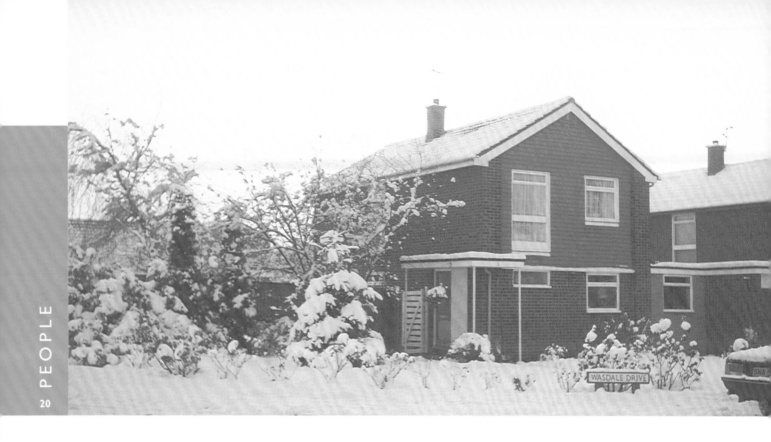

Wasdale Drive, Gatley,
Cheshire

machine-made brown tiles come down to the fascia boards. The tall creosote fence that affords the garden complete privacy no longer looks as invincible as it did when I was a child. In the years since Joan died, Eric became preoccupied with building another house in the garden, a nest-egg for the future. Nothing came of it. On the other side is an attached garage with a laundry smell and the soft tick-ticking of the central heating system: instant signifiers of a place and a time. The car was always parked outside, on the short driveway, overlooked by the master bedroom window.

Eric returned from the war late in 1946, from Burma via India and a tour in devastated Germany. He returned to the position he had occupied since he was 16, before war broke out, as a quantity surveyor in a London firm. As the government began its enormous push to rebuild Blitz-crippled cities, Eric was offered a promotion in the new Manchester office. In 1954, he moved with Joan, Angela (born 1947) and David (1950) to Heald Green. Since the government had relaxed its restriction on new-built private housing in 1954, developers prospected new ground, pushing into the wastes and farmlands on the edges of cities. Stockport, an industrial hub in pre-war days, dirty with the by-products of its mills and manufacturing industries, became a dormitory suburb for the rebuilt city. Their first house, in

Elmsleigh Road, was one of a few, pre-war traditional brick-built, semi-detached, mock-Tudor houses, on a dirt track yet to be tarred, which petered out into a muddy field. The land around was the arable outlands of booming Manchester: farmsteads, small villages like Heald Green, grown up around crossroads, mills and, a short distance away, the now grade II listed Cheadle Royal Hospital, formerly the Manchester Lunatic Asylum. Some of these features remain, either physically or as incongruous ghosts. Waterfall Farm, long since without waterfall or farm, hosts the Gatley Golf Club; the asylum awaits conversion to flats; and, next door to it, a vast new business complex takes the asylum's name and incorporates its 1903 extension as a hotel and conference venue.

It was some time before the council managed to install street lighting on Elmsleigh Road, or provide local amenities for the booming population. Meanwhile, Eric worked on the projects that were to launch Manchester as a stellar city of learning and commerce: the UMIST complex, Eagle Star House, buildings which would be loved then loathed as the 1960s development dream soured. However, they were shining new departures when built, glamour in a city famed for its grimy industry, where Angela remembers walking between bombsites fringed with rosebay willowherb well into the late 1960s. For Joan and Eric and other newly mobile families, the 1950s offered promise, opportunities that were taken as they came. Distances shrank further in the 1960s with Eric's Zephyr and the new M6. Angela and her friend, Joe, would drive to Knutsford Services and drink coffee in the bridge cafeteria: formica, Bob Dylan, a six-lane motorway – the height of sophistication.

We stay the night in a guest room in Eric's block and in the morning I'm surprised to find myself hemmed in on all sides. The village feel of Heald Green has survived partly through its island-ness. Bordered by highways – the A34 Kingsway, the M60, the Styal Road – these private housing estates and neighbouring council estates have managed to feed off the fat of their commuterville origins. Across the north–south Styal Road the residents of Wythenshawe – relocated to public housing from the cleared slums of Manchester – were not so lucky. The intense council estates, lacklustre prefabricated blocks and tight terraces suffered in their own isolation. Built on land donated by the earls of Tatton, Wythenshawe was cut off from Green Belt and open land by Styal Road, the airport to the south, and major roads north and west, and sunk without a community hub or public infrastructure into poverty. Things are looking up now. Commuter routes to the airport stop at Wythenshawe, and break its isolation. The Forum blossoms: a 1960s civic centre revamped for the new century.

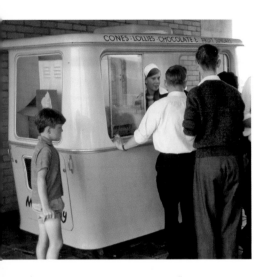

Ice cream selling on Manchester Airport's viewing platform, 1966

The expanse of Manchester Airport is a total departure from the terrain. Eric fought the construction of the second runway – essential for the airport's bid for international expansion – over the River Bollin and through National Trust woodland. In her teens, Angela sold fish fingers in the airport cafeteria while her best friend sold ice cream, 1960s confident in their white hats, on the spectator's terrace of Ringway Airport. The terminal building, opened in 1962, is an unapologetic concrete monolith shaded with aviator dark glass and crowned by the white hexagon of the control tower, which added to the allure of the sleek VC10s for the sky-watchers.

At one time the Bollin fed the mills on this side of Manchester: at Styal, Quarry Bank Mill (established in 1784) once apprenticed 1,000 children, orphans and poor from Manchester's workhouses. The red-brick mill and the park through which the Bollin flows are strikingly attractive this sunny weekend, part of our national heritage, a family destination. In 1997, my mother and her brothers took Eric to the Bollin to scatter Joan's ashes. Sundrenched now, we glimpse a past landscape of harsh labour and industry that has been transformed into something pleasant and unchallenging called 'heritage'.

Eric's former neighbours, so helpful in the months in which Angela and her brothers had been taking turns to journey up on weekends, now greet a new family, of Pakistani origin, moving out to the suburbs from the other side of Manchester where the results of poor planning, employment and education policies had made life untenable.

We drive out past the church that my grandparents worshipped at, St Catherine's, built in 1956 to serve the expanding community. Unlike the patrician church-building of the Victorian age, post-war religious provision fulfilled the desires, and often fund-raising efforts, of a growing and changing population. St Catherine's is a red-brick Romanesque building with an octagonal tower to the side and shallow pitched roofs; my parents were married there in 1969 and Joan's funeral was the first and last time I had been inside. We look at it now from a distance, a part of my family's life that we have departed from, part of the landscape of a constantly evolving society. The pattern repeats itself: when the new family move into my grandparents' old house on Wasdale Drive they apply for and receive planning permission for an extension, a prayer room. Another family creates their own landscape; the view shifts again and we move on.

Manchester Airport

People **Introduction**

England is a landscape of houses: estates, both private and public, mock vernacular gables and moon-landing era tower blocks in crackled cement. The perception of ever-creeping suburbanisation accompanies the expanding commuter belt as the slim gap between urban and rural becomes tighter. England is a latticework landscape of roads – highways, motorways, A-roads, B-roads, closes and driveways – that link urban and suburban conglomerations. These places are punctuated by angular-steepled churches with abstract stained glass, onion-domed mosques and Thai-style temples, while above them aeroplanes stack, waiting to descend.

This landscape emerged out of the post-war challenge to the 'five giants' identified by the Beveridge report of 1942. Want, Disease, Ignorance, Squalor and Idleness lay in the 'road to reconstruction', and the trio of Temporary Housing, New Towns and Town and Country Planning Acts were devised to pave over them. The pragmatism of the pre-war generation and the optimism of the post-war generation met in those immediate post-war years. Churchill, who had seen Britain through the war, was rejected at the polls and, with him, the pre-war social inadequacies. The result was a clear mandate for a brave and forward-looking fight on the domestic front.

That social world created in the 1950s is still evident in the landscape 50 years on. It is a place constructed to give physical form to social support, enfranchisement, neighbourhood and community creation, but it is incapable or unwilling to overshadow its predecessor. Much has happened since, notably the shift (begun as early as Macmillan's stint as Housing Minister in the 1950s, but given its real impetus by Thatcher) from public- to private-sector housing provision which has brought us to the present-day building explosion; but that early dawn has been seminal to the 21st-century English landscape.

By 1957 Britons, said Prime Minister Harold Macmillan, had 'never had it so good'. The road to reconstruction was well underway and by 1958 the motorway was born: Macmillan opened the M6 Preston bypass with the words 'In the years to come, the county and country alike may look at the Preston bypass – a fine thing in itself but a finer thing as a symbol – as a token of what was to follow'.

What followed redrew the map of England. The lines of the new major roadways were marked on maps out of scale. The emphasis overshadowed other features but explicitly outlined how the post-war landscape was woven together. Small towns grew neat but

Thamesmead, Erith,
Greater London

irregularly shaped orbital estates, in turn neatly orbited by ring roads that tied them into a nationwide network of living and travelling. London sprouted carefully planned New Towns. Old communities relocated wholesale – overspill from the cities and the rural poor to the new settlements of Hertfordshire, Essex, Central Lancashire – while new communities, many from overseas, filled the gaps they left behind. Rural and urban identities merged as commuters flitted along conveyor-belt highways between the two and as 'working from home' brought the machines of the office into the front room. In reality, most 'country-dwellers' live increasingly urban lifestyles. But paradoxically, the countryside seeps into the city through suburbia and since the 1980s the lure of the 'cottage' has dictated housing design.

The mark of movement is indelible on this post-war map. Changes to housing culture and the nationwide road network meant that social movement – up and down the ladders of work and home – was physically enabled. The local environment was no longer as limiting and families could, with relative ease, move between cities to search for more work or a better quality of life. On a global scale, immigration changed people's outlook and landscape, and England embraced, absorbed, fought and rejected the influence of overseas cultures that accompanied the global disturbances and economic migrations of the later 20th century. Although outwardly proud of its open-door policy, by 1950 the Atlee government was already looking for ways to limit Commonwealth immigration. Conflict, global north–south inequalities and EU expansion continue to bring new communities into England to share and contribute to Britain's prosperity. The influence of this on the landscape, through both actions and perceptions, has been immense, but is often overlooked.

But our mechanical alter ego, the car, has been the most profound influence on this event landscape of movement. Few places are untouched by the raw bass sound of the internal combustion engine. The weekend family trip has given way to daily routine use and the acceptance of the car as a personal space, an extension of the home and, for many people, one of life's necessities. In 1951, only 14% of households had access to a car. By 1971 the figure was at 45% and by 2001, not only did 75% of households own a car but many owned more than one. From garages beneath bedrooms to car boot sales to city centre multi-storey car parks, from 18-hour rush hours to school runs, auto-mobility is now an intractable, inextricable part of the social landscape. Ancient routes became 20th-century corridors and even in the remotest areas the thinnest lanes are coated with tar, bitumen, asphalt. The networks the car has created have become the veins and arteries of England's social life.

The M1, Hertfordshire

The English love of railway diminished simultaneously. The romance has been extracted from rail travel, which now operates as a tool for commuters and business travellers. The same may be said of air travel despite the optimism and glamour of its earlier days, not so very long ago. Its landscapes are expansive – not just landing strips and terminal buildings but hangars, support buildings, acres of car-parking, service industries, freight depots, access motorways, high-speed rail links – all stretching inexorably outwards. Above, a new skyscape of stacking patterns – unseen by previous generations – and vapour trails that create artificial clouds against blue skies, provides momentary evidence of everyday movement.

But by rail, plane or car, the English love of movement remains apparent. Mr Toad, quintessentially English, forsook the romance of travel for bigger, better, faster, more, and the post-war generations have taken his lead. Our roads today 'make' our landscape, just as they always have. Yet gradually, and like other contradictions apparent in unintended consequences of the post-war planning system, the road has come to be considered a monstrous enemy of landscape. Here is the gulf between how and why landscape was made, and how it is perceived.

In the short-term, the post-war landscape of fast and radical change was accepted with optimism, and as a necessity. In the long-term, for better and for worse, its innovations have become so ingrained that our concept of Englishness, and the way we perceive it to be written in the landscape, has shifted irrevocably. We think ourselves into dissatisfaction with what we have made; England is not a land of lost content, but misplaced content.

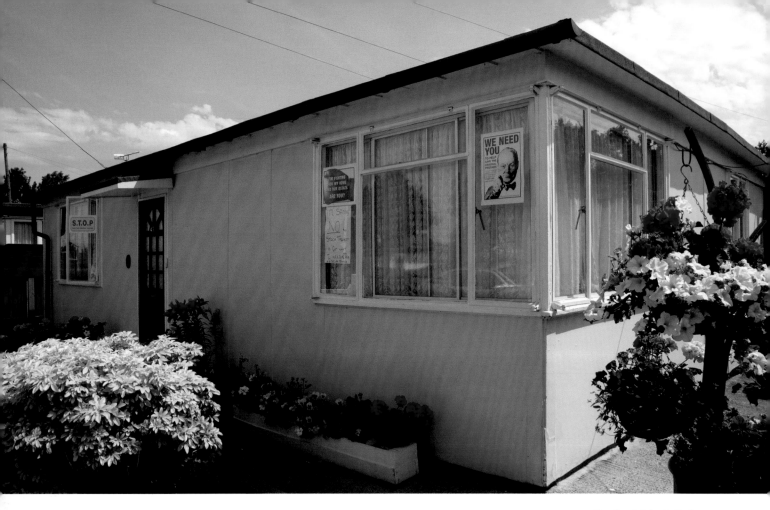

Temporary Housing

Lewisham's endless residential landscape is a cornucopia of 20th-century housing styles. Angled into the edges of Catford's conventional brick-built terraced streets, the Excalibur Estate continues to fend off calls for its demolition and redevelopment. A small grid of roads named after Arthurian knights encloses neat symmetrical rows of prefabs. Erected in 1948, the prefabs are linked to the roads by paths – they predate the ubiquity of the car that so shaped the later 20th century – and each has its own neat front garden. The estate has been altered by the years: occasional extensions, cladding and mature trees have diverted from its original uniformity. Still ministering to the estate (though now with brick support walls) is the prefab church of St Mark's.

Excalibur Estate, Catford, London

Where to see them: Wake Green, Mosely, Birmingham (Phoenix); Avoncroft Museum of Historic Buildings, Bromsgrove, Worcs (Arcon V); Excalibur Estate, Catford, London (Uni-Seco); Beaufort Road, St George, Bristol (Phoenix); Henwood Road, Wolverhampton (Tarran)

The first of the government's answers to the housing shortage that followed war-time bombing was exhibited at the Tate Gallery in 1944 in the shape of an all-steel bungalow. Houses are machines à habitation, Le Corbusier had proclaimed, and the industry machine went into action. By the end of the 1940s, the Aircraft Industries Research Organisation on Housing (AIROH) could produce a self-contained aluminium house in 12 minutes for delivery in four parts by flat-bed truck. An equally minimal workforce could assemble it atop a dwarf wall and all that remained was to plug in the electrics and move in.

By 1949 the government had delivered 156,623 prefabricated houses to feed the post-war shortage. For many, the prefab was their first encounter with privacy, as well as with the fridge, electric cooker and central heating. The simple traditional designs, with front door, small windows and sometimes gabled roofs proved very popular with residents, and prefab estates segmented by white-picket-fenced front gardens became part of the post-war landscape.

The cost of production and the promise of permanent homes ended the prefab factory line by 1949, but their popularity never waned, unlike that of the social housing estates that followed. The perceived temporality and fragility of the prefab as a first home encouraged a pioneer spirit in their ordered encampments which has been echoed in the developer-built private housing estates that have dominated the housing market since the 1980s. Prefab estates flourished for decades, exceeding their 10 to 15-year lifespan. Many became permanent fixtures and a few have survived into the 21st century. Their legacy remains in the ordered council homes that often replaced them and in the use of prefabricated units currently undergoing a resurgence in residential and commercial building.

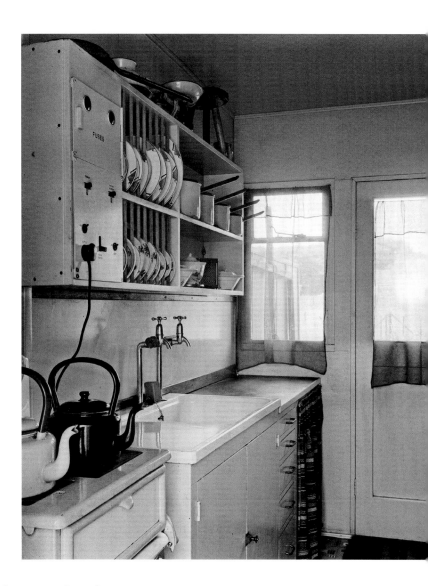

Kitchen in a Howard House, Swindon 1947

Social Housing

The Nightingale Estate dominates its Hackney hinterland as Stonehenge does Salisbury Plain. Begun in 1967, six high-point towers, crenelated with balconies, looked out over decked low-rise housing blocks and across landscaped parkland mapped out in concrete paths. Today the estate is diminished: three of the 22-storey, 65m tower blocks still stand, resurrected and renewed, their balconies and entrances enclosed and glazed. Three sister towers were demolished in 1998, dynamited by an 11-year-old resident and a soap star as a festival gathering cheered. Their replacements – new, familiar, human-scale cottage-style blocks, semi-detached or terraced houses – refer to an idealised rural past in which timber frames and pitched roofs, central front door and symmetrical windows, signified a house. Control of the estate has been ceded to a housing association. While rehoused residents rejoiced in the destruction of their former high-rise homes, other residents enjoy their renewed towers with custom-designed kitchens, state-of-the-art elevators and conservatories in the sky. The Nightingale Estate's neglect and resurrection is as much a part of the landscape as were its six gaunt towers.

In 1945, the Labour government began the post-war construction boom with a pledge to house 'every family in this island'. By the end of 1946, they had provided over 320,000 extra units of accommodation, most in the shape of 'cottage plan' council houses based on the ideals of the Garden City movement, with 12 houses per acre. However, constraints on time, budget and space led to the reduction of these standards, along with the size of the houses. Parlours and entrance halls, and their associated etiquettes, were phased out completely.

By the 1950s, the minimum floor space had become the maximum, and many of the target 300,000 new homes per year were built by private developers. Slum clearances and mass-production met in the construction of challenging high-density urban developments; the cottage plan had been evicted. Modernist architects such as Le Corbusier, and renewed interest in traditional working-class terraces, inspired systems of low-rise 'slab blocks' – high-density blocks of flats and maisonettes four or five storeys high and designed on long verticals.

Cold winds swept the open decks and between blocks: the east–west orientation a necessary concession to enable sunlight into shadowed spaces. Early blocks of brick-filled concrete frames such as Park Hill, Sheffield (1961) were superseded by preconstruction and system builds (steel frames with pre-cast and reinforced concrete structures and wall panels). Large developers, such as Wimpey, enabled by their distribution systems and factory sites, assembled prefabricated units on site.

The Nightingale Estate, Hackney, London

Park Hill Estate, Sheffield, in the 1960s

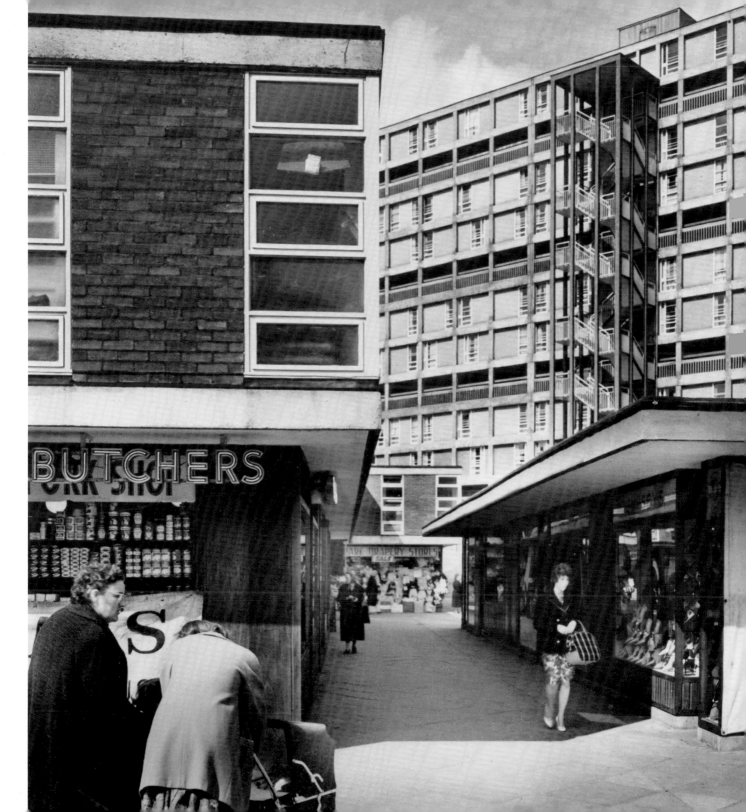

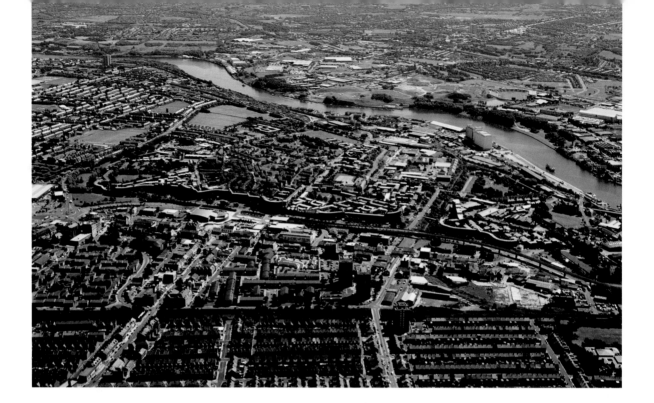

Byker Estate, Newcastle-upon-Tyne

Due to economies of space, local authorities offered extra subsidies for tower ('high point') blocks that often exceeded 20 storeys. However, their popularity suffered a heavy comedown in 1968 when a gas explosion caused the death of five residents and the partial collapse of Ronan Point, a London tower block.

Estates reached unprecedented sizes, mostly as islands in inner city areas or peripheral developments. Set in municipal landscaped grassy or tarmaced surrounds and linked by decks, bridges and concrete paths, these estates were total departures from organic landscape evolution but had much in common with grid-plan towns and villages that had been laid out since medieval times, often to house manufacturing populations. At Bestwood, Nottingham, from 1951 the arable and colliery landscape of DH Lawrence's *Sons and Lovers* was transformed as the largest council estate in western Europe was laid out. Consisting largely of well-built semi-detached houses, the estate departed from geometric grid plans with its curling roads and vistas that reflected the natural topography. But deterioration was often swift as ill-thought-out tenancies and sparse community provision (the Hulme Crescents, Greater Manchester, had one pub for 12,000 tenants) scuppered social cohesion. Material problems heightened the unease: builders took shortcuts with materials and techniques and architects did not always fully understand the new materials they had specified. Residents at Park Hill complained of faulty heating within weeks of moving in.

Park Hill Estate, Sheffield, 1960s

Where to see them: Park Hill, Sheffield (zeilenbau); Balfont Tower, Tower Hamlets (Goldfinger high-rise); Byker, Newcastle (large mixed estate); Picton Street, Shoreditch (prefab slab blocks); Thamesmead, Greenwich (platform housing); Moss Side (prefab point blocks); Bestwood, Nottingham (pioneering 1950s giant estate); Loddon, Norfolk (listed rural council houses by Taylor and Green)

Public spending was frozen in 1978 and housing programmes were abandoned. The death knell for social housing was sounded. The 'right to buy' policy in 1980 lauded ownership, and tenants became homeowners at a discounted rate; responsibility was out of the government's hands. Some estates began to lose their uniformity as owners differentiated themselves from tenants through the addition of new doors, windows or porches, while some estates remained wholly council owned, an indication of the poverty within.

At its height, social housing formed a third of Britain's housing stock, and in some boroughs well over half. The fate of what remains is diverse: at the beginning of the 21st century, neo-slums have formed in the Midlands and the north, unlettable social dumping-grounds in which many of the poorest seekers of welfare are housed alongside refugees; while other former council flats, such as those at Erno Goldfinger's Trellick Tower in London's Notting Hill, can fetch up to £300,000. At Byker in Newcastle, and on the Nightingale Estate in Hackney, tenant-led regeneration illustrates the enduring popularity of the cottage plan: street fronting with pitched roof, two storeys and traditional front door. But the single terraces and small estates of low-key and low-cost housing that successfully endure in every town and village are probably the greatest legacy of the social housing dream.

Privatopia

For keeping the trim gardens full of choice flowers without a weed to speck them; for frightening away little boys who look wistfully at the said flowers through the railings; for rushing out at the geese that occasionally venture in to the gardens if the gates are left open; … the ladies of Cranford are quite sufficient,
wrote Elizabeth Gaskell of the town based on her native Knutsford, Cheshire. Now, as then, a quiet satellite town of Manchester, Knutsford has expanded on its collection of spacious villas. St George's Close, built on the site of an old coal yard, squeezes in between Italianate and Oriental villas built by the Victorian glove manufacturer Richard Harding Watt. The new generation of affluent residents in need of multiple garages and round-the-clock security presence are the footballers and entrepreneurs of the north-west.

The post-war Labour government eventually embraced private construction as a necessary complement to the public programme. Where council estates attempted to divert from the pre-war pitch-roofed semi – a badge of the old world – private developers pursued it. With more potential land to play with, curling roads based on the Radburn system (a non-linear, off-highway type of residential close from New Jersey) spread into the waste spaces on the edges of England's cities, towns and villages. Nuclear families moved in, often before

St George's Close, Knutsford,
Cheshire

amenities such as street-lighting had been installed or roads tarred. New housing was built not only with a back garden but also a defined space in front of the house, a buffer zone between private home and public road. Radburn-system garages – banked at the end of the close – brought cars closer to the family unit but the driveway as centre-piece brought the car to the doorstep. From the 1970s, few new houses came without a garage, often directly beneath a bedroom.

In the 1980s, societal emphasis shifted even further towards material success: houses came in economic bands, incentive for those at the front of the close to climb to the larger house at the end. In an era that saw the end of public housing, developers answered the need for housing with large estates that reassured a public now wary of concrete urbanism. Housing looked back to an imagined idyll of haywains, country lanes and lovelorn swains. Affordable, new, traditional: this was a landscape that rewarded private enterprise and initiative on a par with the pre-war growth of the suburbs, but now in planned urban and peripheral developments often on brownfield land. Criticism that estates were uniform and soulless was answered as 1990s, glossy red brick ceded to clusters of Cotswold-style yellow brick cul-de-sacs, and then to mixtures of the two within the same development. In the consumer-led 21st century the new vernacular home comes in 'contemporary' or 'traditional' schemes, with three choices of size, each with three choices of door, illustrative of the economic status of the occupant. Self-contained and making maximum use of space, the deliberate non-linear nature of their planning – curves, indents, staggered rows – divorces them from earlier eras of public and private housing and allows individuality to conquer the accusations of homogeneity previous levelled at the big housing developers.

The exclusive addition of the gate, once peculiar to the city or the aristocrat, was the height of 1980s segregation, but has become more and more prevalent in both rural and urban contexts where concerns about security and desire for community have created a 21st-century answer to the moated site or walled town. *The Work we are going about is this, To dig up Georges-Hill and the waste Ground thereabouts, and to Sow Corn, and to eat our bread together by the sweat of our brows,* said Gerrard Winstanley, leader of the Digger movement, in *The True Levellers Standard Advanced* (1649). His aim was to create a society in which the earth was free to all, the restrictions of ownership, bondage and enclosure disposed of. In 2000 the exclusive housing estate of St George's Hill, Weybridge, Surrey, was fully enclosed by electric gates that served to enclose and protect a community, though not in the way that Winstanley had intended.

Where to see them:
St George's Hill, Weybridge, Surrey (Europe's premier gated estate); Knutsford, Cheshire (Cheshire Set and Manchester United); Maidenbower, Crawley, West Sussex (latest of Crawley's neighbourhoods – a catalogue of turn-of-the-century styles).

A new housing estate near Stansted, Essex

New Towns

Contained, landscaped, planned: Peterlee, County Durham, occupies the wild east coal seams worked since Victorian times. Its ordered landscaping was a commercial and residential centre for the scattered coal-rush villages that had sprung up around the pits, a hopeful town for the future, a town with no past. The artist Victor Pasmore was appointed to advise on the Development Corporation's town plan. The space age 1950s and 1960s fed Peterlee's design and Pasmore's aim to 'lift the activity and psychology of an urban housing community on to a universal plane' was embodied in the Apollo Pavilion, an abstract bridge across a stream. Under the Durham coastal skies, open spaces of zig-zag low-rise housing (deep mine workings forced the rejection of an earlier high-rise plan), parklands and extensive communal gardens reached that universal plain, but compounded Peterlee's separation from its mining history and local identity.

Peterlee New Town,
County Durham

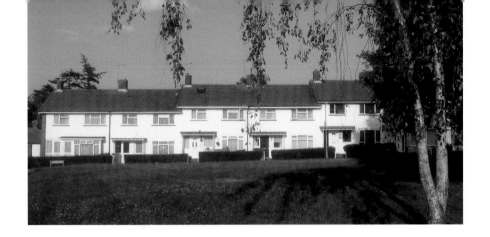

Ifield, Crawley, Surrey

The New Towns Act of 1946 saw 'overspill' – working families from bomb- and slum-damaged London – and businesses relocate to new settlements in greenfield sites: spacious housing and rent incentives eased the transition. Development Corporations (DCs), selected and funded by government, oversaw each town's physical construction and settlement. Between 1946 and 1950 eight new towns were built just outside London's greenbelt, while beyond, the steel town of Corby, Northamptonshire (1950), was enlarged, and Aycliffe and Peterlee (1947 and 1948) centralised the rural mining and urban industrial communities. Later new towns, such as Central Lancashire and Northampton, filled out existing towns. The towns originally had projected populations of 30,000 to 50,000 but although Crawley passed the 100,000 mark in the early 21st century, others failed to meet their target populations.

In 1962 the DCs were dispensed with, their jobs done, and in 1965 ten more towns were designated in England, most famously Milton Keynes (its population of over 300,000 creeps up on the big cities). They were self-supporting, with their own industrial zones, and pioneered new ideas of levened society from the Open University to public ski-slopes. The towns were modelled on the Garden City ideal of pre-war Welwyn: ordered 'cottage plan' houses and gardens in self-contained 'neighbourhood units'. Straight, wide, car-friendly boulevards separated the units and surrounded a central zone. At Milton Keynes, a grid pattern of 200- or 300-acre squares was laid out, each with a commercial or cultural centre.

The land rents for existing new towns were spent elsewhere in the expansion of the scheme. Ever growing townships of alphabetically or thematically named drives and closes compromised original schemes, and the provision of new social or cultural centres was deemed an unnecessary expense. Neither did they provide adequately for single occupants, a factor that influenced the demographic considerably. As Sam Appleby describes in *Crawley: a Space Mythology*, new towns were working-male environments which developed their own social condition – new town blues – replete with the neurotic housewife and problem teen. Nevertheless, the new towns today house over two million people.

Where to see them:
Stevenage, Harlow, Hemel Hempstead, Crawley, Aycliffe, Hatfield, Peterlee, Basildon, Bracknell, Corby (1946 Act New Towns); Skelmersdale, Dawley (later Telford), Redditch, Runcorn, Washington, Warrington, Milton Keynes, Peterborough, Northampton, Preston, Chorley and Leyland, Lancashire (1961 Act Towns)

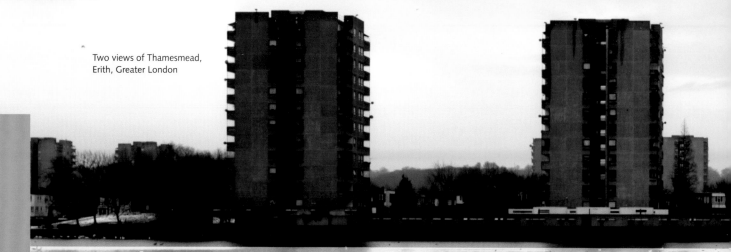

Two views of Thamesmead,
Erith, Greater London

Edge Towns

One thousand acres of Royal Arsenal marshland in the Thames reaches at Woolwich, sandwiched between a sewage works, a pumping station and two power stations, may not have seemed the obvious choice of location for a new town, but the Greater London Council's vision for Thamesmead as a metropolitan frontier town that remained part of the city resulted in elevated buildings – ground-level garages kept residential areas free of the risk of flood – and Thamesmead was billed as a 'town-on-stilts'. 'Neighbourhoods', initially concrete wonderlands, were built around shallow ornamental lakes that hold the drainage water pumped from the wetland peat through which the town's foundations piled. The urban dream began to drift into nightmare as unoccupied tower-block flats and garages succumbed to urban decay. But the river vistas remain a draw, and since improved flood defences have enabled ground-level building, new private and housing-association developments of conventional brick-builds and unconventional eco-housing builds on the Venetian water-world beauty captured in the final scenes of the film *Beautiful Thing* (1996).

Where to see them:
Wellingborough, Aylesbury, Daventry, Swindon, Thetford (expanded towns); Burgess Hill, Sussex; Bar Hill, Cambridgeshire; Chelmsford, Essex; Bradley Stoke, Bristol; Croxteth Park Estate, Liverpool (1980s boom townships)

The American journalist Joel Gareau coined the term 'edge city' in 1992 to refer to the peripheral development so prevalent in later 20th-century urban expansion. In England 'edge town' prevails: countrywide penumbras of housing and industry. The 1952 Town Development Act enabled some boroughs to be designated 'expanded towns'. Thetford, for example, a Norfolk market town of around 4,500 inhabitants, expanded into the surrounding heathland through the construction of large housing estates. Overspill communities relocated and often, as at Thetford, boosted and outnumbered the declining local populace. Industry followed and economic growth, especially in manufacturing businesses, financed the gamble. Industrial estates grew up along peripheral highways.

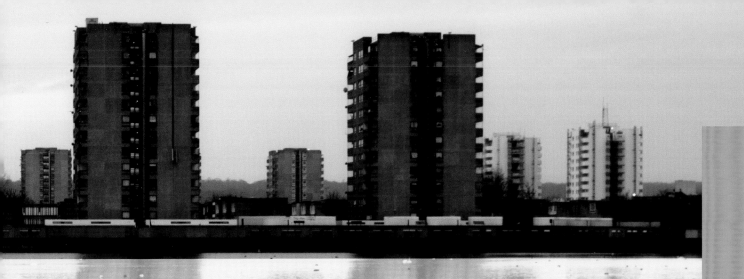

Post-war planners resisted the ribbon development of pre-war days, when speculative suburban estates were strung arterially along highways. However, the growing urban fringe was resurrected during the Thatcher years as private ownership and enterprise was encouraged as answers to housing problems. This change in policy manifested itself physically in the construction of private prospector estates – pioneers in peripheral creeping zones – accompanied by private business means. Bradley Stoke, a centreless town north-east of Bristol which took its name from two brooks that run through the site, comprised uniform nests of residential estates. 650 acres of land parcels developed by different companies meant housing diversity was the difference between developers' catalogues. Work began on Bradley Stoke in 1987 but speculative construction on 20-year planning permissions meant that the edges were built before the centre – a brownfield site owned by a major supermarket – and social and cultural provision came late. Nevertheless, commercial and service developments, attracted by the wedge of transport links – out-of-town rail station and the M4, M5 and A38 intersections – have enabled the town to escape its recession nickname: Sadly Broke.

Migration

Emblematic of post-war immigration is 22 June 1948, when 492 West Indian immigrants, mostly demobilised servicemen, disembarked the *Empire Windrush* at Tilbury docks. Many were to spend their first night in Clapham South deep shelter – a bomb shelter in the underground system that had been used to house prisoners of war – within walking distance of Brixton's labour exchange. Fifty years later, Electric Avenue, Brixton, rocks on market days with the noise and exchanges of the *Windrush* legacy. The physical fabric of the landscape has been changed only by 1960s rebuilding but the Caribbean influence is evident throughout Brixton's social fabric, in cultural deposits both tangible and intangible – from smells and sounds to shop signs and market debris.

Post-war decolonisation saw the migration of people from former colonies to Britain in unprecedented numbers. Recruited to plug employment gaps in industries such as public transport and the NHS, former colonial 'subjects' not only altered the social landscape but were also key architects in the reconstruction of the national infrastructure and economy.

After the war many European refugees and war-time labourers, from Poland, Lithuania and Italy, stayed on in England's mining and textile industries. For a time in the late 1940s, Bedfordshire's road signs read in both Italian and English; decades later, in 2007, some road signs in Manchester have been translated into Polish. They were followed, after the partition of India, by South Asians – army personnel and administrators across the globe who found that they no longer had a home to return to. The geopolitical ripple effect of the breakdown of Empire, from Sri Lanka to Somalia, Cyprus to Iraq, has placed England in a complex landscape of migrations. Significant numbers of Bangladeshi migrants continue to move to England, particularly from the Sylet region. Their relative economic success during the late 20th and early 21st centuries has seen a transnational flow of capital returning to Sylet. It is used there in the construction of shopping centres and other buildings. Sylet has become one of the most prosperous towns in Bangladesh, an extension of Britain's multicultural landscape.

The 'fabric effect' meant that immigrant families found themselves housed in cheap inner-city areas such as St Pauls in Bristol: ghettoized landscapes of unimproved Blitzed buildings amid jerry-built Victorian terraces, interspersed with social housing units. New arrivals often joined already established family members, further bolstering the immigrant population. In such pockets of poverty and instability, tensions could become exacerbated. Poor community relations and provocation by authorities or neighbouring populations led to notorious riots in London's Notting Hill in 1952 and Nottingham in 1958, and later in Brixton and St Pauls

Where to see them:
Notting Hill Carnival;
St Paul's Carnival;
Leicester; Bradford;
Green Lanes, London;
Little Portugal, Thetford;
Koreatown, New Malden,
Surrey; Chinese Quarter,
Birmingham; Little
Columbia, Elephant &
Castle, London

(1980), Liverpool and Birmingham (1981) and more recently in Oldham (2001). A strengthening of civic feeling has emerged out of some of these tensions and, building on Notting Hill, carnival has created a vibrant event landscape of its own.

The commercial success of immigrant groups is as evident in popular mythology as it is in the cityscape. Birmingham's Chinese Quarter has a distinctive physical style announced by a stone pagoda, colourful Chinoiserie gates, roofs and finials of red, green and gold. The city's first Chinese restaurant opened in 1956, and the Hurst Street area became consolidated as the catering trade grew. A 1990s shopping centre adopted Chinese motifs in its design. While London's Chinatown comprises one main drag and several backstreets filled with the all-hours bustle of restaurants, clubs and groceries, a significant number of smaller towns and cities across Britain have self-styled Chinatowns of their own. Chinatowns thrive in Liverpool, Manchester and Newcastle. In Leicester and Bradford, South Asian immigrants who found work in the textile industries have created new cultures in cities which are now made up predominantly of immigrants and their descendents. Although enormously damaging to the fabric of manufacturing cities, the decline of England's industries has not affected the many immigrant families that have followed the economic trend into white collar industry. Now, rows of imported textiles from a range of traditions declare the ever adapting nature of England's population.

Since the 1980s, the second and third generation children of post-war migrants have made inroads into the cultural landscape of urban England and are establishing new communities in wealthier suburbs instead of run-down city centres.

Brixton Market, London

Gujarati shop signs, Melton Mowbray

Faith

Shri Swaminarayan Mandir's ghummats (domes) glow white atop the epic proportions of North London's Hindu temple of the Bhakti tradition. Limestone from Romania (durable in England's changeable climate) and marble from Italy was transported to the stone-carving centres of Rajasthan and Gujarat, then shipped block by carved block to be assembled on the site of a demolished warehouse in Neasden. Permission was granted by the earth itself in a pre-construction ritual. This visual representation of the growing presence of Hinduism in the English landscape followed Highgate Hill Muragan (1965) and many in between, and is juxtaposed with a new symbol of English spirituality, the Wembley Arch.

Appropriation of spaces, from front rooms to community centres, was often the best option for new migrants seeking a sense of home, support, community and religion. Initially, places of worship, whose remit was to serve a religious community, often functioned as a source of welfare and support first, and as a place of worship second. For Caribbean immigrants and, later, African arrivals, multi-purpose sites sufficed until funds were raised to purchase redundant buildings, often deconsecrated chapels. Tamil refugees from Sri Lanka's violence found the 11th-century pilgrim site of Our Lady of Walsingham a suitable substitute for Our Lady of Madhu.

Shri Swaminarayan Mandir, Neasden, London

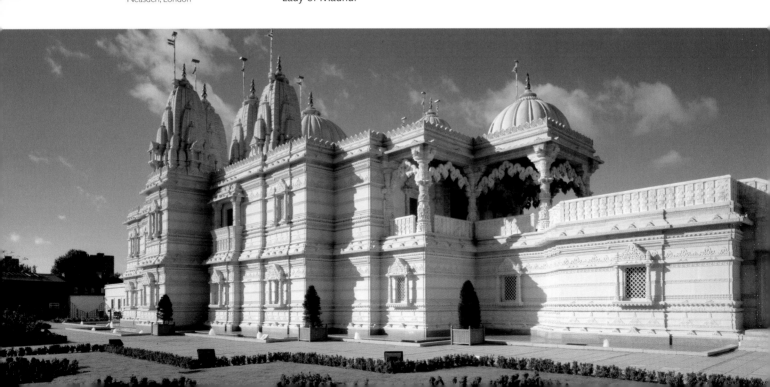

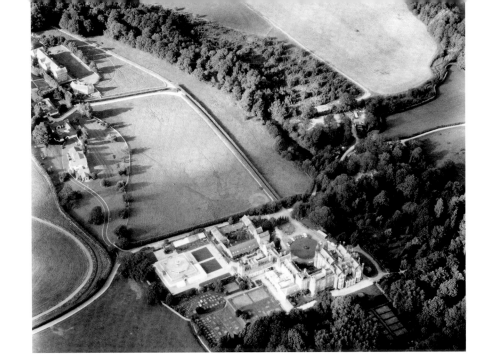

Conishead Priory, Ulverston, Cumbria: main house 1820s; Kadampa Temple 1990s

Where to see them:

Dewsbury, Yorkshire (skyline of mosques); Birmingham Central Mosque, Highgate, Birmingham (second purpose-built mosque in England); Shri Swaminarayan Mandir, Brentfield Road, Neasden, London; Amaravati Buddhist Monastery, Great Gaddesden, Herts (Theravada centre in wartime evacuee hostel); Sri Guru Singh Sabha Gurdwara, Southall, London (largest Sikh temple outside India)

The site of the London Central Mosque at Regent's Park was initially a gift to the British Muslim community, officially opened by King George VI in 1944, and was augmented by the Frederick Gibberd-designed mosque in 1978. The prominent golden dome is a familiar landmark in the royal park. Other central mosques in Birmingham and Manchester, with their adherence to traditional designs including minorets and domes, ensure the visibility of Muslim worship in the heart of Britain's major cities, while prayer rooms built as domestic extensions demonstrate its presence in the home.

In 1957 Sikhs in Leeds marked the holy Baisakhi festival publicly and established Sikhism as a cultural and religious facet of the city. In 1965 London's Sikh community built a Gurdwara in Shepherd's Bush (against local council opposition). With their traditional building and carpentry skills, Sikhs were involved in reconstruction of the wider post-war landscape too, and many Sikh immigrants left an intangible imprint in grand engineering projects such as the M1.

Buddhism has adopted eclectic corners of the English landscape: Zen to Theravada community-centre based worship has seen the erection of a traditional Thai Ubosot wat in Richmond, the conversion (overseen by English Heritage and the Victorian Society) of a former courthouse and cells in Kennington, South London, a temple erected in Conishead Priory, an 18th-century stately home in Cumbria, while on Holy Island, the Samye Ling retreat continues as a sanctuary of peace.

Homelessness

English homelessness finds itself harshly defined in opposition to the concept of 'home', in a land where a home is a castle. The worn but well-lit pedestrian tunnels of Charing Cross underground station in central London provide a dry haven for some of London's homeless. Britain's underpasses, from Victorian railway arches to the elaborate pedestrian throughways of 1960s development, have become ambiguous shelters for generations of homeless: they are covered shelters away from prying eyes, but also neglected public spaces where protection is not guaranteed and reception (by both public and police) is often antagonistic. The soup-vans of the Strand at street level and sleeping-bagged bodies in doorways are the mobile and transient markers of homelessness in the landscape.

The 1948 National Assistance Act provided Poor Law-style reception centres – often converted Victorian workhouses – for 'unsettled' single homeless. The transience of homeless people – between 'home' and its problems and cities that promised better provisions – led to an invisibility and the continued hold of the popular image of the aging and itinerant tramp. But *Cathy Come Home*, first screened in 1966, gave the young homeless a celluloid home. The documentary-style drama depicted a family's spiral into homelessness. It shocked a safely housed society and led to high-profile vigils and marches.

High unemployment in the 1980s and cuts in social provision, such as mental health institutions and social housing, left a human imprint on townscapes. Visibility grew, in the shape of rough sleepers in shop and office doorways, makeshift townships in peripheral wastelands, queues for soup vans, kitchens and charity hostels.

'Cardboard City', a concrete maze of underpasses beneath Waterloo's bullring roundabout (now home to the IMAX Cinema), became a media-celebrated residence to 200 of London's homeless. Temporary boundaries, walls, rooms and beds were erected from discarded cardboard and other flotsam of the city's commercial life. This was a physical symbol of the permanence of transience – in a city where skyscrapers stood empty. It remained so until eviction orders were given in 1998.

Charities such as Crisis and Shelter, and the Salvation Army citadels, successfully fought to raise awareness of the issue and offer material help. The launch of the *Big Issue* in 1991 created an acceptable and permanent public face in thoroughfares and shopping centres, but the closure of resettlement units in the 1990s in favour of supported and sheltered housing changed both the figures and the identity of the issue by dispersing the people who faced it.

Better conditions followed Labour's provision for more hostels, post-1997, but this was offset by the use of anti-homeless architecture and street furniture (sloping, curved or interrupted benches), the reinforcement of problematic legal definitions such as 'intentional homelessness', drug use, development of waste-spaces, and the out-of-sight/out-of-mind/out-of-statistics nature of the hostel and bed-and-breakfast circuit. Once again the homeless community has been forced back into the city's hidden spaces.

Where to see them:
sheltered corners of towns and cities

Charing Cross underground station, London

Airspace

Existing air traffic regulation was set by the UN-associated International Civil Aviation Organisation. By the time it was fully functional in 1947 there were already 35 airfields operating in Britain with landing aids; and 21 radio stations provided navigational frequencies through the Chain Home network of 110m-high transmitter masts along the east coast. The Chain Home system was the foundation of Britain's post-war air traffic control (ATC). A centre had been established during the Second World War at Uxbridge, with others at Gloucester, Watnall, Preston, Prestwick and Inverness. These transferred to civilian use after the war.

But increasing air traffic was leading to dangerously crowded airspace. In 1951 Britain finally established its first airway using 53 beacons which had been set in place by the US Air Force during the war. An aerial network of highways already existed in the US, each up to 10 miles wide and 3,000 feet high. Aircraft had to maintain regulated distances measured in feet (vertical), miles (latitudinal) and minutes (longitudinal). These distances have decreased as

Chain Home radar, Dunkirk, Canterbury

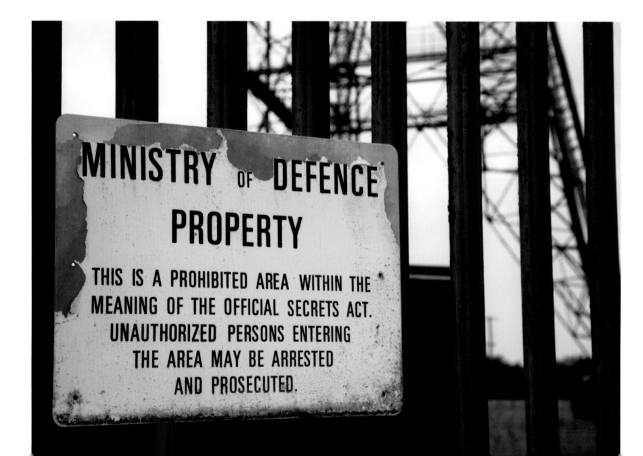

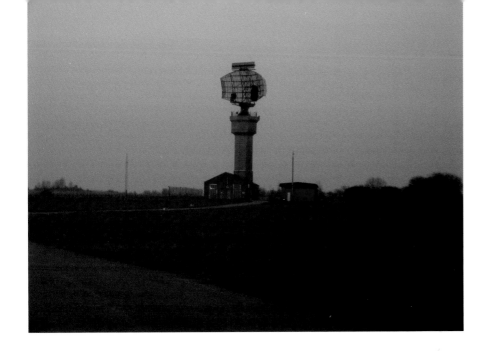

Debden NATS Radar Station, Essex

radar equipment has improved; for transatlantic flights they are currently 1,000ft, 120m and 30 minutes apart. Britain's first airway, Green One (the colours and numbers correspond with their representation on aeronautical charts), ran from Woodley, near Reading, to Strumble Head off the Welsh Coast. It was followed by Amber One, which became one of the busiest airways in the world as a transatlantic corridor.

Airspace exists in several classes and is heavily controlled. Class A airspace, formerly Positive Controlled Airspace (PCA), operates between 18,000 and 60,000ft up, and the aerial highways lattice within it. Airspace is most heavily regulated at airports and over cities (Class B or C airspace) where ATC keeps an ever more technological weather eye on incoming and outgoing planes. Takeoffs and landings must circle in strict patterns, and abide by noise-abatement regulations. The spiral approach stack, wherein during busy periods planes are kept in a holding pattern at 1,000 vertical feet apart until cleared for landing, is visible for miles as an indicator of any larger airport's location.

Airspace regulation was divided in the UK between the Scottish Flight Information Region (FIR) and the London FIR. A further control centre was set up at Manchester Airport to oversee airspace from the ground to Flight Level 195 (19,500 feet up) across the Irish Sea, east to the Humber, and north to Scotland, as well as the uncontrolled airspace (Class G) over the Pennines. Air traffic control was privatised in the late 1990s. Swanwick in Hampshire replaced West Drayton as the main ATC centre and currently controls 200,000 square miles of airspace, split into 30 levels, each 1,000 feet apart.

Where to see them:
Thames approach to Heathrow; Chain Home radar at Great Baddow, Essex; remains of Chain Home radar station at Dunkirk, Canterbury; NATS (National Air Traffic Services) Radar Station, Debden, Essex & Clee Hill, Shropshire; London Swanwick ATC, Fareham, Hampshire

Airports

Gatwick Airport, West Sussex

Until 1989 Stansted was a cheap alternative to Heathrow and Gatwick for small holiday charters. However, the Norman Foster terminal that made an art form of light and airy malleable space soon launched it as the nation's third airport. The Stansted Mountfitchet airfield was requisitioned during wartime for use by the US Air Force and the RAF (some wartime Nissen huts remain in use). When hostilities were over, the military airfield became a temporary camp for German POWs. In the 1970s, the quiet Essex airport's proximity to London and the M11 motorway launched it into national airspace. Stansted reflects both the origins and development of most of England's airports: a shift from fun experimentation, via the military, to speed and affordability. It sits in Essex arable country occasionally interrupted by glossy new commercial developments making the most of the London-Stansted-Cambridge corridor. Its size and relative isolation have also made it 'the hijack airport' as threatened planes, such as 2000's Afghan Ariana incident, when hijackers claimed asylum from the Taliban regime, can be isolated and dealt with quickly.

Pascoe describes in *Airspaces* how Heathrow's first commercial passengers in 1946 flew off in Lockheed Constellations with the day's newspaper bought from the WH Smith kiosk at the departure tent. Over the later 20th century, the millennia-old obsession with flight met modernism, and airports were reconceived to combine technology with a futuristic aesthetic.

Older airports were centralised with a main terminal building at the heart of the airport complex, around which the activity of arrivals and departures hummed. But expansion was often necessary. Heathrow's Queen's Building (1955) needed the support of the Oceanic Terminal (now Terminal 3) just seven years later, followed by others. Deregulation of the air industry in the 1980s along with the advent of the Boeing 747 ushered in the jet age, and an equivalent new phase in airport architecture. The 747 forced older airports to retrofit buildings and runways to accommodate its size – Gatwick's circular satellite terminal was almost immediately outdated. Newer airports, like Stansted, are decentralised, designed with built-in potential for sideways expansion with enormous buildings in which transient fixtures can be moved and removed. Often the only 'whole' element of a terminal building is the roof, a sky-high signature which proclaims the identity of the building: Foster's floating roof at Stansted, Liverpool John Lennon's (previously Speke) 'above us, only sky' rooftop motto.

The airport is bisected. 'Airside' the planes gather on the apron, taxiing for take-off or waiting to be boarded. The east–west runway (the prevailing wind direction in England) is angled in degrees latitude and longitude and often crossed by a service runway, the

coordinates painted on the tarmac (at Heathrow a slightly offline twinned 09L/27R and 09R/27L). A service block enables the maintenance of technology and hardstanding; campanile or ship's-bridge-like control towers sweep the planes in and out. All of this can be watched from the airport's viewing deck across the short grassed, anti-bird landscape. 'Landside', the low-slung widespan terminal building houses a complex system of segregations: of arrivals and departures, of passengers and processes, security and safety. The airport environment has turned inward, with layers of security and a retail environment akin to a shopping mall. Gatwick surpasses the busiest shopping centres for retail turnover per square metre.

British airports are classed: Heathrow is a Class A 'hub' airport, the busiest in the world and home of the (former) national airline. Manchester operates as a 'focus' airport, providing a station for ongoing connecting flights, both international and domestic. Together with other medium-sized international airports, such as Birmingham, it is Class B. Smaller domestic airports such as Newquay, with few international flights, operate at Class C level.

Where to see them:
Heathrow (world's busiest airport); Stansted (hijack central); Kent International Airport (formerly RAF Manston, emergency space-shuttle landing site); Durham Tees Valley Airport (1960s chic); Newquay Cornwall International Airport (twinned with RAF St Mawgan)

Stansted, Essex

Motorways

Carving a straight path across England, Roman Watling Street was not built for the scenery. In 1959, nearly 2,000 years after Watling Street's construction, the M1 followed its path through Hertfordshire, a super highway through the agricultural county that was its own landscape, independent of the spaces through which it passed. The M1 was an iconic route into the future and over the north–south divide. By the 21st century, however, the choked rush-hour traffic begged for extra lanes, but the elegant Owen Williams bridges still stood firm in a network of junctions that had tied London's orbital towns – Hemel Hempstead, Luton, Milton Keynes – into a national network.

In 1946, Minister of Transport Alfred Barnes sketched a spider-legged plan onto the back of an envelope, a rough approximation of the network of 'limited access dual-carriageway roads with grade separations' that would form the British motorway system.

M1 Motorway, Hertfordshire

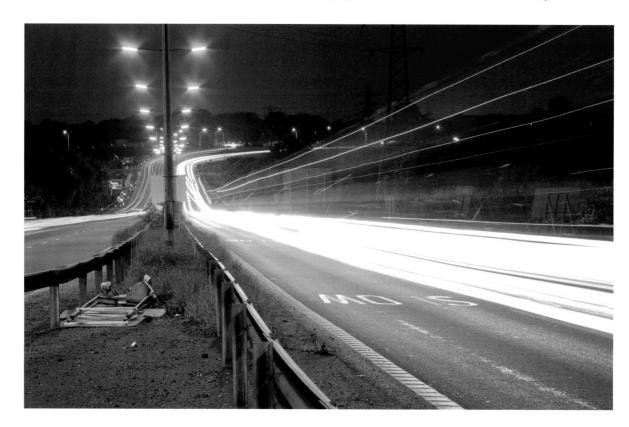

Inspired by the New Jersey expressways, their endless speed and efficiency and open views, Ernest Marples, Barnes' Tory successor, saw the tea-room plan to fruition. In 1958 he opened the M6 Preston bypass, followed by the M1 London–Birmingham motorway (later extended to Yorkshire). The hourglass of motorways gradually connected England's remoter points, shrinking distances and obstacles. It connected new towns to transport routes and enabled the urban expansion project. It supported the British car industry; motorisation took hold and paved the way for the mass-consumption of the car, not just in Britain but abroad too. The booming middle classes took to the road, testing new road surfaces to the limits; a space-age journey in the latest Rover along gleaming new tarmac made a trip to the seaside the ultimate day out. Later motorways elegantly catered for the site-seer and provided scenic aspects as well as gentle curves to keep drivers awake and in gear. The curved lettering of the specially designed motorway alphabet signified all that the roads were meant to be: smart, modern, independent, fast.

Almondsbury Interchange,
Bristol: Junction 20 M4;
Junction 15 M5

The grand design was executed by enormous teams of migrant workers from Ireland, Poland, Jamaica, many of whom lived in transient camps along the road. Engineers pioneered concrete casting techniques to build bridges, while large-scale earth movement was required to put the roads in cuttings or embank them. The ultimate aim was the continuous flow of traffic, and junctions previously unknown in England allowed multiple traffic conduits to meet and cross invisibly. Slip roads transferred traffic from one grade to another – either at grade (traffic meeting at an intersection), grade separated (at an interchange) or fully grade separated (traffic continuing to flow freely). At Almondsbury near Bristol, the M4 met the M5 in a butterfly of climbing road decks that kept traffic moving. A little farther down the M4, the cows of a farm bisected by the road were given their own underpass.

Environmental reaction to the growth of the country's transport network culminated in the Battle of Twyford Down in 1993, when local landed Hampshire folk teamed up with eco-warriors (immortalised by Swampy of the Dongas) in a campaign against the slicing up of an SSSI in the path of the M3. Although the battle was lost, further reaction to the Newbury bypass led to the temporary shelving of the motorway project. More recently it has been resurrected and Britain's first toll motorway (allegedly built on pulped Mills & Boon books), the M6 Toll, opened in 2003.

Roads

Where the Rushall Canal meets the Tame Valley Canal, navigational distraction from the sewage smell and grassy banks is provided by smooth cylindrical concrete columns rising out of the water. They carry 18 elevated road decks, the highest at 24.4m. In total, 559 columns across 12 hectares allow the A38M to meet the M6 and A38 trunk road, slip roads to give access to and between them, and local roads to pass underneath. The monolith required the diversion of the River Tame: motorways trumped waterways (themselves diverted due to heavy canal traffic in the 19th century). Known nationally as Spaghetti Junction, it opened in 1972. Each deck differed from the others, its materials chosen to best suit its need. No roundabouts or intersections were used: traffic could – in theory – flow freely at all times. The Gravelly interchange effectively links all England's motorways to each other; the body of a spider of trunk routes that created an integrated road network.

By the time of the Trunk Roads Act of 1946, England and Wales were divided into six zones around the A1 to A6. 3,685 miles of road were requisitioned, on top of the 4,505 miles adopted in 1936. They were 'trunked' – classed as primary routes of national importance – and put under the aegis of the Department of Transport. Local roads remained with the local authorities. Continuous laying machines eliminated the high labour cost of road surfacing and ended piecemeal laying. This, and constant improvements in road surface materials, made for smoother and, more recently, quieter roads.

Roadside provision for motorists was also standardised: planning restrictions in 1947 controlled the appearance and situation of petrol stations and refreshment hostelries. The big oil companies increased their branding as well as their estate. Self-service pumps introduced in 1963, decimalisation, and metrification processes, replaced older pumps and the station forecourt took on the uniform company-coloured canopy. A remnant of the early days of motoring – the forests of roadside signs and unlicenced services – is the snack vans that are still features of many A-road lay-bys in the 21st century.

Engineering advancements consolidated the A-road network and any unwieldy elements were phased out. In 1961, the Tamar road bridge at Plymouth improved transport access to Cornwall as the Severn suspension bridge had to Wales in 1966.

Gravelly 'Spaghetti' Junction, Birmingham, 1972

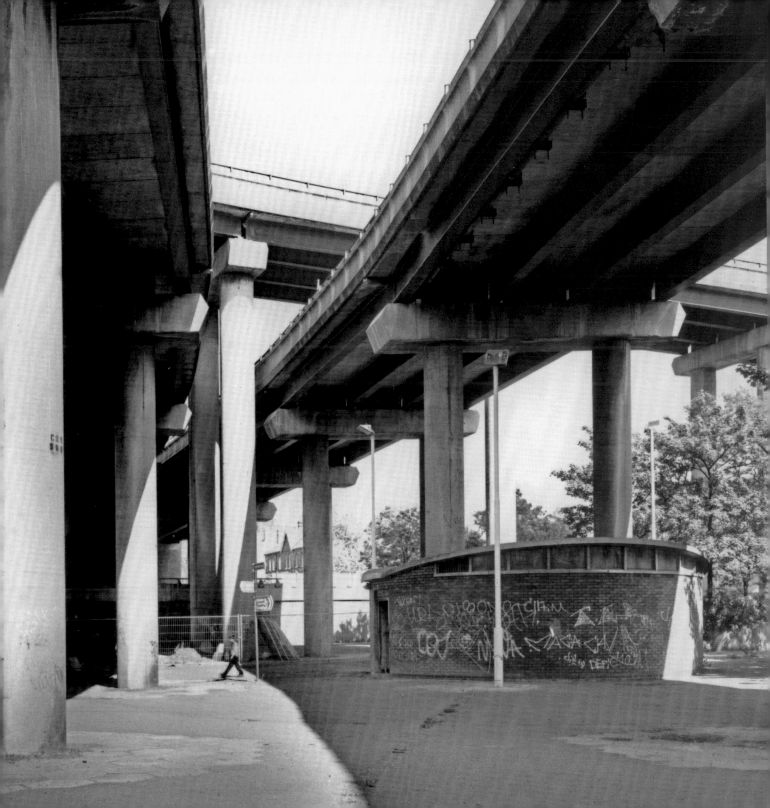

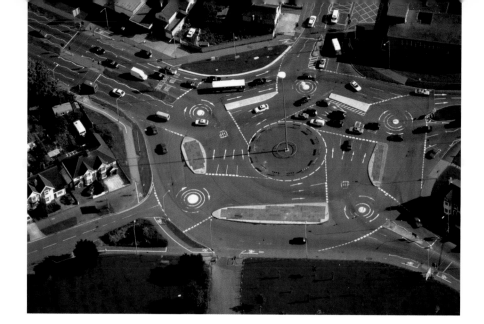

The Magic Roundabout,
Swindon

The road network fed traffic in and out of towns and repopulated rural areas, now falling
within the ever-increasing commuting distances of cities, with car-bound white-collar
workers. 'A man who,' said Thatcher in 1986, 'beyond the age of 26, finds himself on a bus
can count himself a failure.' The consequence of car-centred planning was ever-crowded
roads and a need for traffic calming and parking provision. By the 1980s, most cities had
been circumnavigated or bisected by orbitals, ringroads, flyovers and parkways, thus
necessitating the creation of car-friendly city centres such as Cambridge, where large multi-
storey car parks replaced the medieval streets in the mid-1960s. Zebra crossings had been
introduced in 1951, the yellow line system first appeared in Slough in 1955 and from the
mid-1960s the traffic circle, already in use in many cities, appeared in a variety of roundabout
guises from the massive 30,000m² Hanger Lane Gyratory to mini-roundabout chains.
Famously, new towns and expanding towns experienced an excess of roundabouts. Swindon
eventually renamed its County Ground Roundabout with its colloquial title – the Magic
Roundabout – which is characterised by inner roundabouts with a counter-clockwise traffic
flow, and outer roundabouts with a clockwise flow.

Elsewhere, the concrete hinterlands beneath and beside motorways provided opaque cover
for all of England's urban vices, from prostitution to drug pedalling, stop-off and drop-off
points for consumers and vendors, from both town and country alike.

The formation of the Highways Agency, a government quango, in 1994 introduced private
finance initiative to the road system, as Britain's 14 highway sectors were handed over to be
managed and operated by consultants and contractors.

Where to see them:
Gravelly (Spaghetti)
Junction, Birmingham;
Magic Roundabout,
Swindon; Tamar Bridge,
Plymouth; Gateshead
Bridge

Car Parks

On screen at least, Brutalist architecture begat brutal behaviour: Trinity Centre multi-storey car park, Gateshead (1969), was made infamous by its part in the murder of a dodgy developer in the 1971 film *Get Carter*. The act reflected a popular view of the heavy faceless forms of such architecture. Obscuring waves of concrete lines are the overwhelming features of the car park, raised on columns, monolithic above the city. Futuristic on its construction, its poor weathering ties it into Gateshead's darkest days of recession and lost industry. The restaurant on top of its 11 storeys – a would-be viewing box across the cityscape – never opened and, like the rotten concrete, condemned the car park to love-it-or-hate-it status on the city's skyline.

Multi-storey car park, Worcester

The post-war rebuilding of England's city centres created concentrated zones of public space well connected to the all-consuming city ring-roads. Each road system needed its car park terminus: the dirt plot of the immediate post-war era was soon towered over by the multi-storey castle. No other form of architecture had such a remit – layered space on which nothing happened – but car parks effectively performed the same role as stations: a transport interchange that enabled foot passage into the commercial centre. Aerial plans showed the sense of the commercial district with integrated car park and architect-designed concrete sentinels: bold car-banks to drive into the future. However, badly maintained materials deteriorated and the demoralised multi-storey became a symbol of a downtrodden town and a rotten dream, a suicide spot, sometimes literally.

Car parks and their associated neighbours – underpasses, elevated walkways, in-between concrete places – became congregational points for sub-economies. Tollgate car park in Bristol, a curvaceous enormity at the end of the M32, shared the position, status and name of one of the medieval city's entrance gates. Visitors parked their cars, paid their toll and set off across the pedestrian walkways to the new enclosed concrete shopping precinct, Broadmead. In its final years, archaeologists recorded the half-light life of Tollgate. Early Sunday mornings hosted an economy of car-boot barter and exchange, while at night it sheltered drug-users and dealers and young courting couples and became a business district for prostitutes and their clients. In between, shoppers remembered its original purpose.

The shopping arcades of the 1990s employed different materials. The pseudo-vernacular of the arcades themselves extended to the car park. Bristol's Galleria shopping development is red brick, with coloured trim and brightly painted interiors.

End-of-century regeneration saw concrete multi-storeys disappear: demolitions that denoted a new future for town centres. Tollgate's demise in 2006 heralded Broadmead's redevelopment. Emphasis switched to the removal of traffic from the town-centre. From the late 1980s, park and ride schemes aimed to lure motorists off major roads before they hit the city. Park and ride car parks had the luxury of space and economy, agricultural or brownfield land could be neatly laid out without need for stacking. Hull's Priory park and ride marked the divisions of its flat, shrub-lined car park with signage depicting the comings and goings of the site's former life as a railway marshalling yard. It offers quick links to the city centre, but is situated in a new commercial landscape that contains a large out-of-town supermarket and Hull Football Club's 1990s Kingston Communications Stadium.

Trinity Centre car park, Gateshead

Where to see them:
St James, King's Lynn (AA No 1 car park); Hull park and ride, Priory Park (marshalling yard memories); Trinity car park, Gateshead (film-star multi-storey awaiting its fate)

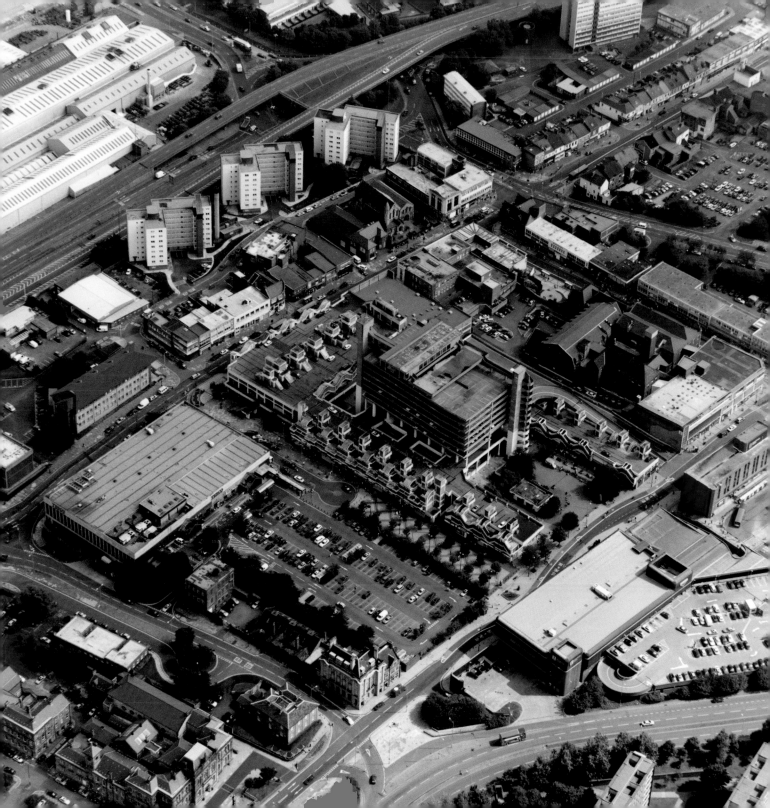

Motorway Service Areas

At altitude, side-on to a wall of windows, diners at the Pennine Tower at Forton services could look out across the Lancaster countryside traversed by the earliest stretch of motorway – the Preston bypass – or sit at the formica bar, a static space like an airport lounge that screamed movement. Moto's Lancaster (Forton) services no longer offer the viewing platform of the aeronautical structure; access, economic and safety issues consign it to the space-age in which it was conceived. Slightly dishevelled and used for office space, the tower is still a beacon on the M6. A glass skywalk bridge supported by pre-cast concrete legs still provides views as travellers cross from the north to the southbound services. Elsewhere on the site though, futuristic transport references have ceded to the chains of self-service food courts.

I left the north again/I travelled south again … I lost my bag in Newport Pagnell, sang the Smiths in the 1980s, capturing the essence of the service station stop-gap. Motorway service stations arrived with the M1 and originally embodied the new transport architecture of the Modern movement: futuristic materials and designs – the triumph of concrete, steel and plastic in an era of space and speed. Inspired by his trip to New Jersey, Ernest Marples' vision for the

Lancaster (Forton) Services, M6

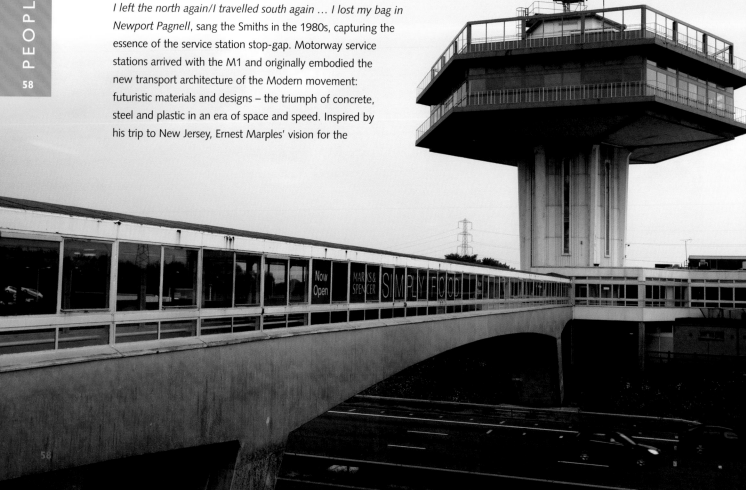

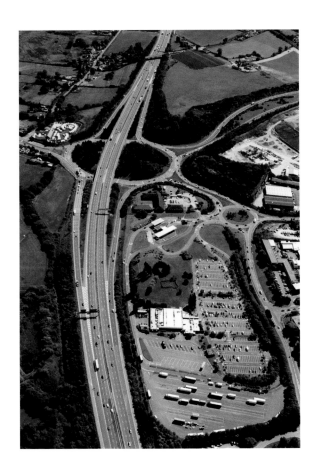

Sowton Services, M5, near
Exeter, Devon

Where to see them:
Newport Pagnell, M1
(the first); Tebay, M6
(local services for local
people); Lancaster
(Forton); M6 (the Pennine
Tower); Leigh Delamere,
M4 (the mall)

British motorway system established the service station in the 1950s and in 1960 the Forte-operated Newport Pagnell Services opened its doors. It consisted of two pre-cast concrete catering blocks joined by a concrete bridge across the motorway itself. The blocks were oriented toward the road, a landscape to be viewed, and contained the upmarket restaurant and downmarket transport café specified by the government.

As the 1960s went on, MSAs like Forton became bolder in design and began to employ the more dynamic elements of international transport architecture. Formica and plastics created the high-speed fantasy of the American diner or coffee bar. Service stations were space age destinations in themselves. The Rolling Stones, among others, frequented Blue Boar's Watford Gap services.

But profit margins were low against high rents and the government's claim of up to 20% of the gross was prohibitive. A 1967 review allowed operators more freedom and presaged the phasing out of expensive materials in favour of easy-maintenance interiors and off-site catering. By the end of the 1970s the vernacular triumphed in the shape of pseudo-local architectural references – faux-granaries hid vents at Easton-in-Gordano on the M5, rustic chimneys and gables hid water towers and stone and wood cladding replaced steel and concrete. In 1981 further freedoms were permitted: franchises and private investment were encouraged. Inside these 1980s services, catering references to country kitchens, with their wood and copper fixtures, ousted the formica coffee bars.

The new century has seen further relaxations that allow the contemporary Moto (formerly Granada) to include high-street stores, arcades and fast-food outlets. The market is saturated and the big three companies – Moto, Welcome Break and RoadChef – are owned by multi-national investment companies, leaving the M6's family operated and locally sourced Tebay services to struggle on alone, as usual.

The Rail Network

The path of the old railway line at Chedworth

Above the Victorian wooden huts, themselves listed, which shelter the mosaics of Chedworth Roman Villa, the embanked track of the former Cirencester to Gloucester railway line is now in the domain of the Wildlife Trust. The line was considered unprofitable and closed in 1961 and, above the villa, the ancient Cotswold beechwoods and the flora and fauna within have gained an ever more secure footing on the steep embankment. A spring, its deposits calcite-heavy, bubbles its limestone sediments, creating a rare geological form – a tufa – where once trains roared by. In Chedworth village, former railway land has been developed. Faux-vernacular Cotswold houses have nestled into the slopes, streets still pass under phantom bridges, and gardens have been extended upwards. The former station building has been converted into a house and cars are now a necessity for residents.

The Transport Act of 1947 divided the rail system into four regional networks run by the 'big four' companies. Merged in 1948, the new nationalised network was split into six nationally integrated regions.

In 1963 the heightened status of science and technology in the post-war political pantheon led to the appointment of Dr Richard Beeching as chair of the British Railways Board, to undertake a review of its services. Beeching, erstwhile chairman of ICI, made recommendations that were to marginalise the rail service. The perception that the network was riddled with regional moneypits meant that 5,000 miles of line were axed, along with stations. A further 2,318 rural stations on retained lines were closed. These measures left many railway towns and villages stranded and forced them into population and economic decline, for example at Corby, Northamptonshire, where closure hit the steel town and its migrant population hard. Beeching's positive recommendations, such as electrifying the system, were slower to be taken on.

Midland and South West
Junction railway cutting,
appropriated for a domestic
garden at Chedworth,
Gloucestershire

Many of the abandoned lines were sold as quickly as possible, for housing or commercial
development, partly in politically motivated games to prevent their resurrection and partly to
fund network improvements. The physical components of the track, if not left to rot, were
sold abroad. Occasional purchases by enthusiasts are now among England's heritage
attractions, such as the Bluebell Railway in Sussex, where a stretch of branch-line closed in
the 1950s hosts well-preserved steam trains.

The lack of investment in rural lines and the increased profitability of higher charges on inter-
city services encouraged the Conservative government to privatise. In 1993 the network was
split between train operators and rail operators. However, a series of fatal collisions at
Clapham (1988), Purley (1989), Southall (1997) and Ladbroke Grove (1999) followed by the
derailment at Potters Bar (2002) emphasised the divergence of profit-driven interests and
public safety under both public and private regimes. The failed rail operator Railtrak re-
emerged as Network Rail, still partially funded by government.

A resurgence in city rail occurred at the end of the century, with Manchester resurrecting its
tram system in 1992, Sheffield in 1994, Croydon in 2000, and others to come. Old lines
were put back in action and the branchline commuter routes back on the timetable, and
elsewhere, nature retakes man's failed enterprise....

Where to see them:
Croydon Tramlink;
Sheffield trams;
Chedworth Nature
Reserve, Gloucestershire;
Bluebell Railway, Sheffield
Park, East Sussex;
Wensleydale Railway,
Northallerton, North
Yorkshire (heritage/MoD/
passenger service brought
back from closure)

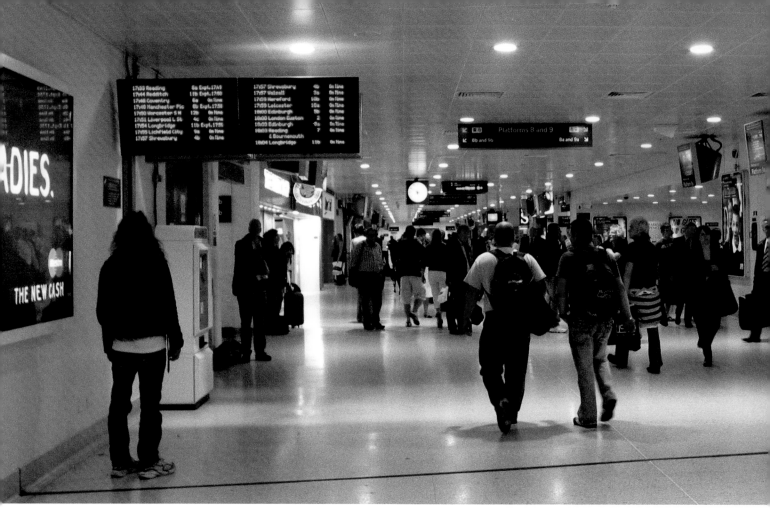

Railway Stations

Birmingham's position as the transport hub of the UK meant that the electrification of the west coast mainline and heavy emphasis in the 1960s on the intercity links, called for a modern and effective flagship station for England's second city. New Street (1965) consolidated the rival Victorian tracks in a Brutalist complex. A city-centre monolith, the vast concrete layers of New Street are integrated into the 1960s traffic-centric city. Pedestrian bridges and underpasses enable travellers to access the neighbouring commercial and residential blocks, while taxis drop off and pick up at road level. Above the station block, a multi-storey car park shares airspace with a shopping centre. A vast station concourse – a dance of comings, goings and kiosks – is separated from the speed of the tracks.

Birmingham New Street
station

Where to see them:
Birmingham New Street
(urban hub); Bristol
Parkway, Bradley Stoke,
Bristol (peri-urban major
station); Stratford
International (global East
London)

Inter city lines became the railways' chief asset and the impact on the cityscape was dramatic. New urban termini such as New Street and London Euston (1968) became landmarks and evicted the classical or gothic grandeur of the Victorian arcade, most explicitly with the demolition of the Euston Arch. Stations took lessons from airport termini with large-scale Brutalism or striking canopies that referenced rail and movement, arrivals and departures, in their design. A threefold economic facility could occur, with the station as mall, gateway and public space.

The necessity of station building to allow the growth of new settlements meant the construction of suburban and urban hubs, as at Bristol Parkway where the 1970s station preceded the growth of Bradley Stoke. These stations were often passenger islands, on one side shored by intercity train track and on the other by car parks and bus-links to the city centre. In an era of rail closure and lack of investment, these stations paradoxically became essential to and iconic of the success of new towns and suburbs. New towns without a station, like Corby, floundered.

Smaller branch-line stations also suffered. Ticket offices and manned crossings were replaced by coin-operated machines and electric barriers, to which the regional networks' and British Rail's livery colours were periodically applied. In the 1990s, generic station elements such as the red-and-blue-coated metal shelter, benches, perimeter fence, standard lighting and pedestrian bridge, made stations indistinguishable from each other but offered a recognisable system of signage to passengers ('customers', since privatisation) and brought the furniture of safety – and accessibility bridges, ramps, electric barriers – to many stations.

Urban regeneration rediscovered the iconic station as gateway to city culture. Neglected stations like Stratford (now International) were redeveloped for the global 21st century. City transport links emphasised this rebirth in city culture. London's Jubilee Line underground stations connected commerce (Docklands) with government (Westminster), culture and cool (Greenwich's Millennium Dome). The stations, such as Foster's shell-canopied Canary Wharf, were relatively inexpensive but exclaimed an exposed functionality, sinking reflected and raw daylight as deep as possible into high spaces in which natural air could circulate. The complete separation of passengers from high-usage track allowed for better environmental control as well as improved cleanliness and safety.

PEACECAMP @ We are staying

Politics M4, A34: journeys back to Greenham

John Schofield

The M4 was crawling again, nose to tail. A frustration, but time to think. Traffic queues are odd places; one's anonymous existence suddenly interrupted as people in their machines are individuals once again, usually sole occupants, their mouths often moving in silent song or surreptitiously conversing with their mobile phones. I try to disengage and avoid eye contact with the men in their Mercedes. It's time for a break from Radiohead – my favoured soundtrack to this familiar nightmare – so I eject the overheated CD and switch to radio. There's a Greenham Common anniversary coming up and on Radio 4, women are discussing the significance of their presence there all those years ago.

I was a field archaeologist back then, doing archaeology on conventional archaeological sites – prehistoric settlements or burial places. I travelled every day from a decrepit office building in Salisbury up the A34 to Newbury, before heading off into west Berkshire – once a wild and open landscape, now characterised more by the trappings of modernity, the expanses of nucleation, industry and militarism. Every day – twice – I drove past USAF Greenham Common. It was quiet usually, with the caravan at the main gate, door open and deck chairs arranged outside in a semi-circle, their occupants chatting and observing: watching as well as engaging with the passing scene. There were banners, though I can't recall what they said, and a dog or two. Otherwise all was quiet – the same every day.

Now my interests as an archaeologist include the more recent past, a challenging and uncompromising area of research for which evidence is plentiful and impressively diverse. Now those campsites interest me more, and the base strikes me as a genuinely fascinating place – a structured and historic environment whose shape, grain and character are entirely due to the political processes (some say tensions) of the later 20th century. True, there was an airbase there before, but the Cold War transformed it, made it even more substantial, more robust, more iconic and more monumental. This is the kind of place that evokes the meaning and manner of the Cold War, and will continue to do so for generations. Even with the base transformed following its closure in the mid-1990s, it isn't lost. Here is a monument, a place, that will remain in the landscape for hundreds of years, whether as a physical presence or in folklore, memory and oral history. Even for those who argued against Cruise, it's questionable whether it should be lost, even if this were possible. Why should we only preserve elements of the past with which we feel comfortable, keeping only those structures that tell happier, homelier and safer stories? Surely we should have an eye for the unpopular, the contentious and the difficult to bear?

The M4 continues to crawl – some accident at a junction far away – so I turn off, submitting to the lure of Greenham. Immediately I relax as I rediscover higher gears and can see more than just stationary cars, enjoying the open road that runs east towards Newbury, parallel to the M4. I plan to stop for a few minutes at Greenham, then presumably join thousands of others along the ultimately fruitless rat-run of the eastbound A4 to London. I decide to take the Newbury bypass to the west of the town and approach Greenham from the south. This was the direction fellow (female) students came from in their university minibuses in the early 1980s, taking time out from coursework in Southampton to protest at the presence of Cruise missiles flown in from the US. The A34 is a pleasure as I leave the congested motorway behind on a virtually open road. But even this road I find troublesome. Here too, a few years later, fellow postgraduate students came to protest against the construction of the Newbury bypass, which sliced through Sites of Special Scientific Interest. Here, tree protestors and tunnellers were seen for the first time – extraordinary people with an enviable passion for the environment and a cause worth digging for, they believed. Other contemporaries worked on archaeological mitigation projects along the line of the route, working for the same firm that had required me to drive past Greenham every day a few years earlier. Archaeologists behind high fences, to protect them from the vitriol of protestors. Archaeologists in conflict, with the historic environment as a battlefield.

And, of course, the ultimate archaeological irony: the metalling from the runways at Greenham, when dug out in the late 1990s, provided hardcore for the bypass. Structural remains from one place of conflict being reused at another.

I arrive at Greenham and decide to park and walk for 10 minutes on the former airfield. Now empty, removed of concrete hardstandings for the most part and returning to the Common from whence it came, this has become an unworldly place. There's someone walking the perimeter and we stop to chat. He has been through all the changes too, but at close hand – he's a local resident, one of those who struggled to find a balance between the presence of Cruise and those opposed to its deployment. Now there's another battle brewing he tells me. A major supermarket chain is looking to build one of their extraordinary and vast redistribution centres on the south side of the runway. Another massive hangar, replacing slightly less massive hangars that housed aircraft in the past. This time though it's road not air transport that's intended. Hundreds of additional journeys each day, all involving articulated lorries rumbling past the homes of people who think they've suffered enough. Andrew Lloyd Webber is reputed to be marshalling local opposition, in readiness for what is being dubbed the 'Fourth Battle of Newbury'; fourth after a Civil War conflict, Greenham, and the bypass.

With fresh air in my lungs and another Greenham chapter to think about, I prepare for the next leg of my journey. The A4 looks busy, so I reluctantly return to the M4. Back in the queue and back to Radiohead: the classic *OK Computer* seems an appropriate soundtrack for this kind of journey, and this type of landscape – Britain's Silicon Valley. I'm back in a queue of rubberneckers, fascinated with other people in their machines, all crawling towards the capital, and the heat and noise of another ordinary day in what has become a characteristically late 20th-century landscape of concrete, cars and environmental pollution – all things the Greenham women and the Newbury roads protestors would have hated. But as an archaeologist I recognise one thing at least – that things do change; just not always in the way we want them to.

A moss-covered toy at the location of one of the Greenham peace camps

Politics **Introduction**

The actions of government and the state are today as imprinted on England's landscape as they ever were. The conviction (thanks to Beveridge and the post-war political settlement) that some things should be provided by the state, not only created the concrete face of the Welfare State – hospitals, schools, modern housing – but also still gives us a benchmark against which to measure the world. Whenever we visit new housing developments or a shopping mall we do exactly the same, though perhaps less consciously, with respect to the physical manifestation of the Thatcherite 'new settlement' – based on faith in the market place – that opened the doors for private finance initiatives, private house-building, present-day prosperity. We have called all of this the 'landscape of politics': what government action has added to the landscape, and how our responses to ideology shape our landscape perceptions.

Born out of war, our late 20th-century political landscapes retain a military flavour. The 20% of Britain's land surface (11.5 million acres) under military control by 1945 was not all returned to agriculture, and globalisation of war during the 'Cold War' and after ensured the survival of a significant militarised landscape. Places where the complex weapons of 'quasi-virtual' warfare were made, stored and used provide a very visible physical legacy of an all-embracing military structure that sits at the forefront of many people's mental construction of landscape, demonstrating the hold that war still has on the 21st-century English consciousness.

Militarisation, however, is surely not a primary facet of England's 21st-century landscapes of politics. Rather more dominant, in a low-key way and for urban landscape at least, is the apparatus of local government: ubiquitous and submerged in quotidian townscape. Although not always remarked, this landscape of politics does exist – 1960s extensions of out-grown Victorian town halls, the wave of towers built for the new county authorities in the mid-1970s, or the mayor's office on the Thames – mirroring in its modernistic way some of the symbolism of governance and power that the gothic Houses of Parliament have for so long brought to the Thames-side and, indeed, the national landscape. Public understanding of the state is shaped by these physical facets of government; that they are so often

Ifield Community College,
Crawley, West Sussex

unremarked is perhaps telling. Politics now, if it ever was, is no longer only about state or civic institutions, and this too is reflected in landscape. Some of the most prestigious buildings are now commercial. What characterises the City of London, if not the tall glass towers springing up like saplings, taller every year?

Whereas in the more distant past landscapes of politics focused on buildings of law and justice, and the defence of the state against invaders or workers, the political landscape that has been bequeathed to the 21st century is much more varied. Particularly important in forging today's political landscape has been the counter-play between the two great political consensuses that have directed the last 50 years of English politics and domestic history. The post-war political settlement pushed state provision of the basics of life onto the agenda in a way never seen before; the 1980s revolution destroyed the monopoly of this view and created an equally powerful acceptance across society that market mechanisms were also effective. People now view the landscape created during the 1970s and 1980s from both perspectives, state and market: they are equally 'political'.

How do these twin poles of 21st-century Britain manifest themselves in the landscape and how do they influence our perceptions of landscape? The Beveridge view gave birth ultimately to a landscape of public building. The District General Hospital was born, and grew into the sprawling NHS hospital sites of the 1960s and 1970s, often with some of the tallest buildings in our smaller towns. Some of them, like their Victorian predecessors' asylums at the edge of the towns – the water towers and chimneys of Enoch Powell's prematurely Thatcherite 1961 speech – may be gone now, but they are replaced by the 'sustainable communities' of

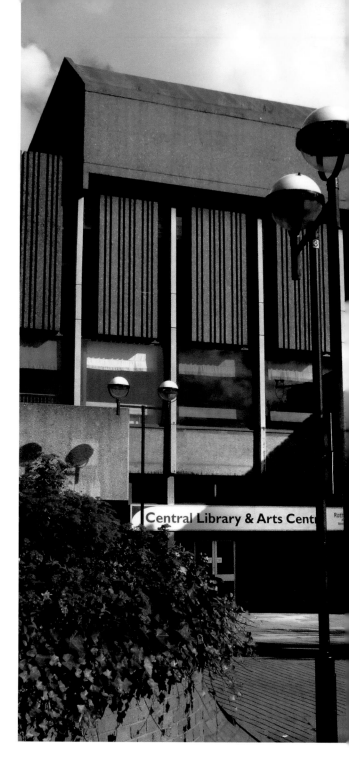

private house building, surviving in townscape as testament to 50 years of political change thanks to the current ethos of recycling and conservation; the old public landscape is leaving its mark. Public provision continues, too, with new hospitals (admittedly through PFI) and new prisons trying to cope with rising demand as the prison population rose from 20,000 in 1950 to 40,000 in 1976 and in 1998 to 66,000.

A problem with the landscape inheritance of the later 20th century is that much of it was created at a time when people believed in Progress, when government and its architects and planners became occupied with a Utopian, international and hopeful engagement with landscape. We have retained some aspects of this period. In many sectors of governance, the design of public architecture was pared back to function rather than symbol; an aspect of Modernism that, albeit heavily diluted, survives today. The requirements of a school, for example, were translated into architectural forms or layouts according to need not symbol; the dominance of gothic and classical styles finally died. And yet, looking at the products of the 1950s, 1960s and even the 1970s from our current perspective (from which, for many, that sort of 'progress' seems less certain) we tend to see things differently. We no longer see post-war architecture through post-war spectacles and our mental landscapes are therefore distorted.

The speed of technological change creates distance from the very recent past, perhaps more than anywhere in landscapes of politics because the changing balance of ideology and policy cannot keep pace with social change. As the pace of change quickens – as social and scientific advancement suggest a new physical dynamic to the built environment – people increasingly consider landscapes to be flawed. It is not the buildings and landscapes that have changed, however, but people themselves and their perceptions. The features and forms of the political landscape sit in an uneasy and fractured relationship with the power invested in them. The only answer is change and creation. In Ifield, Crawley, the tarmac playground of Ifield Comprehensive School, the flagship of 1960s inclusive education, is peppered with the brick dust of the demolished school buildings. Overlooking it is the shiny white-clad prefab of its replacement, a brand new way of addressing the education needs of a generation for whom the moon landing is a distant event and for whom chatrooms are something other than a badly run French class.

Rotherham Central Library and Arts Centre, South Yorkshire

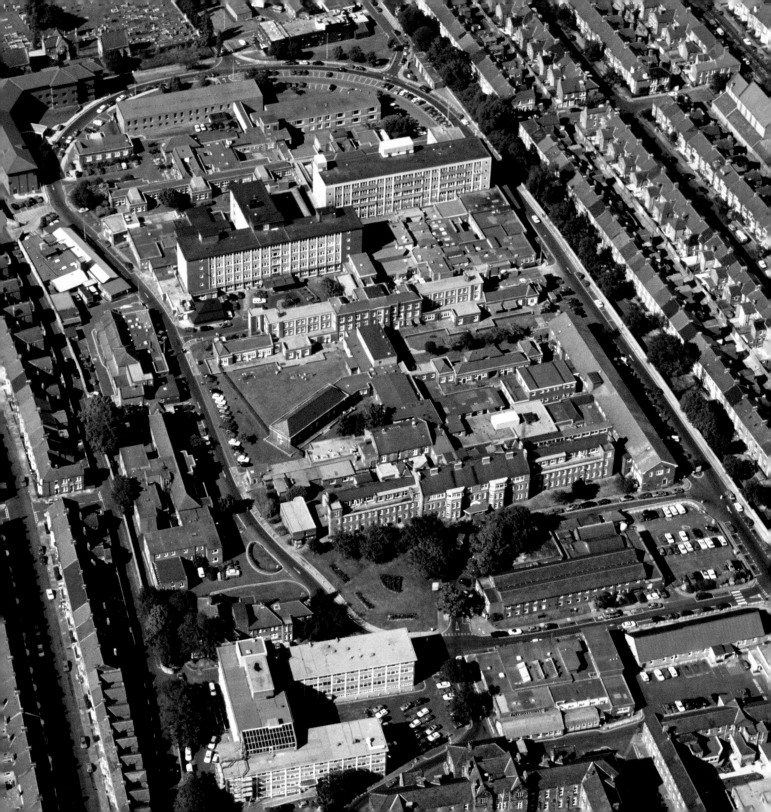

Hospitals

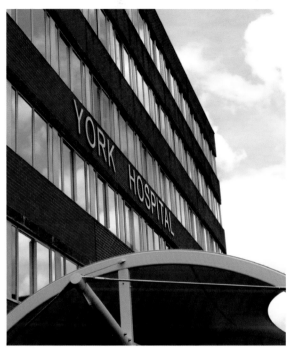

York District Hospital

York District Hospital ministers to a growing populace only a short distance from the city's world-famous cathedral. Built in 1976, the hospital is recognisably related to Florence Nightingale's Pavilion Plan, the foundation of health building, in which manageably sized wards, well ventilated and lit, were served by ancillary blocks along the 'hospital street'. At its rawest this plan could be seen in the wartime and temporary hospitals made up of regularly sized unit blocks. At York, the wards and support zones slotted into a triangular wedge of the city centre, bounded by terraced streets and swathed by car parks.

The National Health Service Act of 1948 drew together a dated and diverse hospital stock with which to implement its aim of providing publicly owned, universal health care. It was clear new facilities were needed.

The new NHS took inspiration from the giant mechanised American hospitals, and advancements in technology and medicine. The Department of Health devised a system in which a District General Hospital would offer all the health provision its community required, but post-war shortages delayed the major period of construction until the government announced the Hospital Building Programme in 1962.

The new automated hospitals emerged – concurrent with the rise of the car – around the concept of the hospital street. The street allowed the separation of the three hospital 'zones': nursing, clinical and support areas. Different hospital designs emerged, as architects and medical professionals worked together. The whole was clearly signed by Jock Kinnear and Margaret Calvert's (creators of the motorway sign system) 'health alphabet' which directed patients and staff alike around the network of corridor streets.

In some hospitals the separation of zones was explicit, such as at the Royal Free in London (1976) – a large hospital on a small site where the tower-on-podium design split the wards into a nine-storey cruciform tower, containing the nursing zone, and a podium containing the clinical and support zones. At York District, a horizontal version of this hung on the spine (street and wards) and pavilion (clinical and support zones) plan. At Greenwich District

Newcastle General Hospital

The new Greenwich Hospital,
London

Hospital (1966), the support zones were on shallow interstitial floors between the nursing and clinical floors, a total separation of the mechanical workings from the human. However, large monolithic blocks presented problems in terms of environmental conditions: large-scale air conditioning and lighting systems were needed for the cores of the buildings, while heat and natural light were problems at the edges. On top of this, they were expensive and made expansion and change difficult.

The solution was the provision of 'universal space', which could be adapted through expansion, technological and clinical change, and made hospitals amenable to simpler prefabricated building systems. However, the prefab low-rise courtyard and pavilion designs were shelved due to the energy crisis and recession of the 1970s. When the programme resumed, dramatic cuts in bed provision and more emphasis on day-care and outpatient clinics had become key in a quest for perceived efficiency. Sites were comprised of units that could be added to as and when cost permitted; as well as being sustainable and flexible, new hospitals had to be cheap. The 'Best Buy' system was an adapted version of the shelved designs, but could only really work on large, landscaped sites.

In 1990 the NHS was reorganised under a purchaser-provider system. The NHS Executive decides policies which are implemented by the 14 regional health authorities (RHAs). Funded by the DoH, the RHAs buy healthcare provision from Community and Healthcare Trusts. The system was designed to create a manageable competitive system and led to league tables and performance targets for hospitals. It also made a tabloid folk devil of the NHS, embodied in 'the manager'. The drive towards a more patient-centred or patient-focused approach trickled into design. The automated hospital, its size and inflexibility, its fast outdating, was phased out (Greenwich and the Norfolk and Norwich for example have been demolished) and replaced by more cost effective and short-term prefabricated approaches with shorter life expectancies, and new additions to old hospitals. In the 21st century Private Finance Initiatives have taken the short-term costs of hospitals from the public purse but have pushed clinical staff out of the design process and forced hospitals to be profit-making, market-driven enterprises, often making more use of their real estate assets than their welfare properties.

Where to see them:
Guys & St Thomas's, London (teaching monolith); St Faith's, Norwich (PFI replacement for Persimmon Homes which replaced General); Bury St Edmunds (pioneer Best Buy)

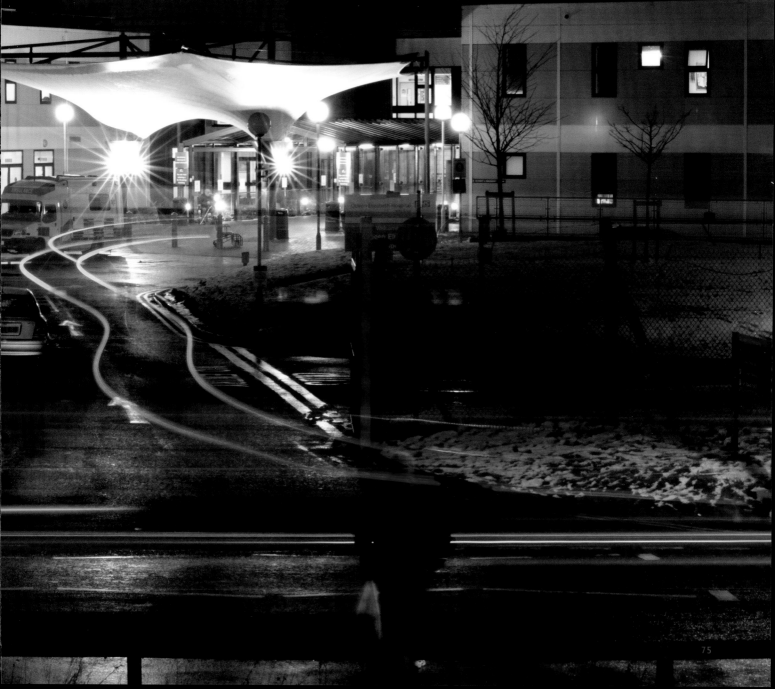

Mental Health

Fulbourn Hospital and the Ida Darwin Hospital provide mental health care in an open setting on the edge of Cambridge, albeit still a long walk from Fulbourn village proper. The gothic gravitas of the Victorian asylum building is rendered familiar by the no-frills post-war community architecture of the NHS. These water towers are functional and fancy-free. More recent landscaping has created areas of congregation and added sculpture and softer materials, while the dark reflective glass of the new adjacent business park reflect the compromises the sector has had to make to remain intact.

Nineteenth-century 'museums of madness' were ostentatious demonstrations of civic pride. After the First World War, realisation that mental illness could affect anyone meant a less penal environment was sought. Treatment, even cure, was the new emphasis and patient numbers, boosted by the new voluntary status, reached a 1954 high of 154,000. Usually sited in rural or semi-rural locations, away from prying eyes, these largely self-sufficient communities – as in Victorian days – had their own churches, farms, recreational facilities and market gardens. They held a powerful place in both the local and national psyche: secret, secluded places for the incarceration of the mad.

Fulbourn Hospital, Cambridgeshire, before construction of the new business park

The onset of the Second World War interrupted a planned building programme that was never resumed; instead, existing hospitals were modified. Thus, for the second half of the 20th century, most mentally ill patients continued to inhabit 19th- and early 20th-century asylums. Mental deficiency colonies were provided for the 'subnormal', again, largely isolated, semi-self-sufficient communities that kept the mentally and physically handicapped separate from the rest of society.

New drug therapies in the 1950s and early 1960s controlled many symptoms of psychosis with the result that confinement was sought less often. However, against the anti-institutional trend, new ideas of the 'therapeutic community' were developed at hospitals such as Fulbourn where understated campus-style modern wards were built despite a lack of funding. By 1961, Minister for Health Enoch Powell, addressing the annual conference of the National Association for Mental Health, described asylums

as 'doomed institutions'. The speech became known as the 'water-tower speech' in reference to the austere symbols that isolated asylum towers had become. The Government publication in 1963 of *Health and Welfare: the development of community care* reinforced Powell's view: the steady move toward community care began and by the 1980s 'care in the community' became official policy.

An almost wholesale hospital closure programme began, now nearing completion, though special secure hospitals for those defined as dangerous, such as Rampton and Broadmoor, remain. In the 21st century these old asylums are being converted into desirable residential properties; still surrounded by leafy parkland, they can easily be distanced from their disturbing past. Those without period features are demolished, for their true worth lies in their real estate value. Community care signifies integration, rehabilitation, treatment and support, delivered in non-institutional, non-threatening locations. With the opening of the York Clinic for Psychological Disorders at Guys Hospital in 1944, mental-health care was discreetly incorporated into general hospitals and day centres. However, the reality for many ex-patients is a succession of hostels, bed and breakfasts and special secure units, that signify the difficulty of assimilation, and the unwillingness of the community to care.

Ida Darwin Hospital, Fulbourn, Cambridgeshire – view from the water tower

Where to see them:
London County Asylum, Epsom, Surrey (flats and hospital buildings coexist); Surrey County Asylum, Cane Hill (awaiting conversion); Fulbourn Hospital, Fulbourn, Cambridgeshire (acute wards next to business-park conversion); Beacon Technology Park, Boundary Road, Bodmin (formerly St Lawrence County Asylum)

Detention

HMP Blundeston – a walled, category C prison at sea in the arable countryside of Suffolk – was first opened in 1963. Within roughly rectangular walls, four T-plan wings contain single cells on upper floors (there are no ground-floor cells) and split prisoners into small community groups. A large service block forms a central hub. Rising prison numbers meant that two wings were added in 1975, each with cells for two or four men, and in the 1990s former hospital cells were requisitioned as induction cells for new arrivals. Separate training facilities – workshops and education rooms – were built between the cells and the prison wall to engender a feeling of 'going to work'. A large prefabricated building holds a therapeutic community and neighbours the football pitch. Blundeston tries to find a human scale – eaves hold chapels, bars on windows are cast in lattice designs – but the prison still follows the tall-winged H-plan and institutional feel of Victorian prisons.

HMP Blundeston, Suffolk

The 1948 Criminal Justice Act abolished transportation and hard labour in favour of training and rehabilitation schemes. The high-walled, isolated Victorian prisons were out, although the difficulties of fitting isolated houses of incarceration into a broader landscape remained. Demobilised military camps and barracks provided a temporary resource, as at Leyhill in Gloucestershire, where a former army hospital of hutted units was converted into the first open prison in 1947. An unforeseen rise in crime in the 1950s dictated a need for new purpose-built prisons, and stimulated a drive in design: the new-wave prototype was HMP Blundeston.

In 1967 prisoners were classified: Category A for serious offenders likely to attempt escape, to Category D for trustworthy prisoners. Category A prisoners were housed in new high-security wings of existing prisons. The drive for stronger security weighed against the treatment ethos, effectively ending the 1948 drive for rehabilitation. To accommodate the growing prison population, an expanded version of Blundeston was constructed. HMP Featherstone opened in Staffordshire in 1976. The 'telephone-pole' design, with blocks cutting across a main block, was different from traditional prisons, but with its homogeneity of red-brick walls, barely punctuated by small windows, it delivered a new kind of starkness. The low, flat-roof design was eventually to prove a security and maintenance problem and many were replaced.

In the 1980s, New Generation prisons in the US inspired a corresponding shift in management and design in Britain. Triangular house blocks allowed communities to develop in small, supervised groups. Dehumanising features – long corridors, large dining halls, poor light and air circulation and inadequate washing facilities – were designed out, while security was made a design feature. In this vein Feltham was built: a new provision for young offenders in the shape of a borstal (1983) and a remand centre (1988). The irregularity of the campus-style landscape along a 'business street' was intended to soften the institutional feel. But the cost of good design was telling, and overcrowding and staffing problems nullified good intentions. A series of prisons were built to the same design as HMP Bullingdon (1991) in order to minimise cost, while the Prison Building Design System (PDBS) provided prefab unit blocks that could be, and were, erected on any site.

Where to see them (stay on the outside if you can):
HMP Blundeston, Suffolk; Lowdham Grange, Nottingham (DCMF Serco pitched-roof prefab)

Riots and disturbances, most famously at Strangeways in 1990, led to another wave of reform. Yet the Conservative 'prison works' policy of the mid-1990s led to a rise of 10,000 in the prison population between 1997 and 1998. Pattern cell blocks were built in force: Department of Works (DoW) VI, and the ready-to-use (RTU) unit, consisted of metal wall panels attached to steel frames, with concrete added for high security needs. Echoing Victorian prison hulks, HMP Weare (Dorset), a former troop transport barge, was also trawled in. It closed in 2005 after failing inspection.

HMP The Mount, Bovingdon, Hertfordshire, on the disused Bovingdon Airfield

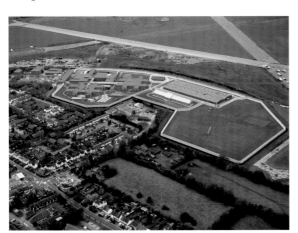

In 1997, the high cost of prison construction resulted in the arrival of private management. Full contracts were awarded for DCMF (design, construct, manage and finance), followed by PFI contracts to build and run prisons. Lowdham Grange in Nottingham (run by the American Wackenhut Correction Corporation and Serco) was built in just 14 months, using prefabricated elements and pre-cast concrete cells in blocks of eight to provide 500 beds in two cruciform wings. The basic standards of public prisons became the premium standards of private prisons. Immediate costs and responsibility were transferred to the private sector. Problems of location and 'nimbyism' were overcome, as brownfield sites became available and the lifetimes of these new prisons were in any case less than 20 years. A new generation of super prefab prisons, housing thousands, has appeared on the horizon.

Schools

Alumni of Cottenham Village College fondly refer to themselves as "nham vets', an intimation of the school's place on the battleground of post-war education policy. Built on donated land, CVC was the ninth Village College, comprehensive dream of Cambridgeshire's Director of Education, Henry Morris. Morris developed community schooling that crossed class, gender and age barriers, even after the secondary modern label was assigned. Cottenham's zoned areas – of multi-age and ability learning and community meetings – hold workshops for vocational lessons, versatile academic classrooms and European-style gymnasia. The signature of the 'Promenade' – an uninhibited corridor-bridge between zones, open for circulation, exhibitions and shelter – is an outside-inside motif. The college expands: a profitable 1990s community sports centre defied a nationwide loss of sports facilities. CVC enters the 21st century as a specialist technology college, befitting its position on the edge of Silicon Fen.

Tripartite schooling was enshrined in 1951, with secondary schooling coming in three guises: secondary modern, secondary technical and grammar. The new inspirational, integrated-

Cottenham Village College,
Cambridgeshire

Kidbrooke School, Greenwich,
London

Where to see them:
Kidbrooke, Greenwich (first
comprehensive);
Cottenham Village College,
Cambridgeshire (last of the
village colleges); Barclay
School, Stevenage
(Hertfordshire County
Council system-built
secondary modern); Bexley,
Erith (Foster-designed city
academy with mini stock
exchange)

education landscape faltered, but not before the first
morning bell rang through the gleaming block-glass
corridors of Kidbrooke School, Greenwich. Kidbrooke was a
secondary school, modelled on grammar school principles
and built to Modernist designs, symbolic of a new
beginning in the bomb-damaged ward.

In Hertfordshire, the adventurous county council
architects exploited their proximity to materials research
centres and the decommissioned aircraft industry, to
develop prefabricated building systems based on a 3ft 4in
module. Elements from each system – wall panels,
windows, doors, floors and roofs – could be used
together to construct well-designed, swiftly assembled
schools. By 1954 the team had assembled 100 new
schools, desperately needed in Hertfordshire's booming
towns. The schools' multi-purpose zones were
emphasised with movable fittings and open rooms, and an emphasis on commonality
meant that many schools became essential local hubs.

In Leicestershire, the radical LEA was the first to abandon three-tier education in 1965 and
return to Morris's ideals. Comprehensive education was firmly established in bold new
neighbourhood schools that were announced with a flourish and specially commissioned
artworks.

In the 1980s, recession forced many schools to engage in their own fundraising to improve
their sites. Sales of playing fields to fund new buildings and repairs became commonplace.
Labour's renewed commitment to 'education, education, education' in 1997 was as
controversial as former drives had been. Labour public–private partnership schemes – much
of their design developed from the Hertfordshire prefab pioneers – built city academies to
serve down-at-heel areas and offer marketable skills. State-of-the-art facilities such as
interactive whiteboards, media suites and restaurants replaced blackboards, workshops and
canteens in the drive for youth enterprise. City academies have been simultaneously claimed
as the death and rebirth of comprehensive education. In 2002, the first city academy was
built at Bexley, Erith, complete with its own mini stock exchange.

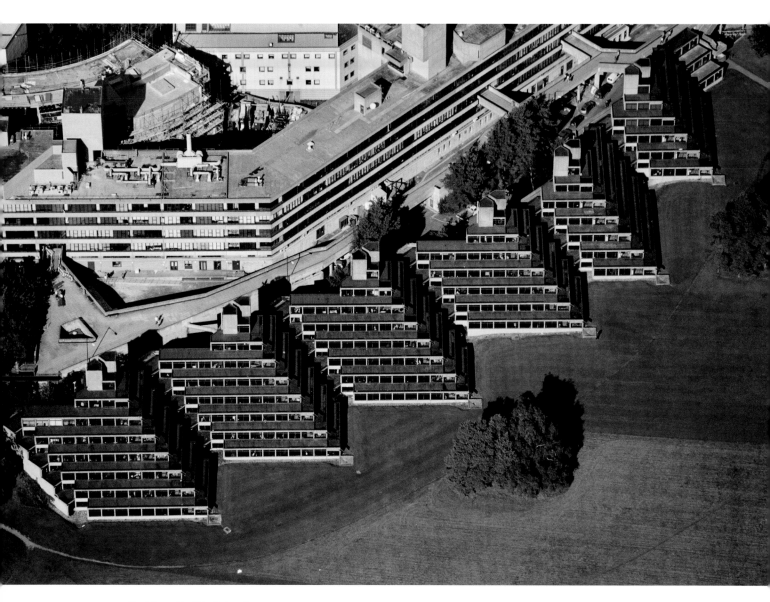

The 'zigurrats' of the University
of East Anglia, Norwich

Higher and Further Education

The University of East Anglia's zigurrats overlook a bank of meadow grass that slopes towards a water-filled gravel pit and broad. The glass façades of the student residences pyramid up from ground level while the remains of golf course bunkers hint at the previous tenant of the landscape. Formerly part of the Earlham Park estate, the site is a layer cake of land-uses. The university's classrooms are mainly set in the Teaching Wall while a later monolith, the Sainsbury Centre for Visual Arts, provides UEA with a nationally important gallery: the centre of its art studies and a foil to its rurality. UEA lies two miles outside Norwich's city boundary and is Norfolk's primary higher education institution.

The 'New Seven' represented 1960s academic pioneering and architectural innovation. In 1963, the Robbins Report into higher education provision recommended a new generation of universities. The New Seven were out-of-town campuses near county towns – county universities: ambitious symbols of a universal education policy, and self-contained communities of education and idealism for all. The universities employed architects who expressed the seat of learning in designs that were unapologetically modern: Essex's piazzas, Lancaster's low-rise townscape, Kent's landscaped high-point towers, York's prefabrication. The universities were set in country estates, parkland complete with lake. These 'plate-glass universities' divorced themselves from the tradition and stuffiness of Oxbridge, and from the town-oriented, non-collegiate red-brick universities, but retained an aristocratic link to 'the estate'.

Meanwhile, in the cities, universities such as Manchester's drew from the optimism abound in the rebuilding of the bomb-damaged city. The campus grew, with challenging blocks that represented the city's drive for an ultra-modern identity. Milton Keynes was home to a social experiment: distance learning. In 1969 the Open University's campus opened at Walton Hall, in its own grid square of the new town. The historic house and grounds contains the OU as it continues to grow. Existing technological colleges were given a new tangible status as polytechnics. Usually city based, their strong edifices marked the polytechnics out as practical seats of technological learning. Brighton Polytechnic's Cockroft Building, with its powerful lateral concrete lines and dark features, reflects the suburb of Moulscombe where it sits, above the light playfulness of the seaside town. Sheffield Polytechnic's Owen Building is an industrial block still edifying in the former industrial city. In 1992, the polytechnics became the 'new new universities', established in particular fields and with smart new logos and names: Oxford Brookes for architecture, Nottingham Trent for law.

Where to see them:
UEA, Norwich; University of Lancaster; Warwick University (the plate-glass universities); Nottingham Trent, Oxford Brookes (the newer universities); UMIST, Manchester; Owen Building, Sheffield (high-rise education)

Defence Research and Development

4,000 horse-power wind suspends indoor skydivers in the listed wind tunnel of RAE Thurleigh in Bedfordshire. The tunnel was built on Twinwood airfield to test the aerodynamics of planes and their components in flight, a major facility of the Royal Aircraft Establishment built between 1951 and 1957 at the cost of £30 million. Three wartime airfields in Bedfordshire were requisitioned for the planned site and a new 3.2km-long runway was laid, long enough for the pie-in-the-sky Brabazon luxury jet and, later, Concorde. It is now used as a storage space for new cars. Five wind tunnels – one built from equipment salvaged from the German establishment at Volkenrode – were erected.

From the 1950s until the end of the Cold War, scientific domination was an important way of asserting superiority, while also exerting constant pressure on the Soviet Union's economic and scientific manpower. This desire to keep one step ahead had a profound impact on England's landscape through the growing number and size of research and development (R&D) facilities built. Yet the influence of these facilities extended beyond the militarised landscape as a growing proportion of government spending was absorbed, and related manufacturing industries boomed. In a break with tradition, many of these places were sited away from what had been traditional centres of arms production. The geography of Britain at war had shifted.

During the Cold War many R&D establishments were designed to investigate specific problems associated with new technologies, such as nuclear weapons and jet propulsion. The sites were often large, unique in design and often purely functional, as at Thurleigh.

Naval R&D sites were also constructed or extended, including the Underwater Direction Establishment at Portland, Dorset. The chemical and biological weapons research site at Porton Down in Wiltshire was given a new campus to house its Microbiological Research Establishment.

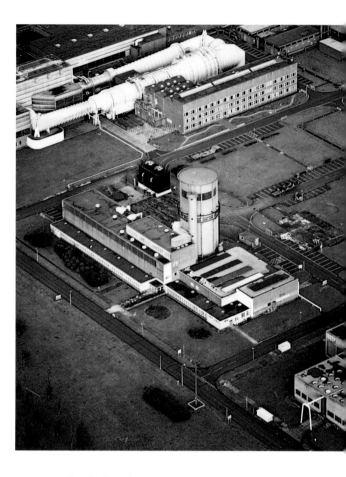

Above and right: Twinwood Wind Tunnel, Milton Ernest, Bedfordshire, behind the Yarl's Wood Immigration Detention Centre

Where to see them:
Bodyflight, Twinwood Business Park, Clapham, Beds; Waltham Abbey gunpowder mills, Essex (Victorian factory converted to 20th-century laboratories)

Defence Manufacturing

Amid printers and tyre fitters in Stevenage's Gunnels Wood Industrial Estate, EADS Astrium, successor to British Aerospace and Marconi's defence branch, continues its work in the development of satellite technology. In 1948 Stevenage was designated the first of the New Towns, and Gunnels Wood was its draw. Set between the A1 and the east-coast mainline, the estate had been deliberately mapped into the town plan in order to centralise the aerospace industry. Stevenage was readily supplied with a labour force from blitzed London and had a distribution system as good as any in the country. Already home to de Havilland, the encouragement of the town's corporation and the Ministry of Defence was enough to further promote Stevenage as a hub of the defence industry, and the town boomed in the Cold War economy.

Following the end of the Second World War defence manufacturing, like research and development, continued apace. Aircraft factories continued production so that by 1950 the RAF had been substantially re-equipped. Many of the firms had expanded and, in keeping with their technologically advanced products, they adopted contemporary architectural designs.

Synonymous with the Cold War were the atomic and nuclear weapons that instilled such fear among the civilian population. In 1947 the Labour government devised a programme to develop and manufacture the atomic bomb. An early 20th-century fort was commissioned at Fort Halstead in Kent, followed by sites at Foulness Island, Essex, and a former USAF airfield at Aldermaston, Berkshire. Later, assembled weapons were tested in concrete bunkers at Orford Ness, Suffolk. Aldermaston was developed for both nuclear weapons research and for manufacturing radioactive components. Today Aldermaston covers 350ha and has around 1,000 densely packed buildings split into at least 11 functional areas.

Forty five of the 52 major firms associated with the R&D industries of the Cold War were located in the south-east, many linked with new towns, as at Stevenage. By the 1980s other concentrations had appeared, for example at Filton in Bristol, Wolverhampton in the West Midlands, and Preston and Salmesbury in Lancashire. But there was an inevitable down-side: heavy dependence on the defence industry made these areas vulnerable to shifts in policy. The abandonment of programmes ultimately led to unemployment, especially after the end of the Cold War in 1989 and with the disposal and privatisation initiatives that followed. In Stevenage, the defence town moves into peace-time again as Cold War technology, such as satellite engineering, is reinvented for the age of commerce; while the days of surface-to-surface missile manufacture are gone.

Orford Ness, Suffolk

Where to see them:
Gunnels Wood Industrial Estate, Stevenage; A38, Filton, Bristol (roadside remains of aeronautical manufacturing, past and present); Orford Ness, Suffolk (National Trust owned seaside pagodas); Tadley, Berkshire (Aldermaston support town)

Gunnels Wood Industrial Estate, Stevenage

Defence Infrastructure and Support

GCHQ – Government Communications Headquarters – has attained a mythical status, like many Cold War remains. British intelligence in its modern form is a creation of the 20th century – an era of professionalism, formality and technological finesse, synonymous with the understated heroism and intelligence of hard-working cipher girls and stiff-upper-lipped radio-operators. These characteristics are clearly in evidence at the Government Code and Cipher School (GCCS) established at Bletchley Park. Today, under the Ministry of Defence, military intelligence is overseen by defence intelligence staff, while civil branches exist in the Security Service and Secret Intelligence Service. Having moved to Cheltenham, the GCCS has now become the GCHQ. The Second World War setting of the country house with associated army huts had its place in the days before the KGB, but GCHQ's subsequent move to unremarkable London premises before relocating to Cheltenham is a story of changing global perspectives. GCHQ's current incarnation – the Donut – is a showy, assertive addition to the defence landscape. Its deliberate positioning on Cheltenham's roughest edge is an acknowledgement of the defence industry's position as an economic force.

Although the classic portrayal of the British 'home front' supporting the forces overseas has its basis in the First World War, the support network – the 'tail' of the armed forces, supporting the 'teeth' overseas – remained explicit in Britain's involvement with the NATO alliance. A diversity of distinctive landscape and site types, from naval bases to army camps, intelligence and communications sites to civil defence, were developed to administer the networks.

Since 1945 the Royal Navy has undergone a steep numerical decline, although its nuclear role became increasingly significant. In terms of fixed places as opposed to vessels, the impact of change was severe: overseas bases were closed, victualling yards, naval hospitals and barracks were shut down, and nuclear refitting facilities – built at Chatham in the 1960s – were later demolished. Warship building in the royal dockyards of Portsmouth, Devonport and Chatham in the mid-1960s reduced the need for workshops, causing foundries and building slips to be closed. Additions to the estate reflect the Navy's changing role, and the changing political scenery: naval barracks have been modernised and berths and workshops constructed, notably for nuclear-powered submarines from the 1970s, as at Devonport and Barrow-in-Furness.

Like naval bases, army camps too were the victims of advancing technology. The abolition of coastal defence gunnery in 1956 did away with the sites and their related infrastructure, as did the abolition of Anti-Aircraft Command. But the closure of camps was balanced by enormous advances in all forms of electronics and communication devices, even if the

procurement and supply has not necessarily kept up with the theoretically possible. Camps were by now concentrated in the south-east (around Farnborough in Hampshire, for example), in Wiltshire around Salisbury Plain, and at Catterick in Yorkshire, where great acreages were demarcated by security fences and patrolled gates. Here, too, are the training grounds essential to improving skills across the three services. They have inadvertently established a peculiar type of conservation: for example, military activity on Salisbury Plain Training Area has contributed significantly to the conservation of the Plain's chalk grassland and ancient monuments.

Yet the home front is perhaps most clearly evident in the many and diverse hardened civil defence structures that were constructed between the 1950s and the late 1980s. In the 1950s, for example, London and each of the 12 British 'home defence regions' had a

Bletchley Park, Buckinghamshire

Where to see them:
GCHQ, Cheltenham; Bletchley Park National Codes Centre (museum), Milton Keynes

heavily built concrete war room, either on the surface or semi-sunken, designed to provide protection against atomic blast. Reorganisation in the 1960s created Regional Seats of Government, alongside sub-regional headquarters in the 1960s and 1970s, and then Regional Government Headquarters (RGHQ) in the 1980s. These buildings, and their reorganisation, cost millions of pounds. The change from teleprinters to information technology required a major and costly refit, while converting a radar bunker to a RGHQ in the early 1980s is reputed to have cost £20 million. The skeleton of emergency government was kept in place until the early 1990s and many of these structures remain. Given their strategic locations close to railway lines, many of the provisions stores – cold stores and grain silos for example – are the buildings most clearly in evidence. Less obvious are the underground structures, such as fall-out shelters, often built in private gardens. These are the personal, more intimate, spaces of the Cold War, in evidence on the landscape but as yet resisting public disclosure.

Runnymede Air Forces
Memorial, Surrey

Memorialisation

Considering its proximity to the M25 and Heathrow Airport, Runnymede Memorial is monumental in its stillness. Signs urge visitors to remember the people for whom it was built and to respect its sanctity. Runnymede commemorates the 20,000 airmen and women of the Commonwealth who were lost during the Second World War. Designed by the War Graves Commission, cloisters and two curved wings encompass stone blocks that look like open books and on which are recorded the names of lost air force servicemen. A large well-tended garden of grass and trees surrounds the memorial, its benches inviting a moment of reflection and remembrance. From the control-like tower visitors can look out over the surrounding woodlands to the Thames. The spiralling stack of planes, above, serves as a constant reminder of the machines those remembered at Runnymede lived and died with.

At the start of the Second World War, local authorities prepared for mass casualties, setting aside large sites for cemeteries and devising monuments to civilians. Though carnage did not occur on the scale expected, the age of Victorian Arcadia – landscaped groves, gothic or classical chapels, monuments dripping with the symbolism of death – was over. A more practical expression of grief emerged from the indiscriminate effects of the wars. After the Great War, it was the War Graves Commission that administered the rites of death and

memorium to the war dead. A new monumentalism emerged, classically influenced but simple, with plain lines, tablets and smooth panels. The need for mass remembrance meant that memorials took on a dual meaning, signifying the universal nature of death as well as individual losses. The military aesthetic caught on, and after the Second World War the simple graves and geometric graveyards of the military cemeteries, such as the American Cemetery at Madingley in Cambridgeshire (1956), became the new aesthetic for the landscape of remembrance.

By the end of the century, the abundance of war memorials (once known as peace memorials) raised questions of absences: so many people had died in action that many losses had gone uncommemorated. High-profile additions to Whitehall and Park Lane in London – two roadscapes already inextricable from the memorials that ornament them – were *They Had No Choice* (2004), a commemoration of animals' involvement in the arena of war, followed in 2005 by the long-awaited bronze, *The Women of World War II*, hung with 17 cast-bronze uniforms, a reminder of the many and often unremarked roles played by the women who served in the Second World War.

Memorialisation through statuary still has the power to raise problematic questions. In London, the seats of culture proclaim peace and resistance: beneath the bronze figure of Ghandi, Tavistock Square Memorial Garden remembers the victims of Hiroshima and conscientious objectors; while in 1992 in Whitehall, Arthur 'Bomber' Harris joined the likes of Haig, Montgomery and Cromwell.

Where to see them:
Runnymede Air Forces Memorial, Egham, Surrey; Tavistock Square Memorial Garden, Bloomsbury, London (continuing commemoration of peace); Phoenix Gardens, Stacey Street, Covent Garden, London (community gardens risen from the Blitz and the car park; a bench commemorates the author of *Person With Aids*, Oscar Moore); St Michael's Cathedral Garden of Remembrance, Coventry

Memorial at Runnymede

Cemeteries

The City of London Cemetery's lawn section is a well-kept example of the new style of layout that has dominated the post-war period. The 'lawn' aesthetic is evident in most municipal cemeteries, even those that date from the 19th century. As is the case in the City of London Cemetery, changing views of what constitutes an appropriate landscape of death are represented in the design of the extensions to a traditional 19th-century 'core'. Lawn cemeteries are almost grid-like in layout, monuments are modest in scale and the memorials offer little comment on the personality of the deceased. In some sites upright memorials are prohibited and grave markers are small plaques set below the level of the green sward. It has been claimed that the post-war disengagement with the place of burial is evidence of a wider cultural aversion to funerary matters.

The lawn cemetery is not an 'invention' that can be traced back to a particular site; rather, it evolved as a commentary on the Victorian culture of death. The Victorian cemetery was considered unhealthily morbid showing an excessive concern for the status of the deceased. In addition, the cemeteries were impossible to maintain. Graves were often mounded, with earth piled up to a foot and a half above the normal ground level. Funerary furniture included elaborate statuary, kerbsets (the stones around the grave), railings and glass immortelles. The stonework didn't fare well in the British climate. Gradually, managers simplified the landscape: removal programmes flattened body mounds and removed kerbsets. By the Second World War, the possibility of removing memorials in their entirety was under discussion.

In both new cemeteries and in extensions to existing cemeteries, the modern aesthetic sought to introduce a 'democracy' in death, by offering a private grave at a more affordable price to more people. The welfare state principals of universality and equality were – perhaps inadvertently – absorbed by cemetery management. Modern cemeteries appear to offer little to the imagination but are an eloquent reflection of recent burial culture.

Where to see them:
almost all municipal cemeteries have lawn sections. City of London Cemetery, Aldersbrook Road (Wanstead Flats); Carpenders Park Cemetery, Brent, North London; Madingley American Cemetery, Madingley, Cambridgeshire

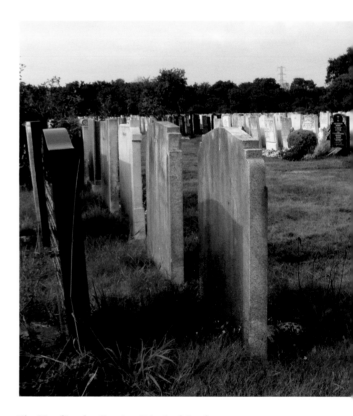

The City of London Cemetery, Wanstead, London

Crematoria

The verdant Glyn Valley cocoons Cornwall's great thoroughfares: the Plymouth–Penzance stretch of the Great Western railway, the A38 and the A30. Just beyond their intersections, a crematorium nestles in the valley's side: car park and looped driveway on one side, while the glass curtain wall of the crematorium's chapel overlooks the green slopes on the other. Inside, mourners may ponder the backdrop of nature's fecundity, beyond the withdrawing coffin. The grounds of Bodmin crematorium (1989) allow a natural, even primal, engagement with death, and its closeness to road and rail allows easy transport and prevents traffic problems for the hearse.

By 1966, cremation was the favoured method of disposal in England. Legally, crematoria are confined to peripheral locations: a minimum of 200m from residential buildings and 80m from public highways. Within these edge spaces, a new architectural vocabulary of comfort and trust had to be created.

Between 1950 and 1970 the number of crematoria increased from 58 to 206. In these mostly local authority facilities, the solemnity of the Romanesque or Classical, with iconic towers that disguised chimneys, was superseded by the ubiquitous municipal Modernist style. From Crawley (1956) to Carlisle (1959) vertical light-brick chimneys and plain windows and walls dominated. But sometimes the striking prevailed: at Manchester Blackley (1959) a dramatic curved frontage of stone mullions was inset with glass and adorned by a giant mosaic cross, part of the city's bold urban movement. Many other new crematoria were conversions of cemetery chapels, a practice that evaded planning restrictions.

The process of cremation dictated their design: the metaphorical and literal route from life to death – in one door and out the other – from car park to waiting room to chapel. The coffin is conveyed to the transfer room, and then to the cremation room. Outside, the columbarium of the Classical crematorium gave way to cloistered gardens of rest as popularity limited space. Landscaped grounds created an illusion of nature and imagined Englishness.

However, the 20- or 30-minute slots required to run crematoria as businesses frequently left mourners hurried and harassed and sometimes in the wrong ceremony. The 1980s popularity of the faux-vernacular created a more sympathetic architecture, less mindful of the event of death as of the ponderances of living. At Minthyn, Kings Lynn (1980), a heavy, upturned wooden longship both inspires and shelters; at Bodmin the valley landscape exults. Both comply with European Union directives on smoke emissions.

Where to see them:
West Norwood, London (cemetery chapel conversion); Sunderland (Classical style); Peterborough (flint cathedral Gothic); Manchester Blackley (glass Modernism); the Heart of England Crematorium, Nuneaton (Tesco vernacular)

POLITICS

93

Glynn Valley Crematorium, Bodmin, Cornwall

Protest

At Greenham Common, Berkshire, six shelters protected US ground to air missiles (GAMA) on a former USAF airbase. The site is now a scheduled monument, a memorial to the impact of the Cold War. Outside the monument boundary are the remains of the peace camps begun in 1981, set up by women at the gates to the base. As archaeologist Yvonne Marshall recorded: 'Outside the fenceline, traces of the peace camps are, as the women intended, few. Those camps located close to the roadside, Red, Violet, Indigo, Blue and Yellow, are completely gone. Turquoise, Emerald, Green and Orange Gates, which were located further from the main road, have fared better and remain largely as left. The only obvious signs of the camps' presence are at Green Gate where there are standing decorated posts. However, at all four remaining campsites closer inspection reveals numerous small clues to the women's earlier presence: bender (shelter) string embedded in growing bark; tarpaulins; plastic for benders hidden in anticipation of evictions then forgotten; kitchen utensils; abandoned children's toys. The landscape holds a material record of events, and as the GAMA shelters record the Cold War's threat, the benders recall the night in which Greenham's women broke through the fence and danced on the shelters or the day 50,000 women marched to Greenham to 'embrace the base'. The site of Yellow Gate was purchased by the Greenham women and is now a memorial garden.

For the post-war generation, the memory of war was recent enough for thousands of people to congregate at sites of power: in 1958 protestors marched from London to Aldermaston in Berkshire, home of Britain's nuclear weapon development. In the late 1960s the war in Vietnam was vigorously denounced at the American embassy in London. Protests declare a wide support base for a cause – Crawley

pronounced itself a nuclear-free zone in the 1980s – and the epic miners' strike of 1984 set the standard by which many subsequent protest battles and strikes were fought.

Protest is essentially a transient phenomenon, a one-off (sometimes annual) event that is briefly a massive performance in the landscape. As an event, its mark on the landscape is fleeting and intangible. Britain's first Gay Pride march took place in 1972 and was 10,000-strong by the mid-1980s. The success of the movement is unquantifiable and often without physical trace, yet once a year in many of England's cities it is visibly marked.

Protest landscapes often draw together wide ranges of people: at Twyford Down (an SSSI destined to be tarmaced by the M3) local residents were bolstered by eco-activists from around the country who built a system of tree-dwellings and burrows that prevented work for some time. The movements of politics and protest, victory and failure, dictate that landscapes are all but lost, although the remains of camps can lie undetected, the paraphernalia – stickers, posters, photographs – provide a record of the often popular voice of protest.

Where to see them:
Greenham Common
Memorial Garden;
Aldermaston, Easter Sunday
annually; Pride, summer in
most cities; Reading
Museum (collection of
Aldermaston protest
placards etc); Brian Haw's
peace protest, Parliament
Square, London

Construction of the M3 at
Twyford Down in 1993

Profit No small change: a journey through the profit landscapes of middle England Graham Fairclough

As so often, I am on a train, writing. This time I am trying to summarise the experience of journeying through middle England, from the edge of 'greater Greater London' to the north-west. It is a journey I have made many times, by rail and road, by different routes. Each time the landscape that flows past is interestingly different. Nothing 'timeless' here: the principal character of this landscape is change.

From my train window every acre seems to be in profitable use, or was very recently. The railway itself, since John Major's act of privatisation, is again privately owned, part of the landscape of profit: it carries people, but mainly it creates wealth for shareholders. My fellow passengers are a mix of leisure and business travellers. When they lift their gaze from magazines or laptops what does the landscape look like to them? Do they filter out modern intrusions as they flash past, seeing only countryside, or is it mainly the new that makes their landscape?

What landscape do I see, with my archaeologist's eye and imagination? I see a landscape of layers and sequence, and human social and economic processes made physical. This England is a landscape of commerce and business with connections to the world beyond: suitably, my train journey today is Watford Junction to Birmingham International. Alongside the railway I first see fields and villages, with occasional teasing and evocative glimpses of the canals whose haulage boats, for a few generations before the railways, carried the raw material of profit. These days their basins and passing-places are full of brightly painted, sparkling holiday boats.

As the train enters the more industrial Midlands, near the radio-mast forest at Rugby whose days seem to be numbered already, the railway and the canal squeeze together through a narrow corridor which had already been sought out by a road centuries earlier. Not just any road, but one of Britain's most important: the A5 – Watling Street – slicing diagonally through middle England. When renewed by Thomas Telford in the early 19th century it was already old; in origin, of course, it is Roman.

It is this road, rather than the railway, that most engages the traveller with the landscape. I never used it in its pre-motorway days but I have travelled it, or its parallel, braided routes, throughout my adult life. I have seen its landscape change and evolve. Its long-distance, strategic function could have faded away when the M1 and M6 came along but instead it found new purposes, and new landscapes grew along it. So old, yet

so many times renewed, it still speaks to us of today's landscape, of how people live in their world.

The Watling Street corridor and its landscape is for me one of the things that defines Britain. This isn't the England described by John Major as a land of 'long shadows on cricket grounds, warm beer, invincible green suburbs ...', but it is a land that Priestley, and Defoe long before him, might have applauded for its productivity and wealth. It is a modern landscape but one that is accompanied by its past like a shadow proving its solidity. It is not a landscape chained in aesthetics but one with a purpose: to make profit, to be useful, to provide services. It is a healthy landscape constantly adapting to new needs and new ideas, a landscape that grows out of social and economic decisions, a landscape that lives.

For all its antiquity, therefore, the A5 speaks to us loudly of the modern era and of the 21st century. So let us abandon the train for our next journey and use the road. The road will lead us past the historic centres that it used to pass through, such as Bletchley, Stony Stratford and Atherston. Its desertion changed these urban landscapes just as much as its new bypasses changed the rural landscape. Instead, all along its route, new and still-evolving landscapes will draw our traveller's gaze.

The first new landscape to distract me, as soon as the long shadow of London's Green Belt is left behind, is farther east, near Luton, where 'Airparks' signs warn us of agricultural fields holding new crops: rows and rows of cars, filling perhaps ten old fields, await the return of their owners from budget-flight holidays.

A little farther north the land sprouts new functions that are also expressed in metal – this time 'retail distribution centres' such as DIRFT (Daventry's International Rail-Freight Terminal). The motorways themselves – mobile landscapes – are extensions to these places because supermarkets 'store' a large proportion of their stock in transit, but it is the shed-parks that most change the landscape. Their giant sheds are fantastically imposing in a literal sense, whole farms given over to massive pastel-coloured leviathans with corrugated skins. Buildings so big that sometimes their ground and roof lines seem to meet at the vanishing point of their receding perspectives, enlarging the landscape; so big that, paradoxically, the oversized logos of their multi-national owners are dwarfed. I cannot bring myself to dislike these new buildings. They won't last long and in the meantime they are only doing their job.

But while they are with us, they attract the service stations and motels that the bypassed historic town centres are ill-placed to provide. These are the makings of new local landscapes. They appear along the road just as in the 1st century Roman military stations attracted commercial and industrial life that grew into road-side towns such as Towcester.

The new shed-parks attract consumption and capital because of their car-friendly locations at big junctions, roundabouts and specially built spur roads. Factory outlets, drive-through burger places, multiplex cinemas – all the 'essentials' of 21st-century dispersed, peri-urban, car-based life – will start to accrete around them. Only a few miles back, after all, our road had skirted around 'MK', a city designed wholly for car users.

But what of the working landscape of fields and farmland that we pass through on the A5? Contrary to some reports, England has not been completely concreted over. Our Midland area is one in which abandoned grassed-over medieval ridge-and-furrow survives best. But farming is no longer the land's only use. Increasing sub-urbanisation marks the landscape in the many new uses that flank the A5, drawing on the enormous urban populations that live close by: golf courses, driving ranges, go-carting parks, moto-scramble, country parks, open farms and farm shops: the list is long – the countryside as commodity not factory floor.

Soon, a sign by the road will tell us that we are passing the New National Forest – very late-20th-century British: planting not to produce wood but for the sake of having trees. Houses as well as trees are taking over these fields, as villages grow and as railway stations throw out dormitories like self-seeded woodland. The land itself is now not the raw material for profit; profit is extracted from those who will visit the Forest or those who buy the new houses and use the golf courses and country parks. People have become the raw material, the crop.

Beyond Birmingham the driver faces a challenge, a metaphor for Thatcher's free market economics: too much choice! It is no longer clear which road to take. Try to follow the old A5 or even its older versions through the historic town centres? Let ourselves be led along bypasses, trading-in the old suburban shops and high streets for roadside Little Chefs and hyper-supermarkets? Or desert Watling Street altogether and take to the M6, if Spaghetti Junction be not too daunting?

Or be seduced onto the new M6 toll road, to be whisked along in the company of the more expensive cars and the smaller trucks, enjoying the private pleasures of a 'gated' road,

though the gates are called toll 'plazas'. The M6 toll's only service station is much less thronged than those elsewhere; it feels like a gated community. It is hard to see, in this sealed environment, how the organic growth of new places or the dogged survival of old-fashioned 'caffs' along the old road can happen. But time will tell and profit will triumph; tomorrow's landscape cannot be easily predicted.

If we travel onwards a mere 5km, for example, we reach a genuine new centre, still emerging: North Cannock, or 'Orbita Plaza' as it is now. Here are acres of supermarkets, restaurants, multiplexes and DIY shops. Cars and people co-exist here in pre-planned harmony. I'm impressed by the sheer amount of tarmac and the number of roundabouts, but what most distinguishes this place for me is that it already has the feel of a place all its own.

Mostly I'm struck by the new chain hotel, a brand new (a week old when I saw it) 12-storey tower, gleaming in the dark wetness with electric blue and white lights, bringing to this once quintessentially suburban place a taste of metropolis. A few kilometres behind us, the low-rise housing blocks at Brownhills – in their day local symbols of white-hot 1960s modernity – now seem small beer, their social and political context gone with the coalfields and factories. Orbita and similar new places, like it or not, are our new landscapes, based on profiting from people and just as redolent of their era as any past industrial or agricultural landscape.

Only another 5km farther – so fast does this landscape change – the A5 crosses the M6 and heads west through Shropshire into Wales. The M6 captures most of its traffic, however, accelerating it northwards through the green fields and past the black-and-white houses of Staffordshire and Cheshire – displaced fragments of the south – to the other edge of England beyond Carlisle.

We cannot go to Wales in this book, nor to Scotland, but we could imagine taking the M6 a little bit further, past Lancashire's twin gate-keepers of Liverpool and Manchester and almost to Lancaster, perhaps stopping for tea at the Forton service station, a slightly surreal cousin to London's GPO tower; a 1960's sci-fi approach to modernity, today standing in the shadow of Heysham's nuclear reactors.

The RAC Control Centre at the junction of the M5 and M6

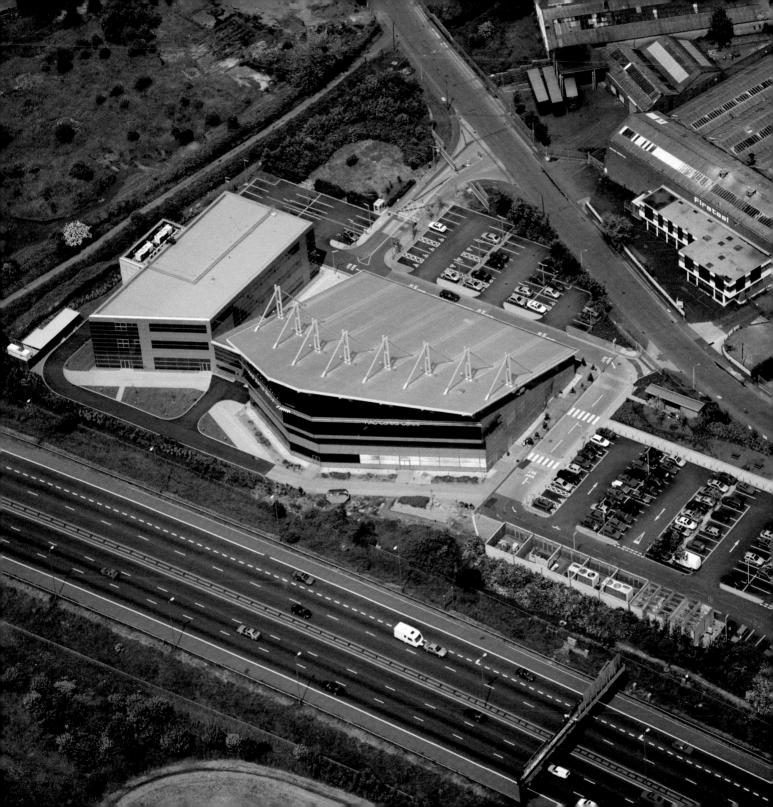

Profit Introduction

The England of Hardy and Lawrence, of smog-ridden northern factory towns and rustic southern agricultural landscapes, was long gone by the end of the 20th century. The balance of making money had shifted drastically, and the landscape thus created is still adjusting to the change. Northern city warehouses are now lofts for living but the remains of industry lie in declining wastelands; in the south-east there are few areas that cannot now in all honesty be described as anything more rural than sub-urbanised. A new landscape of profit has appeared, its skeleton the motorway network started in the late 1960s, its blood the energy of nuclear and North Sea oil and gas, its face the new 'soft' service industries that provide 70% of GDP so that city skylines are dominated not by choking chimneys and hydraulic lifts but by high-tech, high-finance glass office towers.

Britain entered the Second World War a world leader in heavy and manufacturing industry, confident that its empire was born out of the cradle of the Industrial Revolution. Its post-war industrial reinvention, however, was influenced by things other than tradition. A new transport network of motorways changed the location of industry and business, as well as how they were conducted. Agriculture transformed itself – through mechanisation, ever-larger farm holdings, greatly reduced labour needs (so that by the close of the 20th century only 2% of the working population worked in agriculture) and EU Common Agricultural policies – and the face of rural England changed completely. By the 1980s, the unassailable political presumption against building on agricultural land, born from the experience of the U-Boat blockade, was dissolving. Agricultural landscapes are first and foremost profitable landscapes, but they are also increasingly shaped to appear 'natural' – tranquil, rural – in response to public demand and in contradiction to their real nature. The certainties of coal were displaced, first by the miracle of the atom and later the oil and gas harvest from the sea. The country's long love affair with the telephone, with its landscape of low wires on wooden poles, matured rapidly through the later 20th century into a new mast-centred web of communications that slowly changed almost everything, though this new digital age becomes ever more invisible as its networks become all-enveloping.

Selby Business Park, North Yorkshire

Most of all, manufacturing had halved already by the 1970s and other industries went during the 1980s, notably coal and steel, and in its place came a wide range of service and business industries creating very different, largely urban or ex-urban, landscapes; the new 21st-century landscape of profit. Linked to this was the rise of shopping as leisure – as identity even: a landscape in its own right.

A concentration on out-of-town shopping – JG Ballard's 'concrete islands' – whether the 'mere' hyper-supermarket, the middle-range Toys-R-Us groupings, or the new crystal palaces of the mega shopping malls such as Lakeside, Bluewater, Meadowhall or MetroCentre, is the upside of the shopping landscape. The downside is the ultimate failure of the post-war reinvention of the commercial city centre alongside the continued slow decline of the traditional high street. All are reflected in a strange uniformity of townscape – peeling paintwork, difficult road and pedestrian systems, prohibitive regeneration costs – and in the hard choice between ubiquitous glass-fronted high-street chain stores or a slow slide towards the charity shop syndrome. Very early 21st-century planning might change this where investment can be found, as it has with Birmingham Bullring's 'white blob'.

In taking to the shops, however, Britons made England one of the world's most successful markets, so this domestic landscape of shopping is also a gateway to the wider world, through which new wealth flows to create new landscapes of profit. The landscape of business transformed the old industrial heartlands, most emblematically in London's Docklands where the wharves, docks and warehouses of the former hub of London's mercantile elite found themselves overshadowed by the high-rise offices and wine bars of Canary Wharf and Canada Water.

Sizewell A and B Nuclear
Power Stations, Suffolk

Satellite dishes and TV aerials,
West Green, Crawley, Surrey

Elsewhere, businesses began to look beyond the city and take advantage of the value of periurban land. In Cambridge, shiny office developments on the edge of town – the Science Park – built on derelict land but generating new ideas, transformed the regional economy. Like the coal-consuming factories of the industrial age, it was located close to its raw materials: the boffins of the university. Towns and cities that had existed as peripheral feeder towns to London became economic zones in their own right: notably the M4 corridor where Swindon powers the south-west and Reading's environs are home to several car-bound computer businesses; or the M62 trans-Pennine corridor, reinventing northern wealth with its population of diverse company headquarters.

These landscapes of profit are essentially global, however, and their driving forces are not all home grown. In laboratories and universities across the world another revolution has taken place; the transistor and later the chip have changed the way that business, industry and infrastructure are run, and have transformed the landscape. We have a digital landscape just as we have a digital age. The information age enabled a resurrection of England's profit landscapes. Inner cities were regenerated by big business investments in central sites as well as out-of-town business parks.

Globalisation opened new markets – 'soft' industries based around computing, finance, commercial and consumer enterprise – and by the beginning of the 21st century England had firmly emerged as a market-driven service economy. However, the fickle global market brings its own challenges. Educated young professionals and cheaper leases lure the new businesses away. The landscape of English business now includes call-centres in India, manufacturing in South-East Asia, head offices in Frankfurt and New York, and mines in Madagascar.

Forestry

Close to one of the industrial hubs of England – the mining and ship-building heartlands of Tyne and Wear – State-owned Kielder Forest is an enormous living woodland, originally cultivated in the 1920s by unemployed industrial workers. The grouse-shooting moorlands from which the forest was reclaimed are now part of a 60,000-hectare design plan in which coniferous spruces for harvest and deciduous woodland trails are all 'landscape units'. The forest is one of the last resorts of the red squirrel.

British lumber played a key part in the war effort, much of it in a (literally) supporting role to the coal industry and to power generation. The forests and woodlands managed by the Forestry Commission, set up in 1919, had been so depleted that a concerted effort of woodland replacement was initiated and the Forestry Commission doubled its estate between the 1950s and the 1970s to 1.6 million hectares. Meanwhile, private landowners were given incentive through the Dedication Scheme which rewarded tree planting and allowed farmers to make profitable use of unwieldy or otherwise unused land.

The technological advancements of the 1950s made getting at the timber so much easier and the ability to extract uphill enabled fast felling on the steepest of slopes. In the 1960s further mechanical developments enabled planting on even more extreme topography.

In the lowlands agriculture was expanding to meet new profit and consumption demands, while the new technologies meant the Forestry Commission could retreat up England's slopes into moorland and upland areas. Broadleaf plantations, which need mild lowland climates, suffered as a result; as did husbandry skills and forestry training centres were closed.

In the 1970s the Commission appointed the renowned landscape architect Sylvia Crowe to guide the reshaping of the its woodlands into 'multi-purpose forestry' landscapes combining productivity and public access, a response to wider concerns over leisure provision. A new training centre opened in the Forest of Dean, Gloucestershire.

In the recession of the 1980s public funding dried up and new planting ceased. When the pulp mills of Ellesmere Port and Bristol closed the Forestry Commission was forced to reinvent itself. Timber export provided one answer, as Scandinavian markets opened up to British hardwoods, such as oak, and softwoods, such as Douglas Fir.

Sunlight on the water at Lewisburn, Kielder Forest, Northumberland

But the Commission's systemic problems had been exposed. The potential damage to the environment of extensive pine forests was one of many problems identified in a new era of environmental awareness. Compounded by the destructive storm of October 1987, in which some areas – such as Suffolk Forest District – lost a decade's planting, the problems were the catalyst for a new dynamism in woodland enterprises at the end of the century. Agriculture's land requirements decreased and woodlands were able to creep down the hills into the fertile downlands again. The historic destruction of England's forests was recognised and woodlands synonymous with England's real and imagined past, such as Sherwood, were resurrected with broadleaf planting. Designated community forests brought together the Countryside Agency, Forestry Commission and local communities in large-scale schemes. Native flora and fauna species were planted and alien species removed or controlled, and traditional techniques such as pollarding were reintroduced. This holistic approach to the woodland environment inspired community woodland projects: derelict areas of wasteland have been transformed with the help of Woodland Trust and public funding initiatives, as at Fen Reeves Woodland in Cambridgeshire where abandoned allotments have been carefully husbanded into thriving woodland.

Where to see them:
Kielder Forest, Northumberland; New Forest (National Park national forest); Forest of Mercia, Shropshire (community forest); Hill Holt Wood, Norton Disney, Lincolnshire (regenerated private community woodland dedicated to sustainable husbandry and social engagement); Fen Reeves Woodland, Cottenham, Cambridgeshire (regenerated allotment community woodland)

Forestry in Garsdale, Yorkshire Dales

Farming

The Second World War highlighted the need to increase self-sufficiency and productivity and the 'Dig for Victory' campaign had Britons converting their gardens into fields of production for the war effort. But this was not a long-term solution to shortages. The Agriculture Act of 1947 anchored government subsidy and guidance to the restructuring and intensification of the farming industry: 'the twin pillars upon which the Government's agricultural policy rests are stability and efficiency. The method of providing stability is through guaranteed prices and assured markets.' The consequence for the farmed landscape – which still occupies 80 per cent of the UK's land area – was profound.

Regular and large-scale enclosure and intensive capital farming had made their mark on the landscape in the 18th and 19th centuries, particularly in the large farms of southern England's chalk downlands, the Lincolnshire and Yorkshire Wolds, and on the coastal plain and vales of Northumberland. In Northumberland, developments after 1950 reinforced the existing field pattern, in contrast to other areas where few boundaries survived the doubling (sometimes trebling) of field sizes between 1945 and 1972.

The central band of 'village England' that extends from Northumberland to the arable lowlands of Somerset saw the most change: many of the field boundaries introduced with the enclosure of medieval open fields were swept away, although the more ancient parish boundaries were generally left intact. In some areas ancient enclosure swept away complex landscapes of medieval – even prehistoric – boundaries, such as the Suffolk claylands which, since the late 18th century, have been transformed from a pastoral into an arable-based economy.

Large farms expanded as farmers, especially cereal farmers, benefited from subsidies and invested in new machinery. The farmyard changed to accommodate new practices, with multi-purpose sheds and concrete aprons for large new machinery such as combine harvesters. Traditional small farm buildings became redundant and found new economic (overwhelmingly residential) uses as they were released onto the property market.
The rate of change has slowed since 1972 and trade

Arable farming near Ely, Cambridgeshire

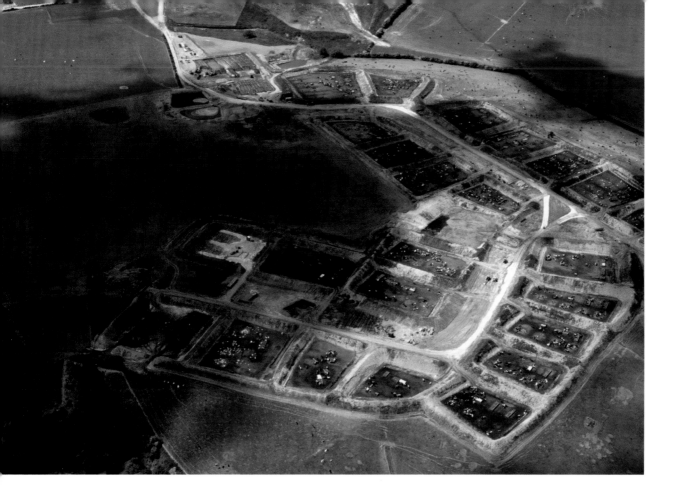

distortions imposed by farm subsidies have come to light. Meanwhile, the green movement has increased awareness of the impact of these maximum production-based subsidies on wildlife, the environment and even the social and economic fabric of rural communities. Hedgerow removal, chemicals and the loss of ecologically rich pasture and meadow has been widespread and by the end of the 20th century concerns over these factors, and the problems associated with agricultural surpluses, precipitated a reversion in some areas to 'organic' and sustainable farming practices that encourage, rather than threaten, biodiversity. Out of this movement have emerged farmers' markets, permaculture practices and a new enthusiasm for allotments.

1986 saw the introduction of Environmentally Sensitive Areas, the first of a range of agri-environment schemes. But concerns about the long-term sustainability of such designated sites and areas, and the pressures thereby exerted on their boundaries and elsewhere, led to the eventual adoption of more integrated approaches to land management.

Pig farming at Clapgate Farm, Greetham with Somersby, Lincolnshire

Where to see them:
Cambridgeshire, Lincolnshire (arable prairie farming); the Vale of Evesham, Worcestershire (England's fruit-growing heartland); upland/ downland England (sheep farming); Norfolk (poultry rearing); pastoral England (dairy farming)

Metals and Industrial Minerals

Post-war steel production in England was heavily reliant on imported iron ores as domestic sources of haematite ores were limited. Nevertheless, although reserves were estimated at only five million tons in 1958, with the majority of that in Cumbria, mining continued into the 1970s. Ironstone reserves were much larger and methods of extraction from the Jurassic Scarp, a limestone strip across the Midlands, mirrored opencast coal-mining techniques of the 1950s, in some cases progressing to underground working as the productive layer dipped farther beneath the surface. As equipment increased in size much deeper overburden could be removed, extending the scope of cheaper opencast working.

Non-ferrous industries fared rather better through the 1950s with production sometimes switching to the gangue minerals – barytes, witherite, or fluorspar – as demand for these increased from the oil and steel industries. Metal prices had been high immediately after the war but they fell in the late 1950s, and the last major English lead mine, Greenside in Cumbria, ceased production in 1959. Barytes production continued into the 1970s and the north Pennines was the site of the two last major fluorspar mines, Whiteheaps and Groverake (though production and treatment continued on a smaller scale in the Derbyshire Peak District).

As was the case with coal working, when opencast ironstone extraction ceased there was a requirement for the land to be reinstated, and as a result there are now few reminders of the industry in the landscape – one dragline is conserved at St Aidans in West Yorkshire. Similarly, the removal and treatment of potentially hazardous waste has removed much evidence of non-ferrous metal mining.

Tin mining, confined to the south-west of England, survived the fall in metal prices and when demand increased into the late 1970s new mines and ore processing plants – Wheal Jane and Mount Wellington – were opened and existing producers looked to open new ground. But the collapse of prices after 1985 signalled the end: Geevor closed in 1990, followed by the new mines, while South Crofty survived in production until 1998.

Apart from the demise of steam power, the outward appearance of tin mines changed little from the pits of the 1940s and 1950s, with steel lattice headgear, processing plants covered in profile steel sheet, and extensive spoil and tailings dumps. But the other major extractive industry in the south-west, china clay, did change significantly with mechanisation, particularly with increasing vehicle size: pits became larger and the characteristic conical

Where to see them:
Maidens Hall, East Chevington, Northumberland (working open-cast mine); Monument Pit, Forest of Dean (last of the full-time free mines); Geevor Tin Mine, Pendeen, Cornwall (mine closed 1990, preserved as a museum); China Clay Country Park, Wheal Martyn, St Austell, Cornwall (china clay heritage centre set in a landscape of 250 years of extraction); National Coal Mining Museum, Caphouse Colliery, Overton, North Yorkshire (converted coal mine on the edge of the Yorkshire coalfield)

waste-sand heaps, tipped by inclined tramway, were superseded by profiled dumps, shaped by massive dumper trucks and scrapers.

China clay extraction near St Austell, Cornwall

Increased mechanisation also dominates stone quarrying; underground quarrying is a thing of the past and the multiplicity of small quarries has largely been replaced by massive pits worked by excavators and dumper trucks. The demand for limestone alone resulted in a fivefold increase in production between 1950 and 2000.

Today's landscape is populated by features from past extractive industries and there is increasing interest in their history and archaeology, but few survive in context. Most stand alone, like the Pleasley engines and headgear in Derbyshire, shorn of the industrial clutter that once surrounded and gave them meaning. Museums from Caphouse (West Yorkshire) to Geevor (Cornwall) educate new generations. For others, like Wheal Kitty (Cornwall) and perhaps Chatterley Whitfield (Staffordshire), alternative uses ensure their continued presence in a changing landscape.

Industry

Swindon, home of the Great Western Railway, moves with the times. A designated expanded town in the 1950s, Swindon took to the motor age with gusto. In 1954 a factory opened for the production of body panels for cars; built on farmland at the edge of the city the factory was self-sufficient, with its own electricity sub-station and railway (an obsolete branch line); new estates were built to house the émigré factory workers – overspill from London – and other, related, companies followed suit. The railway town became a locus of the M4, a cornerstone of the car-manufacturing Midlands triangle with Oxford and Birmingham on the M40. In the 21st century the factory remains, although partially rebuilt for the robotised IT revolution. The Mini Cooper has been the Swindon car industry's salvation.

In the decade after the Second World War, investment and consumer buoyancy resurrected civilian industry. The 1950s was an era of strong performance in traditional industrial areas, historically interlinked with the coal industry. But changes in infrastructure – better roads, energy and water supplies – meant new industry was able to pick and choose its locations, and the new towns of the south-east came with a ready-made overspill labour force. Automation meant the assembly line no longer needed so many human hands. Proximity to transport links remained an important factor but the decline of the waterways as the motorway network grew, lighter goods and the increased production and availability of the heavy goods vehicle, meant that businesses were no longer in thrall to the old freight routes. New light and 'soft' industries – electronics and high-tech engineering – were established near their markets in the south-east. In particular, Berkshire, heart of Cold War defence research and development, became home to light factory estates – container architecture on cheap farmland, close to transport routes. Edges of towns became manufacturing landscapes, then urban centres in themselves. Towns like Reading and Basingstoke boomed as financial and commercial businesses followed manufacturing success and the south-east fast outstripped the rest of the country in terms of affluence.

The expansion and consolidation of surviving industries left some towns and cities, like Swindon (as in the industrial past), dominated by just a few companies. This domination had the power to break an area, as the consolidation of plants and company takeovers could lead to the closure of factories and town decline. In Corby, Northamptonshire, the collapse of the steel industry led to high unemployment and ultimately the degradation of the town itself. In the textile towns of the north, Bradford and Oldham, the total decline of the industry resulted in housing problems, racial tensions, social separation, and economic hardship. In the 1990s, this problem was exacerbated by the relocation abroad of remaining industries.

MG Rover works at Longbridge, Birmingham

Where to see them:
BMW Group plant, Parsonage Road, Swindon, 1954/2006 (a mini history of UK car production); Corby, Northamptonshire (declined steel town); Basingstoke city centre (soft industry tower blocks); trading and industrial estates nationwide

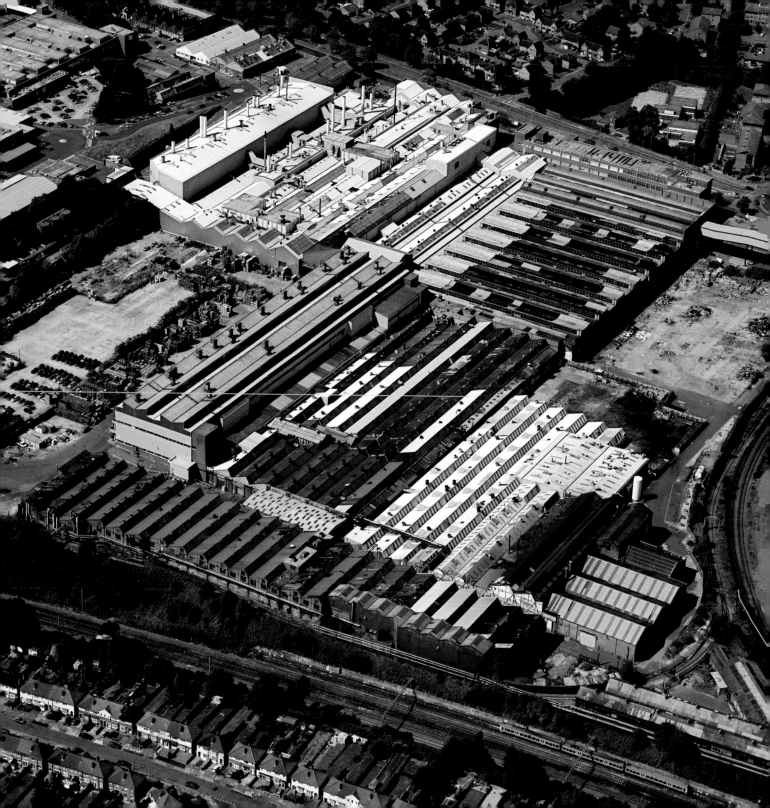

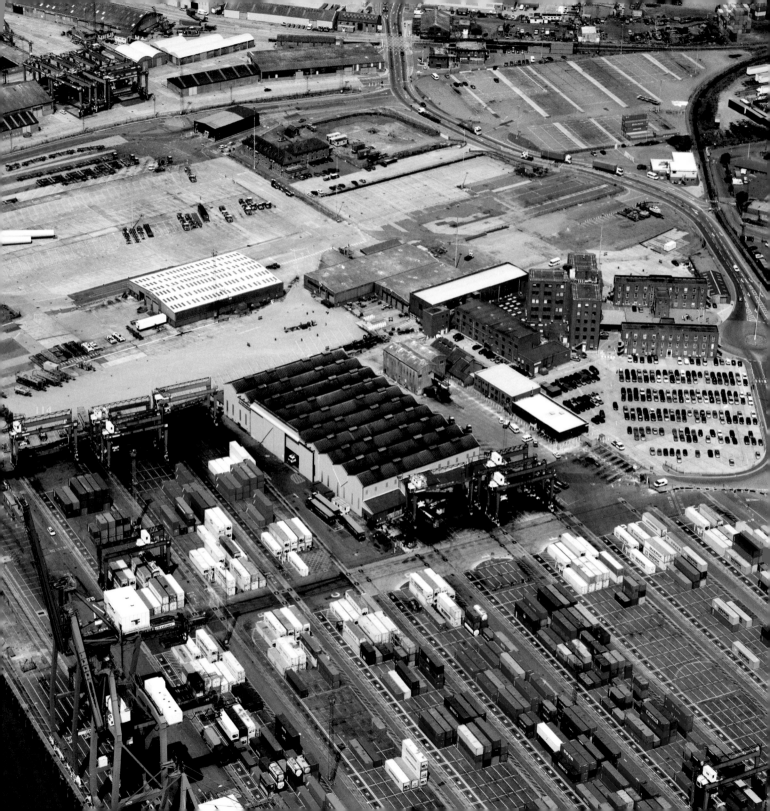

Freight

England's rapid development from manufacturing nation to one hungry for imports transformed the Suffolk backwater of Felixstowe, with its wartime batteries, Victorian wharves and steam cranes, into a vast tract of container-stacked tarmac, hydraulics and fork-lifts. Roll-on/roll-off conveyors ensure a swift turnaround for cargo ships anxious to return to the North Sea's lucrative shipping lanes, while the A12 and A13 are choked with trucks transporting freight to London and the Midlands. The Great Eastern Railway – formerly a single-track resort line – can finally aid this transit. Coastal Felixstowe links East Anglia to the great European ports of Rotterdam and Hamburg.

The shipment of freight both nationally and internationally was revolutionised by the advent in the 1960s of the container. Steel containers – sturdy boxes 8ft wide, 8½ ft high, 20–45ft long – first impressed the shipping industry during the Vietnam War, when their uniformity and resultant efficiency meant that manpower on the docks could be slashed.

Container shipping killed the great maritime ports, London, Hull and Liverpool. Their antiquated storage, machinery, wharves and shallow harbours were unable to cope with the increased hectarage and heavy cranes that were needed. A new age of freight shipping arrived, that removed the skeleton of freight infrastructure from the urban and residential worlds. Throughout the 1960s, container docks were constructed in dredged harbours at Southampton, Felixstowe, Portishead and Liverpool, while Tilbury replaced the London docks. The shelter of the river's estuary was no longer a factor in port location as new super-container ships docked at purpose-built wharves on accessible coastal sites. The modern freight ports occupy vast tracts of open land; wharves and warehouses have been superseded by containers; and tarmac is laid out in grids on which containers are stacked.

Where to see them:
Port of Felixstowe, Suffolk; DIRFT Logistics Park (formerly the Daventry International Rail Freight Terminal), between the A5, A428 and M1 near Rugby, Warwickshire; Avonmouth docks, Bristol (new docks for the great port city, complete with Swedish consulate portakabin)

Containers promoted the notion of 'Intermodal Freight Transport'. From the 1960s, freight was transferred from ships straight onto the railways on specially made flatbed carriages, for delivery to regional depots. But road concessions made the biggest impact and truck-bound freight hit the motorways with force, as the container docks were farther from final destinations than the old docks had been. Distribution depots were therefore needed to transfer goods to road distribution. These depots – transport termini and multi-functional supersheds – are positioned at out-of-town access points to the road transport system. From there, lorry loads of freight are trucked to edge-of-town distribution sites ready for further decanting to the shops and stores of the cities. Meanwhile, the old docks and warehouses find new life as flats and cultural centres from Penzance to Gateshead.

Desford Brickworks,
Leicestershire

Brownfield

The clay soils of east Leicestershire have long been exploited for brickmaking. At Desford, the continuing works have been extended while used land, including a clay pit, have been prepared and replanted. Amenity woodland has been planted with broadleaved trees in keeping with the aims of the National Forest, an area of the Midlands in which Desford falls. Deforested for centuries, it has now been marked out for major re-forestation. The pit becomes a lake, arable land is replaces, and brickworking continues.

Brownfield – a turn-of-the-century buzzword – encapsulates the swathes of redundant industrial or commercial land that appeared to answer the growing needs of both private and public development when the term was coined in 1992.

The steady redundancy throughout the later 20th century of the dinosaurs of industry – large factories, gasworks, docks, freight yards, quarries and mines – left huge expanses of wasteland, sometimes vacant, sometimes filled with the decaying skeletons of industrial process. Added to these sites were the bombed-out sites of the Blitz, left empty and unfilled as they waited for planners and developers to get around to their rescue.

Due to their former industrial uses, the sites were contaminated with waste products, pollutants or chemical hazards – often the reason for their dormancy. Less pressure on land resources and the continued decline of urban and industrial centres in the 1970s and 1980s meant that these sites often became havens to urban wildlife, inadvertent pockets of real verdancy in otherwise cement and metal jungles: 'a whole urban ecosystem of majestic triffids, migrant birds, opportunist animals and feral children', wrote Richard Mabey in *The Unofficial Countryside* in 1973.

In the 1990s, the scarcity of quality development land, environmental concerns for the rapid consumption of 'greenfield' (undeveloped) land, urban renewal projects, and a general resurgence in city living, proffered brownfields as the solution. In many cases, years of abandonment and revegetation meant that hazards had dissipated naturally. Elsewhere, a new industry in remediation sprung up in which various methods of decontamination were developed, from removal of contaminated materials to chemical or natural cleansing.

Brownfield's use to developers extended to the domestic, and a craze in 'back-land development'. 'Infill' housing (building new houses in gardens) answered the property demand in the towns, but elsewhere wholesale brownfield redevelopment brought life back to former industrial centres such as Salford, Gateshead and many areas of east London.

Redevelopment has been the loss of many of Mabey's ecosystems: harbours to sometimes rare, even unique, plant and animal life. Many of these important sites along the Thames Estuary have been swallowed up in the city property-rush. Meanwhile, however, other sites have become 'official' havens of green in the city, such as Camley Street Natural Park, a two-acre former canal coal yard that is now an oasis behind London's King's Cross Station, and across England exploitation companies are now legally committed to restore the land they quarry and mine.

Where to see them:
Camley Street Natural Park, King's Cross (former canal coal yard); Olympic site, East London (industrial brownfield redeveloping for 2012); Desford brickworks, Leicestershire; Avenue coking works, Chesterfield (one of Europe's most contaminated sites undergoes redevelopment as community site)

The site of the demolished Easington Colliery, Co Durham, worked since 1899 and closed in 1993

The nodding donkeys of
Wytch Farm above
Kimmeridge Bay, Dorset

The Isle of Grain oil refinery,
Kent, which closed in 1982

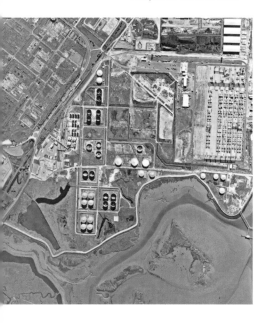

The Materials of Power

Where to see them:
Telford (coal infrastructure support town); Canvey Island shore terminal, Essex; Ellesmere Port (oil refinery and processing plant); Buncefield oil refinery, Hertfordshire (Junction 8, M1); Great Yarmouth (North Sea oil service town); Dukes Wood, Eakring, near Newark (nodding donkey in woodland-regenerated oil field setting); Aldermaston, Berkshire; Sandy, Bedfordshire; Beckton dry-ski slope, East London (gasworks waste tip)

High fencing surrounds an oil well at Wytch Farm, Dorset, where nodding donkeys have been extracting oil since the field was opened in 1973. The Goathorn Peninsula on the Isle of Purbeck overlies Europe's largest onshore oil field, Sherwood Reservoir, and BP reaps the benefits: its exploration licences currently operate three Dorset fields. Hidden in BP's purpose-planted evergreen forests and on islands in Kimmeridge Bay, drilling enterprises extract oil which is then pumped underground through the Purbeck–Southampton pipeline to a refinery at Hamble. Rail links tie the oil field into a wider oil-producing network that includes ship transportation from Poole Harbour.

England emerged from the war with its belief in, and reliance on, coal intact. Coke was the prime mover in the creation of gas and enormous gas holders were still major features of most towns. But the hunt was already on for an alternative.

A vast natural gas field was discovered at Groningen in the North Sea and then at West Sole (1965), within striking distance of Humberside. Shore terminals were built close to the fields: at Canvey Island, Easington, Humberside and Barrow-in-Furness. The gas mains network was extended and gas supplies spread, while underground storage units replaced gasworks and gas holders. The remains of the coke-burning landscape disappears as waste tips and gasworks are lost, although some icons of the industrial age survive, such as Battersea's Grade II listed giant blue holder.

In 1973, an oil crisis precipitated by the Yom Kippur War brought into question England's reliance on Middle Eastern oil. Home supplies were sought to supplement the oil fields that had been opened in the Midlands during wartime. Commercial, citadel-like refineries were built behind heavy security fencing: the Thames Gateway at Shell Haven (Shell, 1947–98); the Isle of Grain (BP, 1948–82) and Fawley (Esso, 1951). Underground pipelines, begun in wartime, linked the major distribution centres of Avonmouth and Stanlow (Ellesmere Port), and fed the defence industry in the south-east. Pipelines linked Shell Haven to Shell's other major refinery at Stanlow via the Buncefield (1968) storage depot in Hertfordshire. Buncefield's giant tanks adjacent to the M1 quietly pumped 'white oil' (diesel and petrol) and black gold around the country, until a major explosion in 2005.

More bounteous reserves were struck in the North and Irish Seas in the 1960s and 1970s. Oil platforms – commercial landless stations – fed shore terminals and inland pipelines. Former fishing ports became onshore base camps for the industry and wharves and warehouses were converted to cater for the oil world.

The National Grid

Lines of L12 pylons are a ubiquitous, paradoxically invisible, feature of the landscape. Planted in arable land across the country, the lines are part of a criss-crossing network of electricity transmission: the widening of the M1 in Hertfordshire required the replacement of a major 400kV supergrid line.

The electricity industry was nationalised in 1947, an act that drew together hundreds of disparate plants and a sporadic distribution network under the aegis of the Central Electricity Generating Board (CEGB). Formed in 1926, the National Grid – the transmission network of power stations, substations and distribution lines – was recognised as the pulse of the industry, and in 1953 the Grid became a 'supergrid', its voltage upgraded to 275kV.

The great power stations were linked through transmission lines to the main supply centres and then to regional substations where transformers reduced the voltage for distribution to small urban or rural transformers, that further decreased the voltage for distribution to the consumer. Lower voltage lines were often carried by wooden poles or underground lines.

Power lines beng replaced between Junctions 8 and 9 of the M1 in Hertfordshire

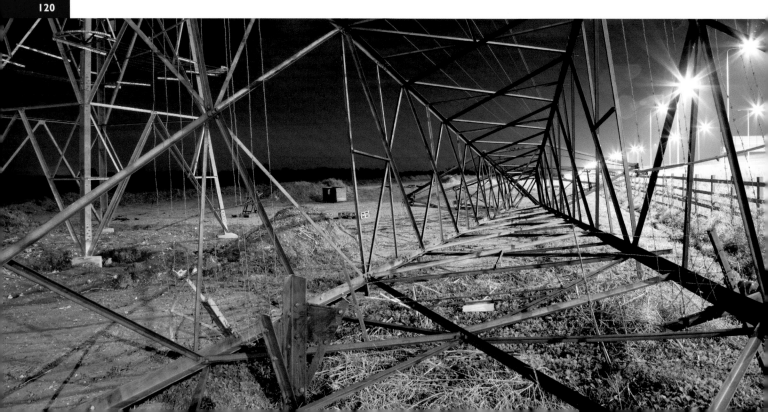

The work of the CEGB was administered at regional level by 12 area electricity companies (AECs). In an era of Cold War suspicion and influence, the headquarters, control centres and substations of the AECs were isolated and bomb-proof.

Squat pylons near RAF Brize Norton, Oxfordshire

The increased voltage required new power lines, and new electricity pylons – the purpose-designed L1 – were erected to carry them. The heavy voltage meant the pylons had to be safe and secure, and anti-climb barbed-wire fencing was often applied at the base.

In 1956, however, the recognition that a greater power output was likely in the future meant that new lines had the capacity to carry 400kV, though at that time they still carried 275kV. The L2 pylon emerged, distinguished by its three equal-length cross-arms. Steel pylons were mainly erected over agricultural land in an effort to minimise risk, and the L2s marched across the English countryside in their thousands, until their sheer numbers leant them a kind of invisibility. It was superseded by the L8, with a longer middle arm that prevented the clashing of conductors. In the 1980s, improvements in steel technology created slimmer pylons: tensile, latticed and metric.

In 1965, a 400kV, 150-mile power line was installed from Sundon, Bedfordshire, to West Burton in the Yorkshire Dales. The line was extended over the ensuing decades and by the end of the century covered the length of the country from Land's End to Dounreay.

Where to see them:
Harker, Carlisle (rare glimpse of L1 pylons); Filton, Bristol (squat L9 pylons beneath the airport flight-path); regional grid control centre, Aberford, Leeds (Cold War bunker electricity HQ); 400kV supergrid transmission line (M1 Junctions 6a–10)

Energy

Where to see them:
Eggborough, Ferrybridge,
Drax, M62, Yorkshire;
Didcot, Oxfordshire
M4/Great Western
railway (the 'Cathedral
of the Vale'); Rugely,
Staffordshire (guided tours
available); Isle of Grain,
Hoo Peninsula, Kent (oil
refinery companion plant);
Rocksavage, Cheshire
(natural gas powerplant)

Eggborough Power Station,
North Yorkshire

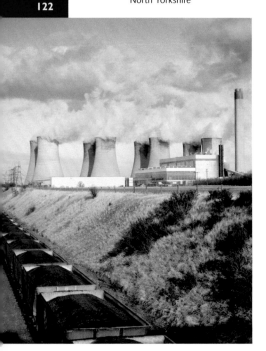

Eggborough Power Station is at the heart of an energy-producing landscape fed from below ground. The merry-go-round wagons brought coal from nearby Selby coalfield, opened in 1976, though now, aside from a couple of deep mines near Doncaster, coal comes from open mines in Scotland, South Africa and Colombia. The wagons unload the coal onto the stockpile – its size an indication of the rate of generation on any given day – and loop back to their source. Most of the station's water is taken from the River Aire, extracted for use in the cooling process as well as in steam production. Around half of the water used is returned, somewhat warmed, and much of the rest is emitted as vapour from the eight giant cooling towers – hyperbolic natural-draft cement chimneys with lattice bases. The 1,960mw station opened in 1965 and forms a chain with Ferrybridge and Drax. The neatly landscaped plant space is divided according to the processes of power generation, its silos, turbine-halls, pulveriser and waste plants linked by conveyor belts and pipes. Between the station and the road, a golf club, cricket pitch and bowling green tie the functionality of the station to the wider lives of its employees, who park outside the site. The M62, the great coast-to-coast motorway that links Liverpool to Hull, was diverted via the Selby coalfield and ensured easy road transport from the Humber ports and the oil stations of Merseyside.

Eggborough, Ferrybridge and Drax were built to capitalise on the rich Selby coal seam. Their large outputs marked a departure from the earlier post-war power stations which still lagged behind European and American production. The location of such power stations at transport hubs is epitomised by Ratcliffe-on-Soar near Nottingham. Its guardianship over the power production heartland, at the meeting of the M1, River Soar and Midland main line, established it as an alternative angel of the north.

Oil-fired gas stations in coastal locations took hold in the 1960s, but in turn gave way to diesel-fired gas stations. At these stations the power sources are kept in giant tanks buried beneath earth bunds, and pumped around the site in above-ground pipes. As demand for more ecological fuels hots up, a new era of combined power stations dawns; at Barrow-in-Furness, the glass façade of Roosecote Power Station reflects the surrounding open landscape.

The waste and by-products of energy production have themselves fed back into the landscape. Ash from the combustion process is used in road-surfacing materials, cement and building blocks, and larger waste particles – clinker – are used as aggregate in the cement industry.

Rocksavage Power Station,
Cheshire

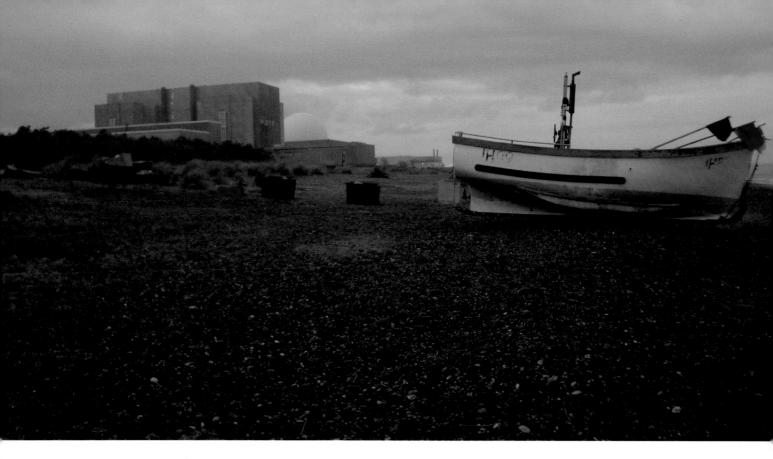

Sizewell A and B Nuclear
Power Stations, Suffolk

Nuclear Power

The Suffolk seaside: a landscape of beach-front fun, piers and arcades, wildlife reserves and nuclear power. The blue-and-white domed pressurised water reactor of Sizewell B (watchful over the surf-topped waves) looks like it might contain maritime wonders, but is actually designed to disappear in an East Anglian shore mist. Sizewell A, next door, is a pebble-coloured monolith more striking in its visibility. In production from 1966 to 2006, it was one of a generation of Magnox reactors (so called for the alloy used to coat the fuel rods), and wears much of its plant on the outside, adornments to its concrete coat and at the mercy of the salt sea air. B's plant is all enclosed – hidden in the low-level duotone container architecture. Sizewell B's reactor was first fired in 1995, enclosed by a steel inner-wall cased in 1.3m-thick concrete and a metal skin. Sea water is drawn into the station through an inlet that looks like a broken pier in the sea, and is used to condense the steam that drives the turbines before being pumped back, a few degrees warmer, through a twin outlet. Waste is stored in pools on site, waiting for transportation to Drigg in Cumbria – the graveyard of nuclear waste.

Nuclear power stations were in the vanguard of post-war industrial modernity, enclosed in the most up-to-date architecture. In opposition to the mid-century brick cathedrals of power, such as Bankside (now Tate Modern), nuclear stations used light steel or concrete frames and concrete-and-glass cladding. Some designs left plant exposed to the elements. Externally and internally, the use of colour was an integral part of their design, as windows on the pastel-shaded turbines at Calder Hall show. In 1958, *Nuclear Energy Engineer* commented that the 'nuclear revolution will add a splash of brightness and cheerfulness to the industrial scene'.

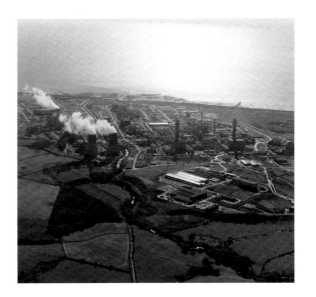

Calder Hall Power Station and Sellafield, in 1956

The world's first commercial nuclear power station, Calder Hall was opened by the Queen in 1956. Adjacent to the Windscale site in Cumbria (later Sellafield), Calder served the dual functions of weapons-grade plutonium and energy production. Its huge gas cooling towers were identifiable symbols of the contemporaneous giant coal-fired power stations. In 1950s Britain new housing was at a premium, but so were skilled scientists and workers; a seaside village, Seascale, was expanded to serve the site.

Due to their twin requirements, of remoteness – a prudent consideration for a new technology – and access to large sources of cooling water, undeveloped coastal locations were the preferred choice for the new power stations. Conscious of their impact on the local environment at Sizewell, Suffolk, and Hinkley Point, Somerset, leading architect Frederick Gibberd was commissioned to oversee their design. Lighting for security and production purposes, the hum of machinery, tannoy announcements and, latterly, armed security presence, brought the modern 24-hour landscape to these previously isolated places.

In contrast, many of the nuclear research establishments and supporting industries were located on former airfields or munitions factories. While their underlying form often remains discernible, they grew in an unplanned way, with new processes and experimental buildings. Most of the first- and second-generation nuclear power stations face decommissioning; reactor buildings, however, may endure for another century to allow radiation levels to decrease.

Where to see them:
Sellafield visitor centre, Cumbria, and Seascale nuclear support town; Sizewell beach, Suffolk; Hinkley Point, Somerset, (with Sizewell A, decommissioned Gibberd-designed Magnox stations)

Renewable Energy

Kirksanton Airfield at Haverigg, Cumbria, disused since the Second World War, is whipped by the south-westerly wind coming off the sea. These conditions make this exposed and remote corner of England ideal for farming the wind's energy. Sentinel along the old runway, and overlooking the adjacent prison, the fibreglass turbines have a 1.125mw capacity, and growing.

Renewable energy – electricity generated from the motive power of naturally renewing sources – has an enduring history throughout 20th-century British landscape debates, while structures for the exploitation of renewable resources have become increasingly visible across Britain's rural landscapes. The term 'renewable energy' usually conjures visions of imposing wind turbines traversing distant hillscapes, but until recently most renewable energy installations in Britain have used water, in the form of hydro-electric power (HEP).

Dependent on a plentiful supply of rainfall and a strong head of water, almost all Britain's significant HEP projects have been built in upland areas, particularly in Scotland, where isolated communities did not benefit from the networked electricity grid.

In the early 1990s the government committed to a renewable energy contribution of 10% by 2010 and 20% by 2020. Wind-power sources were prioritised. Thus, towards the close of the 20th century, Britain's seascapes and landscapes became the focus of a series of cultural conflicts over landscape use as the government struggled to address global climate change through on- and off-shore windpower installations. The first UK windfarm opened at Delabole in Cornwall in 1991 and over the next few years, often amidst vocal protests, rounds of windfarm construction began in Yorkshire, Cumbria and Cornwall, as well as Wales and Scotland. Arguments over the character and aesthetics of rural landscapes escalated as the picturesque was sent in to battle the productive. Windfarms were demonised as modernity gone mad, as industrial structures invading the rural idyll of natural Olde England.

Faced with potentially damaging criticism and green taxes, new business developments began to incorporate renewable-energy-generating rooftop installations. 'Individual' windmills were constructed for suitable business locations and solar panels became common features of higher office blocks in particular. At GreenPark in Reading, a windmill powers the business estate, a striking declaration of a 21st-century eco-commercial ethos.

As the 10% renewables target date approaches, with numerous public windfarms in the pipeline and private usage of wind and solar power increasingly viable, large and small-scale structures look set to find England's hidden corners.

Haverigg Wind Farm, near Millom, Cumbria

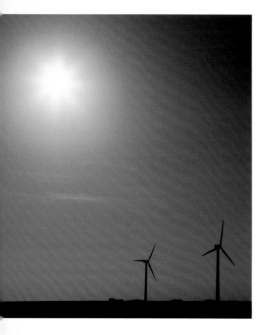

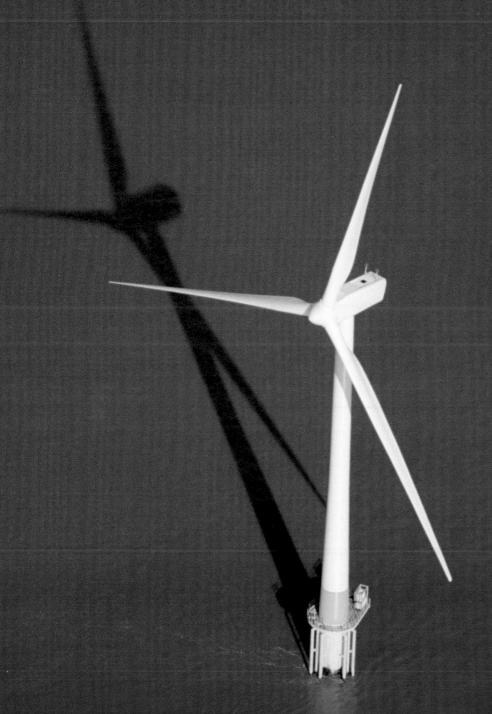

Where to see them:
Haverigg, Millom,
Cumbria; Delabole,
Cornwall; Ecotech Centre,
Swaffham, Norfolk (wind
power); CIS Tower,
Manchester (solar panel
clad office tower);
Alexander Stadium,
Birmingham (largest solar
roof installation); Barton
Locks Small Hydro
Scheme, Barton,
Manchester (Manchester
Ship Canal lock-based
generator); Ely Straw-
Filled Power Station, Elean
Business Park, Ely (East
Anglian straw combustion
power); GreenPark wind
turbine, Reading, M4
(business park turbine)

Scroby Sands Wind Farm,
Norfolk

Water

As the new town of Milton Keynes unfolded across the Bedfordshire countryside, infrastructure plans demanded a new reservoir. In 1965, a great earth covered dam enclosed the water of the flooded Diddington Brook. The water was and still is extracted from the River Great Ouse. Built for the new towns, part of a new generation of public amenities, Grafham Water was immediately made accessible to the public. Nature reserves were planned into the project, and a leisure centre that exploited the sailing and fishing opportunities of the lake was made possible by new filtration techniques. The lake is circumnavigated by a 10 mile cycle and walking trail.

In 1613, London's ongoing water crisis was solved through the shrewd engineering of the New River, a waterway that brought a fresh water supply to a city famed for its filth. At the end of the 20th century London faced another water crisis, and an equally ambitious project, this time deep underground, has contrived to save it. The cement cover in London's Hyde Park marks the underground pumping station of the New London Water Ring-Main (opened 1994). The ring-main circles around London, far deeper than the tube system. It charges and is charged by the New River, London's 18th-century answer to water shortages, and feeds the North London aquifer that had been almost drained during the 20th century.

The 1945 Water Act stopped short of nationalising the industry, but rationalised the hundreds of water companies into regional and local authority water boards. Meanwhile, technological advances in water extraction, especially in drawing groundwater from aquifers, created a broader water resource. The difficulty lay in storage and distribution. A handful of large new reservoirs were built to consolidate the resource and more service reservoirs were constructed in lowland areas. These were fed by reservoirs and serviced settlements below. Widespread in pre-war years, the water tower proliferated in the 1950s and 1960s. A number of iron Braithwaite tanks that serviced RAF airfields were acquired for civilian use, but it was the unusual modernist designs that stood out the most: strong megalithic features of the skyline that were understood and accepted for their life-giving properties. Public water towers were sited on ridge lines, on high ground or in rural areas, all beyond the pumping mains. Elaborate classical designs gave way to functional concrete panels, smoothly finished or textured with spray-on concrete coats. Water boards developed their own tower styles. Pre-stressed concrete-and-steel reinforcement led to new expressions of the essential function of the water tower, perhaps most strikingly in the 'wine glass' (pioneered in Northumberland in 1963), where the conical slope of the bowl on the shaft eliminated the leakage hazard of right-angles.

Grafham Water,
Cambridgeshire

Developments in approaches to landscape use meant that the construction of Rutland Water in the 1970s created a landscape of sculpted nature: earth bunds hid engineering plant while grassed banks disguised the reservoir wall. Pumping systems were miniaturised with the development of the centrifugal pump, making the large iconic pump-houses redundant.

Privatisation in the 1980s led to a period of investment in the neglected infrastructure. Water conservation problems, leakage and the heavy burden of the dry south-east, begged huge engineering undertakings – such as mass pipe replacement – and hid the water landscape below ground.

Where to see them:
Kielder Reservoir, Northumberland (Europe's largest man-made lake); Hyde Park, Park Lane, London (enormous manhole cover for London Ring Main); Morwick, Northumberland (wine-glass water tower)

The Office

Not shy of its presence, Canary Wharf transformed a decrepit corner of London's Docklands into an office-centred 'mini-town'. Towers are arranged to create inter-office outdoor spaces with bars, restaurants and shopping centres incorporated into the complex: the Canary Wharf worker need not stray too far from the office for anything. Modern planning legislation favours new urban offices as part of 'mixed-use' developments with the offices themselves situated above purpose-designed street-level social and retail areas. Canary Wharf Underground and DLR stations form a major part of the complex, designed for the needs, flows and volumes of commuting office users.

Canary Wharf, London

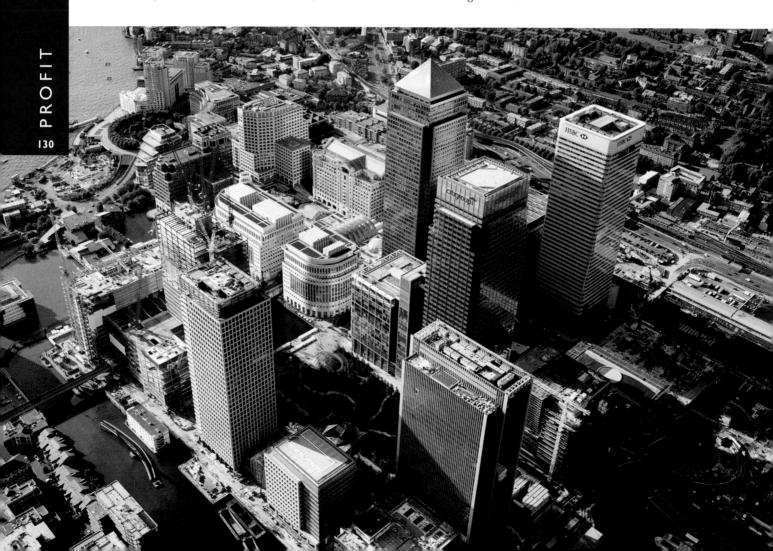

Clearance of bomb-damaged buildings in the 1940s, modernist planning philosophies and a new commercial drive created complexes of urban offices across post-war cities. Nowhere was this more dramatic than in Manchester, where the construction of US-style slab-and-block buildings in the 1960s created an upper pedestrian level within the town. This 'death of the street' ideology was prevalent in modernist urban thought from the late 1920s onwards, but first made its mark on Manchester's Piccadilly Plaza. The upper-storey car park, shops and office entrance were intended to be regarded as street level by office users, although the interconnection of office buildings at a raised level was never fully realised.

Internally, offices moved away from the compartmental arrangement that characterised their pre-war predecessors and is still favoured in the offices of continental Europe. Office hierarchies were reflected in the new Americanised open-plan designs of the 1950s and 1970s. In core-access systems, the private offices of managers and specialists were placed nearer to the building's stairs and elevators. In light-access systems, the open-plan area of an office was central, with manager/specialist compartments given privileged access to natural light around the edges. It was this increasing specialisation of office design that led to the construction of complexes like Canary Wharf through the 1980s and 1990s. Such complexes are often in former industrial areas or form out-of-town business parks. At Temple Quay in Bristol, office development was the major factor in the regeneration of the old canal and goods yard area, adjacent to Bristol Temple Meads Station, a major transport node. The 'population' of these complexes is generally non-local.

The depersonalisation of office space continues with the advent of 'hot-desking'; whether operating within individual companies or on a wider 'desk-rental' system, the need for specifically designed offices has diminished and open-plan offices appear in a wider variety of adapted locations. This retreat from the predominance of specially designed office complexes mirrors the development of electronic communication, as a person's access to a network becomes more important than their physical location in an office. As the virtual office is born, the empty office building is once again in the ascendant.

Empty office building adjacent to the M25 at Egham, Surrey

Where to see them:
Canary Wharf, Docklands, London; Piccadilly Plaza, Manchester city centre (1960s elevated office); Temple Quay, Temple Meads, Bristol (offices over industry); the M4 corridor (Slough, Reading, Newbury, Swindon)

Information

On top of the finest copper lodes in Cornwall, Caradon Mast is a monument to the triumph of information over industry in post-war Britain. Abandoned engine-house chimneys jut up from the granite hillside only to be outdone by a latticed steel transmission mast and its low whitewashed transmitter station. In 1961 the mast brought ITV to Cornwall, six years after its first broadcast. Black-and-white VHF television broadcasts on one channel (12) were joined by UHF in 1969 and, later, smaller masts for telecommunications and wireless internet services, created a triad of transmitters that lift antennas the requisite height above sea level. The copper deposits of Bodmin Moor that became components of the electrical age are now pinned with the guy ropes of invisible networks. Radiowaves pulse out across the south-west, replacements for slower information systems that decline with the advancement of the masts. The mining villages that surround the hill resonate with the increased global access that they provide, and antennas and aerials receive the mast's outpourings.

Caradon Hill transmission mast
and Wheal Jenkins mine,
Cornwall

Marconi's first transatlantic radio transmission was sent from Cornwall and by the Second World War radio had become an essential technology, an instrument of communication that held armies together and supplied cheery propaganda to civilians. Television broadcasting used similar systems, and the sprouting of receiver aerials across the country made a considerable impact on the skylines of low-rise residential districts. Later, as satellite technologies emerged, the family-sized receiver dish hit house façades.

From the late 1950s, the satellite technology of the space race resulted in the exploration of satellite communications, and Telstar (1962) – in which Britain's GPO had a significant interest – was launched by the American telecoms company AT&T in conjunction with NASA. Transatlantic television pictures were beamed to Goonhilly Satellite Earth Station on the Lizard Peninsula in Cornwall, via this 88cm-diameter satellite in low orbit over Earth. In contrast, Goonhilly's enormous parabolic dishes (up to 32m wide) loom over the Cornish heathland.

Cables provided an alternative to satellite and radio technology, and hid much of television's paraphernalia below ground. The excavation of cable trenches through England's towns and villages, and the ubiquitous black tar strips in roads and pavements, became a fixture of 1990s urban life.

At the end of the century the Internet turned information systems inside-out. Fed by military and business technologies, the development of the worldwide web swallowed up many of the communication networks that had physically affected the landscapes in the preceding years. Banking, shopping, auctions, chatting, dating, research, business meetings now happen online between user, computer and information superhighway. Alongside these, other interfaces – the worlds of pornography, shadier business deals, the grey spaces between legality and illegality – have become widely accessible and more visible, in the social and cultural landscape at least. The freedom of the internet has created a fast-changing world in which nothing is far from anything else. It has created a virtual landscape of possibility in which divisions of every kind are overcome as kindred spirits are a dial-up away. Virtual fantasy worlds have formed, such as EverQuest, in which money can be made that transfers into the real world. The external, 'real', landscape need no longer be experienced at all.

Where to see them:
Caradon Hill, Cornwall (tri-mast moorland); Goonhilly Earth Station, Lizard Peninsula, Cornwall (satellite farm); Holme Moss BBC transmitter, Holme Valley, West Yorkshire (high moorland mast with views to Elmley Moor freestanding transmitter and Drax Power Station)

Mobile Phone transmitter at
Canary Wharf, London

Mobile Phones

Canary Wharf, once teaming with the maritime trade of all nations, now buzzes with the fast and furious financial shenanigans of the world's high-tech commerce. Aiding its anytime-anywhere-anyhow ethos, a lone Cyprus tree disguises a mobile telephone transmitter amid the paved and landscaped playground of office workers on their cellphones.

In 1947, hoping to make a profitable peace-time industry of advanced wartime telecommunications technologies and manufacturing capacity, the Post Office gave licences for civilian mobile-phone networks to companies like the AA, RAC and London's Radiocab. These private systems were constructed on an ad hoc basis. Each system provided coverage to a limited area via freestanding or building-mounted masts that supported aerial radio systems at 45–90m. Transceiver equipment was housed in large purpose-built brick structures or inside existing buildings. By 1969, 6,100 private companies were operating 74,000 base stations. The Post Office launched its own subscription service for the business elite: Radiophone. Piloted in Lancaster in 1959 and rolled out over 20 years to a dozen cities across the UK, the network of giant masts was staked out on skylines above Britain's business and manufacturing centres.

On privatisation in 1981, the Post Office's telecommunications arm became British Telecom, and launched the first national mobile telephone network, Cellnet, two years later. The handful of giant Radiophone masts gave way to hundreds of smaller, cellular, masts, typically 15m high. Designs were standardised and the purpose-built brick structures were replaced by small, moveable metal cabins. In 1985, Cellnet replaced Radiophone in major cities. Snaking along motorways and commuter routes, mobile telephony was brought to the yuppie generation.

The first digital networks, introduced between 1989 and 1993, required all 47,000 existing cellular base stations to be rebuilt. As mobile phones fell within the financial reach of young urbanites, base station provision was revised. Smaller base stations – microcells – were installed to provide coverage outside cinemas, in shopping centres and fast-food restaurants; placed inside illuminated signs, behind billboards, on lamp posts or (thanks to advances in radio-friendly glass-reinforced plastic) disguised as any number of architectural features. The launch of 3G in 2002 has so far necessitated the installation of 10,000 new, even smaller, base stations – picocells – so small they can be fitted indoors, behind cavity walls, in false ceilings or in ubiquitous but unobtrusive white plastic cases, only a few centimetres long. As the technology of mobile phones becomes ever more pervasive it also becomes less visible in the landscape.

Where to see them:
RAC Membury, M4 (Private Systems); the 'Horwich' station (Radiophone), Winter Hill, Lancashire (Cellnet); Millennium Square, Bristol (Digital); the Orange 'Tree' A453, Nottinghamshire

PROFIT

Out-of-town Commercial Estates

With slightly inclined wings to both embrace and sweep forward, Antony Gormley's *Angel of the North* (1998) stands 18m high on the site of the pithead baths of Team Colliery, closed in the 1960s. Its copper-hued steel is a reflection of the place of industry in the north-east. But perhaps the great monument of industrial survival is the Team Valley Trading Estate that lies over the culverted River Team behind the *Angel*. In the 1930s, unemployed industrial workers built the estate along a wide arterial road that now joins the congested A1 at the 'coal house roundabout' that recalls the colliery and overlooks the open river. The estate has well over a thousand businesses established on site in a growing business park with hotel, a retail park, and many of the original 1930s Wimpey-built light industrial buildings. The new century revival of Gateshead owes more than a little to its teeming success. Although a long-closed station once linked the site to the city proper, it is the A1 that bares the brunt of traffic, causing the Highways Agency to place (much contested) restrictions on future development.

The logical progression of the automation of manufacturing was its total independence from the existing landscape; it began instead to dictate landscape construction. The 'cargo cult' began to emerge, and in the 1970s developers of out-of-town industrial estates could almost rely on the belief that space would be filled. In some suburban or periurban areas – the pre-war commuter dormitory suburbs of the Midlands, Manchester and London – this created

Cambridge Science Park

new industrial centres, like Stockport. Other, rural areas became affluent and independent of the cities they orbited, as their proximity to the open road made them attractive manufacturing locations. Off the A45, an old quarry site became Cambridge University's answer to Stanford's Silicon Valley: the Cambridge Science Park, has transformed the landscape. 'Silicon Fen' has grown out of the villages and new towns such as Cambourne have been built for the technological workers and new businesses that the park has attracted.

The post-war industrial estates were mainly comprised of metal box units that could be converted to suit many purposes. Distribution warehouses and company storage facilities occupied units next to light manufactories. The logical next step was for companies to use the warehouses on out-of-town estates for retail purposes and in the 1980s the retail park took off. Industrial supersheds were stacked high with bulky items – customers could park easily in vast purpose-laid car parks and companies were able to minimise ordering and delivery costs. Retail parks became meccas for the home, garden and car and became extensions of the family landscape. The arrival of the Swedish firm IKEA at the Gemini Retail Park, Warrington, in 1987 began an inexorable association of the retail palace as activity, a visitor centre in its own right. IKEA's 2005 opening of its Edmonton store resulted in one stabbing and several hospitalisations.

Where to see them:
Cambridge Science Park, Milton Road, Cambridge; Purley Way, Croydon; Gemini Retail Park, Warrington (J8 & 9, M62); Selby Business Park, Yorkshire (offices in development replace traditional industry)

Team Valley Trading Estate, Gateshead

Town-Centre Shopping

Tricorn Centre, Portsmouth,
demolished in 2003

The post-war new order of zoned designs, blocks of textured concrete draughted on squared paper were constructed as citadels of commerce in each city and large town across the country from the 1950s. In the severely damaged coastal cities of Portsmouth, Plymouth and Southampton, these new forms were icons of a changed world, but often became the victims of drawn out consultations, crossed wires and bad investment. A failure to let large units at the beginning of a centre's life could condemn it and prevent investment in its maintenance. Portsmouth's Tricorn Centre – towering and dark on the seafront – existed in controversy until the last, when English Heritage's last minute Grade II* listing did not save the battered and unloved nautical form from demolition. Likewise, Plymouth's Mayflower Centre with its strips of charity and discount shops now faces redevelopment.

At Broadmead in Bristol, the Blitz destroyed the major town-centre shopping streets. A miraculous survival of the bombing was the 13th–19th century Quakers Friars site, now the register office. Plans to make it the centrepiece of an Italianate piazza were scuppered by shopkeepers who wanted their shops oriented as they had been before the bombs. The building was instead left stranded among industrial bins, worker smoking breaks and car parks, as the 'piazza' was made 'back-of-house'. Twenty-first-century redevelopment will see the initial plans realised.

The automobile dictated the shape of the new shopping world. Cities sacrificed swathes of land to multi-storey car parks, many of which dominated the new city skylines, as at Broadmead where the curving white concrete floors of the Tollgate car park signalled the entrance to the commercial heart of the city. In keeping with the planned ethos of these new town centres, shopping precincts were often pedestrianised to enable a new social core to develop.

During the 1960s and 1970s more and more cities adapted to this new shopping world. The demands of consumerism meant that historic cityscapes – seen as redundant, dirty and rotten

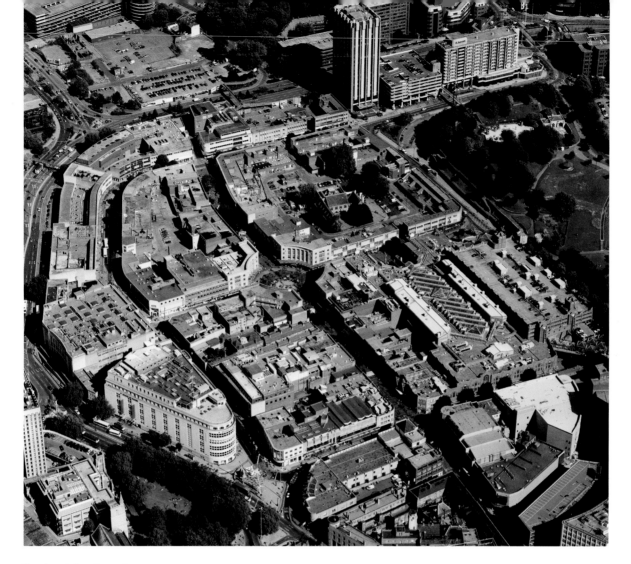

Broadmead shopping centre,
Bristol

Where to see them:
Broadmarsh, Nottingham;
Coventry city centre (first
traffic-free shopping
precinct); Mayflower
Centre, Plymouth (juxta-
position of the dedeveloped
and the degraded)

– would give way to concrete post-modernism. In Cambridge, the twisting medieval streets
owned by the colleges were flattened to make way for Lion Yard, home to the central library,
ground-floor shops and a five-floor car park. The 21st century saw these often down-at-heel
centres resurrected. Broadmarsh in Nottingham took its name from the city's medieval
outskirts over which it was built. Designed as a modernist gateway – between rail station and
city centre – Broadmarsh instead became a barrier that disoriented the visitor and upset the
street order. It entered the 21st century under compulsory purchase order for redevelopment,
but many city shopping centres are resurgent in a new era of affluence, chain stores and
popular high-street bargains.

Shopping Malls

England's giant malls are vernacular temples of materiality – towering frontages, wide, covered naves and galleries, cloistered shops and counter altars – sited in the badlands at the edge of the city, exclusive transport systems and acres of parking space pull worshippers from all over the country. Bluewater in Kent (1999) fits into the transport hub of the M25, on the site of an old quarry – the angled chalk cliffs remain. The white cladding and glass walls reflect the chalk cliffs and nearby River Thames while oast-house funnels and other industrial shapes house extractor fans or elevators and evoke the area's industrial past. The sextant-shaped central hall is anchored by prestigious department stores and forms the hub of three malls. The Guild Hall, Thames Walk and Rose Gallery all try to link the quarry to Kent's medieval commercial heyday. Bluewater's Englishness hit the cinema in *Kabhi Khushi Kabhie Gham* (alongside Bleinheim Palace, Heathrow Airport and the British Museum) as the backdrop to the 2005 Bollywood blockbuster's family reunion. Beside the 13,000 car-parking spaces (with orchard divisions), the quarry pits have been landscaped and filled to provide woodland walks and boating lakes.

In 1961 Arnold Haggenbach and Sam Chippendale opened a large concrete-covered shopping centre in Jarrow modelled on the great malls of America. Other Brutalist Arndale centres sprung up across the country. In 1996, Manchester's yellow-tiled Arndale Centre – somehow a symbol of English imperialism – was the victim of an IRA bomb.

In 1990 a derelict steelworks on the edge of Sheffield, framed by a Victorian viaduct and a stone's throw from the M1, opened as the site of England's first 'regional mall', a giant and not-too-often replicated shopping mecca. Meadowhall, like many shopping centres and malls, took the evocative agricultural name of its site, while replacing England's defunct heavy industry with light, intense commerce. Meadowhall Interchange provided the centre with a transport hub of rail, bus and tram from the city centre and surrounding towns. The mall was acknowledged as the primary reason for the decline of Sheffield and Rotherham city centres.

The new generation of supermalls are gleaming structures of glass and steel surrounded by acres of colour-coded car parks carefully planned to minimise the distance shoppers need to walk. Fitted into the margins of the motorway network, some, like Cribbs Causeway off the M5 at Bristol, support their own new settlements (in this case Bradley Stoke). They have become the central communion and congregation points of frontier towns. Bluewater's position as the new seat of commercial worship is signalled by the decision in 2005 to outlaw the wearing of 'hoodies', swearing and smoking; the overriding ethos of the mall is to be respected by uncovered heads, clean living and thinking, and family values.

Where to see them:
Bluewater, Kent; Lakeside, Thurrock, Essex (first southern regional mall); Arndale Centre, Manchester (rebuilt since IRA bomb); Meadowhall, Sheffield (regional mall on derelict steelworks)

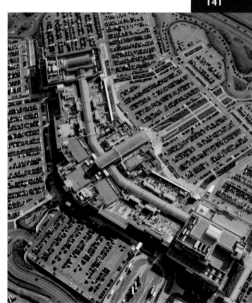

Above: Cribbs Causeway, Bristol
Opposite: Bluewater, Kent

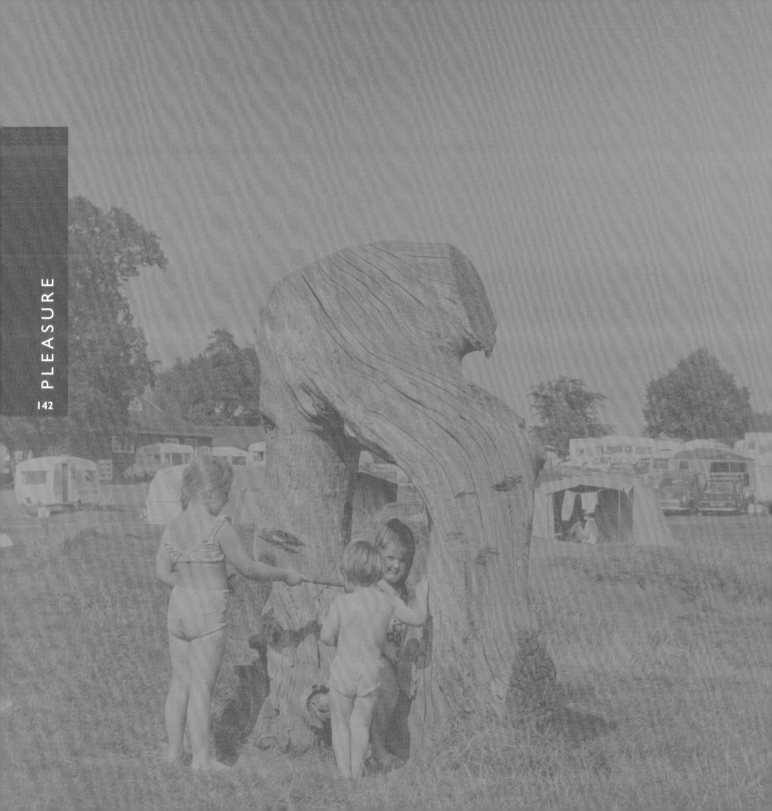

Pleasure **A journey through the Forest of Dean** Lisa Hill

The Forest of Dean in west Gloucestershire was reserved for royal hunting before AD 1066. The Forest survived until 1919 as one of the principal Crown forests in England, the largest after the New Forest in Hampshire. Crown hunting rights provided the original motive for its preservation and as a Royal Forest it was successively exploited for its sport. In 1924 the Crown Commissioners of Woods and Forests transferred control of the Royal Forest of Dean to the Forestry Commission.

The 1930s saw mounting pressure for public access to the countryside, and in 1938, a period of consultation on the suitability of the Forest of Dean as a National Forest Park gathered evidence from, among others: the Automobile Association, Boy Scouts Association, Camping Club of Great Britain and Ireland, Council for the Preservation of Rural England, Cyclists Touring Club, Girl Guides Association, National Cyclists Union, Pedestrian Association, Ramblers Association, Wye Valley and Royal Forest of Dean Publicity Board, and the Youth Hostels Association. Later that year the Dean Forest and Wye Valley National Forest Park was designated as the third National Forest Park, and a series of new recreational landscapes, based around walking, were created. Although the development of recreational amenities was historically seen as secondary to the Forestry Commission's main duty – to create and maintain a national timber resource – the Commission was undoubtedly the single greatest force responsible for shaping recreation policy and leisure provision in the Forest.

The growing countryside activities during the 1930s of ramblers, scouts and guides, health campaigners, charabancers, youth hostellers – and their walking, cycling, camping and map-reading – were transformed from the 1950s by middle-class car ownership and better access for the urban working-class to bus travel and communal charabanc trips, all of which enabled ever more urban dwellers to spend their leisure time in the country. But this gave rise to new concerns over litter, noise, flower-picking and outdoor bathing, and from its third edition in 1964, the *Forest of Dean Guide* supplemented its educational content about flora and fauna with a discussion of leisure activities.

As the Forestry Commission's recreation policy and leisure provision changed, so did the recreational landscapes used and created by locals in, and visitors to, the Forest. The resulting landscapes were precursors of the mass recreation of the 1980s and 1990s. New elements of the Forest of Dean's leisure landscapes included Biblin's Youth Camp at Whitchurch, and a log cabin 'refreshment chalet' at the viewpoint at Symond's Yat Rock, which was built in 1956 by Forest staff using 78 logs from locally-grown Western red cedar. And in

Previous page: Christchurch campsite in the 1960s, Forest of Dean, Gloucestershire

Fragment of a 1980s viewpoint sign

collaboration with the Royal Society for the Protection of Birds, a slag heap was transformed into a viewing platform for bird-watchers at the former site of the New Fancy Colliery.

But the provision of waymarking from the 1960s, in collaboration with the Gloucestershire District Ramblers' Association, was perhaps the one aspect of this transformation of the landscape that had the greatest impact on visitors' experience. Tony Drake, Secretary of the Gloucestershire Ramblers' Association from 1949, explained:

[Around 1960] *a colleague, my opposite number in Somerset, was…considering waymarking public footpaths. It's something we take for granted now, but at that time it wasn't the done thing to waymark paths in Britain....*

The Deputy Surveyor called us in to advise on a programme of signposting and I said 'If you want another forest made of signposts we can do that, but…the logical thing to do is put signposts at strategic points'. Now, what they provided was a wooden sign, with…the letters individually painted on. There's none of them survived – but I've got one in my back room! Now you see, you can understand these things are not lasting.

The issue of waymarking caused considerable controversy within the Ramblers' Association as it was not seen as part of the walking ethic:

As a result of the waymarking scheme…the chairman of our local committee resigned! Yes, he thought we were spoon-feeding the rambler! Well, we argued that whilst we didn't want to just discourage people from wandering about in the woods…it was necessary to guide them on selected routes otherwise they just wouldn't venture for fear of getting lost.

Without a precedent to follow, Tony Drake and his colleague were responsible for designing the first waymarking symbols.

… My colleague, Stan Marriott…was experimenting with…his idea of a waymark…[but it] disappears at a distance; you can't distinguish it…Sanson-Baker [deputy surveyor] agreed to have…arrows… and we had to decide on a colour. Well, now he said you can't use white, because the Forestry Commission use white for various markings on trees (…what's going to be felled and that sort of thing) so we said, well, the next brightest colour is yellow.

Tony was responsible for writing the first rambles included in the third edition (1964) of the Dean Forest and Wye Valley Forest Park Guide:

They just added an extra chapter. I think that presumably Mr Edlin [editor of the guide] wanted to put suggested walks in…and obviously the waymarked ones…were a priority because they were easier for people to follow than the worded description. But in order to give…an adequate selection, he got us to do some…route description…well what we eventually produced was two different kinds of rambles – ones that were waymarked, and those that weren't. And for those that weren't we always had to give more description.

Waymarking was, and remains, a relatively mundane activity involving a bucket of paint and homemade stencils. Although parts of the routes were signposted the waymarking arrows were painted directly onto trees. This early waymarking experiment influenced the development of a national system of waymarks, a key enabler for the mass recreation that ensued in the 1970s. The 1968 Countryside Act made waymarking compulsory for county councils, while in 1974 the Countryside Commission published the first set standards for a national system of waymarking. As Tony explained:

In the Forest of Dean we didn't have to distinguish between bridle paths and footpaths – we just went and marked it as an advisory route…but once we got going in other parts of the country people were wanting to distinguish bridleways by a different colour…in the absence of co-ordination there were different colours in different places. So the Countryside Commission (as it then was) brought out a plan… They decided on [a single national standard for waymarks].

In undergrowth near Blaize Bailey in the Forest of Dean lie the splintered fragments of painted wood – the remains of a 1980s viewpoint sign. Archaeologists tell stories from such traces and fragments in the landscape. This is as true for the later 20th century as it is for the more distant past, but in the recent past the processes of change are often also within living memory. In this case, these fragments can remind us of how broad changes in 20th-century leisure landscapes were worked out in local situations, how processes of change took place, how these processes are remembered by those who were involved, and how such change is marked in the landscape.

The Forest of Dean,
Gloucestershire

Pleasure Introduction

The English have a reputation to keep up – as holiday makers and hobbyists: it is a reputation that crosses borders. England invented the 'English Week' – five days of labour – as well as 'the weekend' – a term coined in the north and, according to the *Oxford English Dictionary*, first recorded in 1638. Even the French have been enjoying *le weekend* since the 1920s. With such a short time-period set aside for the nation to enjoy itself, it is unsurprising how imprinted leisure is on the landscape. From the days of the Victorian seaside, with extended station platforms to accommodate the holidaying hoards, to the multiple vapour trails that, for a moment, betray the locations of the many English airports and the directions of their low-budget airlines, the 'leisure-market' has defined huge swathes of England, from its coastline to its urban centres. It is an industry in itself and, for many, a religion and a life. Leisure has its temples at Old Trafford, Twickenham, Wimbledon, as well as its wayside chapels: the Astroturf goal centres that are home to corporate and community 5-a-side leagues and the concrete basketball courts slotted under flyovers. It has huge palaces of culture – exhibition halls and museums – as well as the golden calf of entertainment, the television. Survivors of the older recreation landscapes still come rapturously to life in summer – municipal tennis courts, recreation grounds, rambling routes – and newer landscapes, recycled from old industrial sites have joined the stately homes of England as reliquaries of imagined and remembered pasts.

Before bank holidays were established, visitor attractions such as Bristol Zoological Gardens closed on Sundays, denying access to those who worked on all other days. Most of England's population had neither time nor money to indulge in leisure. Leisure was for the leisure classes: those who could afford club memberships, theatre tickets; those for whom the concept of touring was a possibility; those who had enough lawn to draw out tennis courts. For the middle and lower classes, seaside resorts offered varied delights from swimming to evening dances. Hotels, bed-and-breakfasts and boarding houses lined the promenades and backed street by street into the towns, catering for all budgets. But for many, the local pub, a Sunday matinee and perhaps a Sunday football match were as much as free time and spare cash allowed.

Steady improvements in statutory holiday pay, paid public holidays, the five-day week, and increases in real wages all contributed to the creation of the consumer society and the realisation that a buoyant economy could not be an elitist one. Ownership of 'white goods' reduced time spent on household tasks and cars shrank journey times and expanded possibilities.

Seaside Blackpool in the early 1950s

Uncertainty and war in Europe were perhaps the overwhelming forces behind the later 20th-century's greatest advancements in leisure provision. The Physical Training Act of 1937 extended the power of local authorities to provide facilities for physical recreation. It had become apparent that a healthy population was a necessity on the home front as well as in the theatres of war, however, leisure time for the working population had become more and more restricted. In pre-industrialised England, leisure was rest and respite from work, essential and varied. For agricultural workers, long breaks, in which to recover from rigorous seasonal work, were filled with seasonal sports, games and revels. As workers submitted to the rule of the clock in the industrial and technical ages, games that had previously been fluid and locally distinctive became set, regulated and bounded. Football for example, entered the 20th-century as a 90-minute match played on standardised pitches with official rules and a ruling body, instead of the extended game of former centuries that was played across whole days, in fields, sometimes streets.

Campaigners from varied backgrounds demanded better pay and holiday provision and better access to England's parks, gardens and countryside. By the end of the war, the campaign to provide the population with a more comprehensive leisure system was well underway, and many of its leaders had made their way into the post-war government. Wider social improvements meant that leisure provision was often a given. By 1939 two-thirds of houses in England and Wales had gardens, on a model derived from the dominant suburban pattern of a villa with a small front and larger back garden. New houses were built with gardens as a matter of course, and larger blocks of flats were given surrounding land, and often play areas. However, increased housing densities and high-rise plans did reduce the importance of the garden as an emblem of neighbourhood standing, and the advent of the automobile changed the nature of the front garden from neat floral display to parking hardstanding.

However the car opened up the idea of a bigger country, of accessible 'wilderness' further afield. The National Parks seized the public imagination, particularly those such as the Derbyshire Peak, surrounded on all sides by ever-growing conurbations. The National Parks eventually became the emblematic image of the countryside itself. A similar reinvention of Englishness occurred in the perception and invention of 'the past'. National Trust car parks, neatly bounded by timber posts invited the public to view their 'heritage': the houses and gardens of the aristocracy, which had become too expensive to maintain privately.

Car boots became the repository of the weekend shop: our out-of-town shopping malls are

as much a part of the landscape of leisure as they are of the landscape of profit, and often include leisure activities, such as pedal boats at Bluewater. And perhaps it is the linking of leisure and commerce which defines the end-of-century leisure landscape. Changing economic emphasis and technological development has started to reshape the pleasure-seeker's landscape. In the 21st-century, growing numbers of car owners can transport themselves to any number of leisure destinations while, paradoxically, technology offers an imagined array of televised landscapes and computer-generated worlds in which to travel. Growing disposable incomes for the majority equates leisure with consumption, and units of leisure time and activity are bought and sold. The consumption of leisure – the almost work-like way in which the English must enjoy their free time – has led the inexorable boom of leisure's market share, from the contemporary obsession with the gym and pursuit of the body beautiful to the reinvention of the past for modern-day amusement. The 21st-century landscape of fun is a diverse web of imaginative worlds, fitness regimes and holiday-scapes. The English enter the new century with hobby and holiday reputations definitively intact, while a new landscape of weekending constantly unfolds.

Basketball court, Spring
Gardens, Vauxhall, London

Back Gardens

Market Harborough has retained its market town identity through changing times. The pattern of the town's tofts – long, thin strips of land attached to a homestead that date from medieval times – remains in the land parcels that reach between Leicester Road and Fairfield Road in the town centre. Market Harborough's back gardens now no longer hold the productive role of the tofts, but have become ornamental private spaces, while production occurs outside.

However illusory the privacy, a safe and secluded back garden fitted in with the nationwide desire to recreate a home-centred family life after the disruption of the war. It was an extension of the home where children could play and the baby sleep; French windows opened the living room onto the garden in fine weather. Geoffrey Jellicoe's 'Minimum Garden' laid out for the Festival of Britain in 1951 initiated a trend for innovative garden design that suited small-scale gardening as plot sizes decreased. The large gardens of pre-war years became a burden without the benefit of a paid gardener and the 'labour-saving' garden of perennial plants and shrubs, rather than annual bedding plants, was welcome. Domestically available garden chemicals and devices, which played an increasing role, were kept in a small shed or garage.

As affluence increased and plot sizes decreased, the zoned garden with its productive area was retired; planting, play space, clothes-drying and garden furniture were integrated into one area. Concrete slabs and other new materials were increasingly used and the 'patio' garden, with barbecue and outdoor furniture, became an extension of the indoor living space.

The 1980s boom in television gardening encouraged interest in the 'outside' room and makeovers could instantly replicate any style – formal, sculpted, cottage – on any scale. Interior decoration extended into the garden, with little relationship to horticulture or horticultural skills. Regional weather and soil conditions and local materials were abandoned in favour of quickly installed TV designs. Nevertheless, membership of the Royal Horticultural Society, which had stagnated during the 1960s and 1970s, enjoyed a resurgence in the 1990s as a new population of home gardeners pursued science, learning and advice.

From the 1960s, micropropagation revolutionised the nursery industry. Nurseries expanded into garden centres, selling not only container-grown plants of every size and species regardless of season, garden tools and chemicals, but myriad garden-related leisure products.

Where to see them:
behind houses
everywhere; Museum of
Garden History, Lambeth,
London; myriad TV
programmes

Private back garden, Market
Harborough, Leicestershire

In 2004, UK gardeners spent £5.4 billion on their gardens, especially products that provided
instant effect, such as pre-planted hanging baskets and labour-saving solutions.

The 'Dig For Victory' ethos of the war and the pre-war pattern of decorative gardening,
recreation and produce-growing on one plot were challenged by the lack of garden space in
many post-war council estates. But as high-rise blocks came down in the 1990s, residents
sought calm and colour in community gardens, and allotments enjoyed a resurgence of
popularity among a diverse range of people, as interest grew in healthier diets and
sustainable living patterns.

Front garden, Lewisham,
South London

Front Gardens

In the later 20th century, the evidence of England's industry and economy shifted to the front of the house. The importance of the garden is subdued by the car on the drive, waiting at the garage door, while wheelie bins reel from regulated waste collection. A neat lawn keeps up appearances; a paved yard is easier to manage.

By 1950 considerable uniformity of design had been achieved in England's front gardens, through covenants and social pressure in private-sector developments and regulation and standardisation of design in the public sector. The shrubs, conifers and hedging plants which flourished in the soils of many areas of suburban expansion were suited to the neat hedging or grouping which answered the desire for screening and privacy. The quick-growing and robust privet came to typify the neat, well-maintained green suburban barrier whilst summer displays of colourful annuals were intended to give pleasure to those within and impress those passing.

The Garden City Movement had encouraged the widespread provision of gardens and the enhancement of the urban environment. Early post-war estates adopted the visual unity of the wide grass verge on each side of the street, between road and garden.

Hedges, fences and gates were often standard to public-sector design, while private developers encouraged competition and individuality. The gradual increase in the decorative function of the front garden, coupled with the increase in car ownership and the advent of the driveway, meant the front of homes began to open up and more and more houses were built with a garage.

Increasing urban and suburban populations, together with more vehicles per household, increased the pressure on the parking space on residential roads. New developments, on smaller plot sizes, required a built-in garage, and the front garden often gave way to a small-scale driveway. Existing front gardens were often paved or gravelled over to provide parking space, and as car ownership has boomed, even those estates already provided with garages have required more parking provision. By the beginning of the 21st century the Environment Agency and the Royal Horticultural Society, amongst others, advised that hard surfacing and loss of vegetation in front gardens increased the risk of flooding, air and water pollution, rising temperatures, dust and noise levels, and threatened wildlife.

Gardens in Chatham, Kent

Where to see them:
fronts of houses everywhere; Museum of Garden History, Lambeth, London; myriad TV programmes

The formal pride in manicured front lawns and floral display gave way to workshop, garage and waste-disposal activity which had formerly been confined to the privacy of the back garden. The arrival of the wheelie bin in the 1990s brought waste further into the public eye and often required the addition of purpose-built bin shelters at the front of the house. This switch of back-yard activity to the front led to some experiments with house construction in the 1960s, with lawns 'fronting' pedestrian access paths and the back yard fronting the road. But generally speaking the private world of the back has become the pride of gardening.

National Parks

Nova Foresta was recorded in William I's Domesday book, and the New Forest was known all too well to his son and successor William Rufus who met his death there in 1100. Nine hundred years later, designated boundaries declare the New Forest a National Park as well as a World Heritage Site. The forest is marked as much for its deforestation as for its woodlands: its heaths have been formed by the harvesting of timber from Stone Age times and the Royal Navy took most of its ships' timbers from the forest in the great age of sail. Now, the forest is scattered with the timber waymarking signs of cycle or walking trails, and brown heritage signs; but it is also a working woodland of timber cultivation, animal 'commoning' and agro-forestry, sometimes administered by the ancient order of Verderers whose origins lie in Norman times and were re-established in 1877. The New Forest's enclosures and boundaries are carefully shaped into its landscape, following natural features or defined by coppiced hedges – perhaps the keenest symbol of the balance struck by the National Parks between preservation for the nation, biodiversity, and continued working.

The New Forest National Park, Hampshire

The pre-war movement to create accessible national parks culminated in the great mass trespass of Kinder Scout in 1932, a showdown between ramblers and landowners. The

movement found a sympathetic ear among the ideals of the post-war government. Lewis Silkin, Minister for Town and Country Planning, was himself a member of the Ramblers' Association.

In 1949, the National Parks and Access to the Countryside Act was passed, as a result of a 1945 report by John Dower. The Act recommended the designation of 12 National Parks in England and Wales: 'extensive tracts of beautiful and wild countryside' to be opened up for 'everyone who loves to get out into the open air'. A National Parks Commission was instituted to oversee them. The parks were to be protected, their landscape types and ways of life conserved, yet public understanding was to be encouraged and access enforced. In 1951, 143,800 hectares, predominantly in Derbyshire, were designated as Britain's first National Park. By 1957, 10 parks had been designated, all in the north and south-west; the Midlands and south-east remained as yet uncatered for.

Dower's vision for the National Parks was of wild and rugged terrain: 'spiritual refreshment'. The original parks were either moorland (Exmoor, Dartmoor, Yorkshire Moors) or uplands (the Peaks and Lakes, Northumberland, the Yorkshire Dales). Lowlands and downlands were left to arable agriculture, where economics outweighed the importance of landscape.

Town and country were soon at war again as landowners, conservationists and even ramblers, lobbied for access restrictions against the perceived tides of day trippers and their autos, seen as a threat to the sanctity of the parks.

National Parks currently cover over 10% of Britain and are a primary tourist draw. Millions enjoy the footpaths, rivers, cycle paths and bridleways each year. But erosion and the demands of forestry, reservoirs, communication and the Ministry of Defence have taken their toll, and road improvements and tourist facilities often cater for visitors' needs rather than the ethos of conservation. Dower's view of the agrarian countryside is at odds with today's giant farm machinery and industrial-scale quarrying, but nevertheless the parks begin the 21st century protected and intact.

In 1989 the Norfolk Broads joined the National Parks as 'equivalent to', though has yet to achieve, full status. In 2004, the New Forest became the first woodland to be designated a National Park and the designation of the South Downs as a National Park (2006) completes the original list of 12 over half a century on.

Where to see them:
Norfolk Broads ('equivalent-to' park); Dartmoor (granite Torland); Exmoor, North York Moors (moorlands with coastlands); Lake District (mountains and lakes); New Forest (historic wood- and heathlands); Northumberland ('land of the far horizons', Hadrian's Wall country); Peak District (rugged peaks close to industrial cities); South Downs (first downland park); Yorkshire Dales (vales and dales)

Country Parks

The beach at Keynes Country Park flies the sought-after Blue Flag, symbol of cleanliness and safety. But there is no seaside at Keynes; instead the crescent of orange sand emerges from a former sand quarry, now water filled – one of over 140 former sand and gravel pits that comprise the Cotswold Water Park. Keynes Country Park opened within it in 1969, when some of the worked-out pits – water filled once pumping had ended – were officially opened for public use. Many of the quarry pits allow public fishing and boating, swimming and water sports, their steep sides made safe with inclines, while landlubbers swing in the adventure playgrounds and enjoy the woodland walks. The richness of the water resource is also used for conservation work: a reed-bed is haven to rare waterfowl. Elsewhere quarrying continues, and new lakes are created annually.

East Carlton Countryside Park, near Corby, Northamptonshire, home to the Steel Heritage Centre

The 'spiritual refreshment' of the wilderness that inspired the National Park movement did not cater for all, as many believed that the parks were not for the enjoyment of the hoi polloi. The 1968 Countryside Act created new country parks for 'open-air recreation', defined by their proximity to urban conurbations. These areas of 'countryside' were like the pleasure grounds of old: the phrase was even included in the Act. Parks' amenities – refreshment kiosks or cafés, information and educational facilities, car parks, playgrounds, animal exhibits, boating lakes and, most importantly, picnic areas – were certainly not restricted by the 'natural' layout. Natural assets were exploited, as at Cannock Chase in Staffordshire (1973), an Area of Outstanding Natural Beauty, while others embarked on planting schemes that have since grown into mature collections. Nature trails were marked out and walkways designated for differing abilities.

Disused industrial sites, such as the Cotswolds quarries, proved ideal unwanted land, and at some sites the remains of older industries became integral to a park's life, such as the rails and gullets at Irchester Country Park, Northamptonshire (1971), features of the ironstone quarry on which it was laid out. At East Carlton Countryside Park on the edge of Corby, the town's industrial past found a home when the Steel Heritage Centre opened in the old stables of East Carlton Hall.

Where to see them:
Pugneys Country Park near Wakefield, Yorkshire (a former open-cast mine and gravel quarry); East Carlton Countryside Park, Northamptonshire; Buxton Country Park, Derbyshire (a hillside woodland)

The rights of access given to National Parks were not applicable to Country Parks, and charges could be levied for car parks, access or particular attractions. At Ilchester, CCTV cameras watch over the pay-and-display car park. But many country parks remain local authority administered and free.

Cotswold Water Park,
Gloucestershire

Heritage

Yellow Bath, Postcard City, World Heritage Site; Roman spa town and home of Georgian gentility, Bath is one of England's biggest tourist destinations, its streets awash with costumed legionaries, Jane Austen frocks, and stars of the latest period drama. The heritage economy thrives and in recent years its historic heritage industry has come under the microscope. Bath's identification with Cotswold stone even infiltrated a 1990s car park, in contrast to the 1960s concrete bus station. Street and shop signs are careful pastiches, new developments wear Georgian disguise. Twenty-first-century Bath is a projection of its past.

The declining aristocracy inadvertently created the heritage industry as it exists today. Country estates crumbling under poor management, bad debts and high taxation, were 'given to the nation' in lieu of taxes and administered by the National Trust. 'Heritage' allowed the public to admire the loot of the rich. An aesthetic of period decoration juxtaposed with recent family photos developed, but nothing surpassed the importance of the tea room, ideally situated in a quaint outbuilding. The 1980s and 1990s saw new visitor reception and interpretation centres, some of which sought to stand out from their historic settings, such as at Studley Royal and Fountains Abbey, while others were incorporated within existing buildings or ruins, as at Whitby Abbey. Many sites, however, retain the aesthetic of the 19th century: consolidated ruins, cast-iron or cleft-oak fences and neatly mown lawns. The ubiquitous brown tourist sign, often bearing the National Trust acorn or English Heritage fortress symbol, is now a common feature of the modern landscape, as in York where it blends in, part of the minster-city's fabric. But St Piran's flag painted over the 'English' sign in Cornwall demonstrates that custodianship of the heritage landscape is controversial.

In the 1980s and 1990s heritage became a commodity: themed shops (Past Times), pubs, period-style street furniture and garden ornaments, and the pastiche Cotswold new-build estate, complete with barge boards, porticoes and mock sash windows, proliferated in the landscape of Olde England.

There was a greater understanding of the 'historic environment' towards the end of the century, and the character of a city, town or landscape was recognised, not just that of individual buildings or features. Heritage began to be seen as an important asset for regeneration and social inclusion. Heritage Lottery Fund grants transformed historic urban parks from no-go areas to vital public places, while decaying market towns found new life through the Township Heritage Initiative. The 20th-century's own heritage has been

Tourist signposts in York

recognised as an asset to be understood: military buildings and structures, tower blocks and zoo buildings have been listed or scheduled. Heritage met popular culture in 1995 when the National Trust purchased 20 Forthlin Road, Liverpool, Sir Paul McCartney's childhood home: a 1950s terrace, two-up, two-down, the epitome of the ordinariness and extraordinariness of the post-war landscape.

Where to see them: Bath, World Heritage city; Fountains Abbey, award-winning new visitor centre in ancient monastic site; 251 Menlove Avenue, Liverpool (John Lennon's childhood home, National Trust)

Zoos

A resort town without a zoo? Show without spectacle? Unheard of propositions for a town like Blackpool. In 1969 the Tower Zoo closed down and Blackpool was left without an animal collection. In 1972 a former airfield, Stanley Park, once a parachute training centre, became home to gorillas, rhinos, lemurs and sea lions. The old control tower became the zoo offices and education room, while four aircraft hangers that once housed Wellington bombers were converted for another kind of jumbo – the zoo's elephants – as well as maintenance and hospital facilities. The zoo, with new 'habitats' (Amazonia and Gorilla Mountain – the former water gardens and goat enclosure) and a children's nursery (the latest occupant of the control tower) enters the 21st century in the portfolio of a Spanish leisure company alongside safari and water parks. Blackpool Zoo, the former municipal collection, is back where it started in 1972: balancing spectatorship with education.

Post-war zoos reflected their pre-war precedents: those with a claim to science such as Chester and Bristol; municipal zoos run by local councils, such as Blackpool; those owned by animal collectors or eccentric landowners with an interest in certain species, as at Banham in Norfolk; and those whose ethos was based entirely on spectacle, like Belle Vue, Manchester.

Sea lion pool at Blackpool Zoo

Blackpool Zoo, incorporating elements of its predecessor on the site, Stanley Park Aerodrome

In the immediate post-war period zoos were cheerful distractions from everyday hardship. They boomed throughout the 1950s, with little change to their landscape or architecture. Animals were kept in rows of unsuitable cages or enclosures, with cold concrete floors and no natural distractions. Large animals – polar bears and the big cats – were the most prized exhibits, and elephant rides were especially popular: Wendy of Bristol was frequently seen about town. The power of anthropomorphism meant 'houses' were built for animals, with swings and slides for the more playful species.

However, a shift in attitudes, especially after the film *Born Free* (1966), meant that zoos had to reinvent themselves with a conservation ethos. Never great money-spinners (animal importation was an expensive business), some were unable to modernise and a steep decline in popularity followed. The Brutalist architecture of London Zoo, although aesthetically acclaimed, was unsuitable for purpose and the untimely death of the elephant Pole-Pole in her concrete pit was a tragedy often repeated. Popular protest in Bristol prevented the acquisition of more polar bears when a confined stepped enclosure drove the zoo's last pair to violent and fatal depression. But conservation was the saviour and reinvention of the zoo, in uneasy juxtaposition with the core visitor: the child. 'Show' animals (penguins, lions, seals, monkeys) are displayed in smallish enclosures with nowhere to hide, while signature breeds (such as Chester's Pere David's deer herd) are given a free and almost unseen reign over many hectares beyond. Bristol Zoo's Penguin Coast exhibit opened in 2001: visitors aboard an imagined exploration ship observe penguins and seals below. Meanwhile, beyond the city boundary, a rare herd of okapis flourishes in the zoo's out-of-town Hollywood Tower estate, away from zoo visitors.

Where to see them:
Blackpool Zoo (municipal zoo with gorilla mountain and lemur wood on 1920s airfield site, hangers intact); Bristol Zoo Gardens, Hollywood Tower Estate, M5 (free-range okapis); Banham Zoo, Norfolk (private zoo)

Television Landscapes

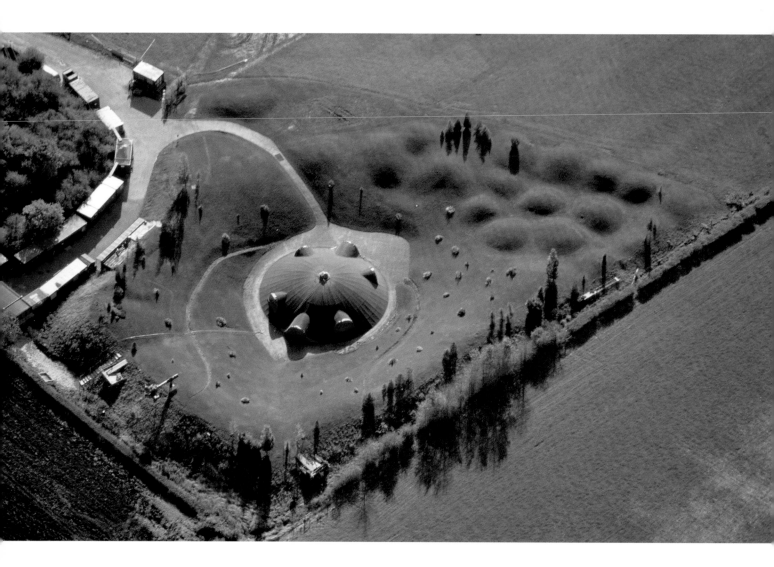

Teletubbyland, Warwickshire

The mythological fantasy land of *Teletubbies* (1997), devoid in reality of preternatural greenness and baby-faced sun, was embedded incongruously in Warwickshire farmland. Field boundaries were marked by hedgerows that shielded camera operators, tracks and multi-coloured bouncing beings before the field was ploughed back to farmland – as if the teletubbies had never actually existed.

The dawn of mass-production, hire-purchase, and the queen's coronation in 1953 hurried television ownership in England. Over half the population remotely followed the young queen along the streets of London and into the centre of church and government. Television became a myth-making factory that broadcast England back to itself.

Television popularised a rose-tinted version of an often un-industrial past and present, and demonised the ultra-urbanised bleak cityscape. The mass broadcast of the coronation and its symbolic images inspired the most iconic of television landscapes; *Coronation Street* (1960) was a line of seven terraced houses based on Archie Street, Ordsall (a Salford street that was eventually demolished). To counterbalance the small dimensions of the first set, actors had to walk slowly until an outdoor set was built in 1968 at the Granada Studios. The full-size set, built in 1982 of used Salford brick, became one of England's top tourist attractions.

Both *Corrie*'s Rover's Return and *Eastenders*' (1985) Queen Vic thrive, despite being Victorian pubs of the kind that suffered mass closures as leisure habits altered, and appeal to all inhabitants of 'the Street' and 'the Square'.

Brookside (1982), a 1980s Merseyside cul-de-sac, showed the changing living environment, its bland street sign reflecting the developer estate's commemoration of eradicated natural landscape features. This slice of suburban life, blighted by terrorist plots and religious cults, met its fictional end with a whimper – sold to an industrial waste company – though its houses lived on in *Hollyoaks* (1995) and its bar as *Grange Hill*'s (1978) student union, before the real-life houses of Brookside were sold as homes, as originally intended.

In another city, police battled with unnaturally high murder rates in *Inspector Morse* (1987), which twitched in a montage of photogenic Oxford college shots; a far cry from the smog-enveloped studio landscape of *Dixon of Dock Green* (1955).

Regional Tourist Boards sell simulations of themselves: a television tour of the Yorkshire Dales takes 'post-tourists' to the imagined event landscapes of Summer Wine Country and the nearby enclave of rural anarchy, *Emmerdale*.

Other, even more alien, landscapes haunt, as often familiar sites were disguised by clever camera angles and location ellipses. *The Avengers* (1961), *The Saint* (1962), *The Persuaders* (1971) all exploited the changing fortunes of country houses and decommissioned defence sites.

Where to see them:
Summer Wine Country, Holmfirth, West Yorkshire; Hollyoaks tour, Chester; Inspector Morse tours, Oxford; Emmerdale live webcam (www.itv.com)

PLEASURE

163

Theme Parks

'Amity Cove welcomes careful drivers' the fallen sign says, Americanisms conspicuous in the very English surrounding of paving and lawn. The cartoon ghost town hit by a tidal wave neighbours Calypso Quay, a pirate-infested town beneath a dormant volcano. Elsewhere, a beach is lapped by bright, fresh water at Neptune's Kingdom, and a ten-looped rollercoaster called Colossus navigates the Lost City. Isolated from the normal world by a water-filled gravel quarry, Thorpe Park is filled with miniature worlds comprised of fictional fantasy lands engrained in the psyche – Atlantis, Wild West, pirate enclaves – all adorned with death-defying variations on the rollercoaster.

English seaside amusements have a heritage of their own – still living at Blackpool's Pleasure Beach or Brighton's East Pier. Helter skelters and dippers vied for space with hand-driven carousels and travelling menageries, remnants of the Victorian age that had survived into pre-war Britain. Travelling amusements, fairs and circuses were the carnivals of English towns and villages in one form or other for centuries. Fond of short, sharp shocks and laughs, the English have always been fans of spectacle. Landowners keen to make money from their estates were quick to spot the opportunity and often acquired or rented machines and rides. In 1949, 86 acres at Drayton Manor, Staffordshire, opened to the public for picnicking and

other distractions. It advertised itself as a kind of inland seaside resort. After a booming Victorian era of firework and carousel spectaculars, Alton Towers, a Puginised former home of the earls of Shrewsbury, was stripped of all its assets including the lead lining of its roof. The post-war house had little to offer the public except a few show attractions in its landscaped grounds until 1980, when a new owner added a double corkscrew rollercoaster and visitors came in force.

At Belle Vue in Manchester, the successful zoo became host to a significant number of animal evacuees. Its peace-time operation, however, was funded and dwarfed by the fantastical showmanship of the site. Frequently, enclosure sizes were sacrificed to themed spectaculars such as Gunsmoke, the Wild West saloon, and paddocks were squeezed between rollercoasters. The link between animal exhibition and the thrill of the ride on a country estate is explicit at Chessington. Chessington Zoo had a pre-war history of performing monkeys and circus tricks; post-war it has expanded and claims success in the conservation of rare species. The zoo's Trail of the Kings – Gorilla and Big Cat Experience, neighbours the World of Adventure's sea lion shows. A monorail (Safari Skyway) hovers over themed zones – Pirate Cove, Mystic East – separated by clever planting and illusory landscaping, in keeping with the development of the country estate park.

Where to see them:
Chessington World of Adventure, Surrey (family theme park and zoo); Thorpe Park, Surrey (thrill-seeker capital of the UK); Alton Towers, Bedford-shire (cartoon Pugin and death-defying rides); Drayton Manor, Tamworth, Staffordshire (the original day out)

Thorpe Park, Surrey

Central Swimming Baths
from the Cathedral Church
of St Michael, Coventry

Swimming

Coventry's Brutalist cathedral is juxtaposed with its Central Baths (1966), a cathedral of glass that shone natural light onto sand-filtered water. Beneath an Olympian 55-yard pool (shortened by 110mm to 50m on metrification), the individual stainless-steel 'slipper baths' catered for those without such conveniences at home.

The 1944 Education Act listed swimming as an activity essential to children's development, but in cash-strapped post-war England swimmers improvised and councils economised. In 1950, a stretch of river at Water Eaton was set aside as a natural lido for the swimmers of Bletchley, Buckinghamshire. An island kiosk in the centre of the pool served swimmers with ice cream and tea.

But in the hot summers and blithe communalism of the 1950s, communities raised their own funds. At Bletchley, a purpose-built community- and council-funded outdoor pool opened in 1958. Other pools were built by rivers, as at Wallingford, or, building on pre-war popularity, next to the sea. In Worthing the pre-war bandstand was converted to a lido in 1959; in Portishead a cliff-top lido was built to overlook the sea in 1962. Sundecks and muscle beach platforms were the order of the Californian day.

For a time public baths, still an essential facility for many, continued to be integrated into the increasingly more sophisticated indoor leisure complex panoply, as at Coventry, but private bathrooms eventually conquered public provision.

The centrepiece of the Bletchley Leisure Centre, opened in 1974, waved in an era of fun. Set beneath a pyramidal glass prism, its iconic pool of curved, inter-linked kidney shapes accessed by steps and slides, advocated the fun side of swimming. The tide had turned on lane discipline.

Swindon developed the consumer experience of swimming and further divorced the swimmer from the outside world. The sundeck and open glass frontage (at Coventry and elsewhere) was forsaken for fantasy lagoons and wave machines beneath a domed space-frame. Even the name of the Oasis Leisure Centre (1976) guaranteed heated sun and fun all year round.

The exoticism of warm, blue water culminated in themed water parks dedicated to fun and fantasy. When 1980s Doncaster saw the systematic closure of its coal industry and associated business, a profitable and feel-good regenerative salve came about with the (coal-fired) Dome, opened in 1989. The aquatic experience included seven evocatively named lagoons including Amazonian Falls and Wild Water Rapids. At Bracknell's Coral Reef, those tired of the flume rides, rapids and erupting volcanoes could recover at the Coconut Grove cafeteria.

Where to see them:
Bletchley Leisure Centre, Milton Keynes (Louvre-style pyramid); Coventry Central Baths (glass cathedral in concrete sea); Oasis Leisure Centre, Swindon (domed lagoon – inspiration for the Gallagher brothers); Bracknell Coral Reef Water Park, Berkshire

Doncaster Dome

Leisure Centres

The success of the new towns and expanded towns of the 1960s and 1970s required an intrepid drive in leisure provision. When the former market town of Bletchley, Buckinghamshire, became home to thousands of overspill Londoners, the pitches of its Manor Fields did not conform to the new age of indoor precision and year-round exercise. Bletchley Leisure Centre opened in 1974. A raised walkway left maximum space for cars and linked sports hall, squash courts, bowling green and alley, pool, saunas, billiard room and cafeteria. It had a theatre too. The boundedness of Bletchley – its position on the edge of Bletchley and of Milton Keynes – located it in a car-driven society. Its cafeteria, like the bar at Rotherham's Herringthorpe Leisure Centre (1974), linked physical training with socialising but kept it within a single complex.

Bletchley Leisure Centre, Buckinghamshire

The Physical Training Act of 1937 extended the power of local authorities to provide facilities for physical recreation. The approaching war alerted government to the need for fit young people, but the end of compulsory education at age 14 challenged this provision. The post-war government's commitment to extending compulsory education went some way to improving the health of the nation, but more pressing commitments meant that it took longer to provide more general sports facilities.

The National Sports Centre at Crystal Palace – its flying roof and glass façade an echo of its predecessor on the site – was one of five centres designed to provide elite and competition-quality facilities to Britain's athletes. But sports elitism was not to dominate the recreational landscape. In the same year, Swiss Cottage Library and Baths, a London Borough of Camden initiative, opened to the public. A cigar-shaped library and angular pool complex with sundeck and sports hall designed by Basil Spence embodied the 'healthy body – healthy mind' requirement for the development of the muscular nation. The Teeside Billingham Forum (1967) went a step further, including a theatre in its complex. With striking architecture and capacious canopied roofs these complexes were central features of town development plans (at Swiss Cottage the only features of a vast plan to come to fruition). They firmly rooted the right to leisure into the English landscape and placed sport, swimming, drama, theatre and community literally under one roof.

The entrance of private business into the market saw the rapid rise of the leisure centre. In a society in which both disposable income and health-conscious individualism was increasing, public sports facilities and voluntary run sports teams did not always cater for all needs. The leisure centre has become an urban and suburban landscape feature: an ideal place for time-poor office workers to spend self-dictated units of time at known monthly cost. Leisure centres employ the multi-purpose 'supershed' architecture of their neighbours on industrial estates and business parks, an easy drive from home or office.

In 1987 the leisure complex as its own landscape reached its apogee in Center Parcs. The futurism of its geodesic domes was juxtaposed with a 'village' of lodges: the comfort of the holiday camp immersed in back-to-nature forest locations such as Sherwood. The company's commitment to woodland management balanced its recreational land use. Retractable roofs over subtropical water parks allowed visitors to be fully part of their 'natural' surroundings – provided it was warm – or to raft rapids with shores lined with hibiscus and palm trees.

Where to see them:
Bletchley Leisure Centre, Milton Keynes; Swiss Cottage, London; Billingham Forum, Stockton-on-Tees; out-of-town leisure complexes; in-town small gyms

Herringthorpe Leisure Centre, Rotherham

Sports Stadia

Football League grounds have shifted from cities to periurban industrial landscapes, where international-standard stadia blend with supersheds and car parks. The City of Manchester Stadium is a much-altered event landscape. Built in 2000 on the site of rundown mills and warehouses in Eastlands, a mile-and-a-half out of the city centre, the stadium was designed for Manchester's failed Olympic bid, built for the Commonwealth Games, and adapted (the race track was removed and the pitch sunk to make room for a third tier of terracing) to become Manchester City's home ground. Eastlands is home to other major sports venues – for track events and squash – and lucrative conference facilities, together known as SportCity. Its light materials – aluminium, steel, plastic – create a gleaming landscape of big boxes: containers of events. Inside the stadium the enclosed, vast all-seater oval is reached through smart gates and access halls. The lost racetrack is remembered in the shadow cast by the delicate hood. SportCity is a landscape of commercial and local sport, part of the out-of-town leisure landscapes of multiplexes and megabowls that exist without the city proper.

Eastlands is a far cry from the wooden stands and platform terraces that were still in place at the end of the Second World War. These extensions of the city streets – named for roads, areas and parks – have been replaced stand by stand, sometimes in entirety. New concrete bowls, as at Home Park, Plymouth, or stands, such as Highbury's North Stand, began to shift the concept of the ground towards the stadium.

A culture of localised violence developed in which off-pitch games included 'taking' the away fans' enclosure. Crowd disorder led to the installation of high wire fences around pitches and between enclosures to pen groups and prevent circulation. Although an electric fence installed at Chelsea in the 1980s was never used, surveillance requirements lent a sinister aspect to fandom.

The fatal fire in Bradford City's rickety wooden terraces in 1986 and the disastrous FA Cup clash at Hillsborough in 1989 spelt the end for standing terraces. Chelsea fan and prime minister, John Major, raided betting tariffs to help pay for the required seating, but the poor finances of many clubs led to an era of 'container' architecture. Cheap concrete and steel industrial units coated the sacred turf of clubs like Everton, while Walsall's uncompromising new stadium was sited in an industrial estate adjacent to the junction of the M5 and M6.

For larger clubs, seated stadia transformed the perceived grass-roots terraces to more comfortable enclosures. Executive boxes such as White Hart Lane's Shelf Terrace, allowed

Where to see them:
Town and city football grounds; the City of Manchester Stadium, Eastlands, Manchester; Stadium of Light, Sunderland; Roker Park Close, Midfield Drive, Monkwearmouth, Sunderland (commemorative street names in the housing estate that replaced Sunderland's old home ground); Highbury, North London (football lovers' flats)

Roy Keane's 'cucumber sandwiches' brigade to enjoy, at a price, a heated and catered theatrical view of the game.

The City of Manchester Stadium, Eastlands, Manchester

Greater comfort and the reduced threat of violence on the terraces have increased football's appeal to a wider range of fans, and increasing numbers of women and children now attend games. Meanwhile, features like exposed cantilevers and trusses and retractable roofs have lent an impressive architectural aspect to stadiums such as Eastlands.

Artificial Surfaces

Concrete, the all-purpose, low-cost material of the later 20th century, has its many detractors. Across England, unwelcoming rotting concrete – where water has penetrated the mix and rusted its metal supports – is a frequent emblem of urban decay. But young people have ad-libbed in these incongruous concrete wonderlands and urban sports have evolved as physical engagements with a white-elephant landscape. In recesses beneath London's South Bank skateboarders undermine the capital's cultural crown in an unofficial residence of contours, dips and troughs. Elsewhere, in the French free-running movement, Parkour, athletic and adventurous use is made of the rails, walls, concrete and spaces of the urban environment, outside supermarkets, shopping centres and housing estates.

From the late 1950s city estates largely comprised low-rise or high-rise blocks. Lack of provision for young people became a regular bugbear for residents and councils frequently addressed the problem by hardscaping rectangles of leftover land, on which hop-scotch, rings and goal mouths were painted in case children had forgotten how to play in the meantime. When basketball – a sport associated with the 'cool' urban youth of the US – hit English cities, courts of the required size and surface were easier and cheaper to provide than football fields or well manicured cricket pitches.

Where hard ground was needed, poor drainage caused problems in the cities, especially on London's dense clay subsoil, but artificial surfaces offered all-weather play areas. With the continued commercialisation of spare time (a product of the Victorian era) periods of sporting time could be bought – courts rented, pitches booked – and this revenue allowed councils to improve the quality of more lucrative outdoor play areas. Space was found off arterial roads and the artificial sports centre gained its place in the panoply of out-of-town complexes.

Scaling the concrete heights of London's Westway, one of the busiest stretches of road in England, a climbing wall reached up beneath the roadway. Westway Sports Centre entertains 2,000 visitors a week. The North Kensington Amenity Trust provided the boon to newly subterranean residents after the flyover was opened in 1970. From 1976, pay-and-play artificial football pitches and clay tennis courts appeared between the intersections of the White City roundabout. The success of the enterprise has been confirmed by the recent addition of a rare Eton Fives court, but travellers can still spot West London 5-a-side stars hard at play between road sections and, a little further on, a riding stables, calm beneath the busy roundabout.

Children playing outside a post-war housing development near Brockwell Park, Streatham, London

The remains of Beckton Alps, a former dry-ski slope on a former slagheap, Alpine Way, Beckton, East London

Skateboarders at London's
South Bank Centre

As cities morphed and infrastructure went underground, former industrial sites, often unfit for housing, could be opened up for leisure activities. In Beckton, East London, a gasworks slagheap opened as a dry-ski slope in 1989. Across England, former industrial sites offer planning permissions to leisure groups, as at Redcote Lane, Leeds, where a 5-a-side football complex nestles between the River Aire and the Leeds and Liverpool Canal, across the railway tracks from an electricity substation.

Where to see them:
South Bank Centre, London (theatre of skateboard); Westway Sports Centre, Crowthorne Road, London; Beckton Alps, Alpine Way, East Ham, London (former dry-ski slope); Goals Soccer Centre, Redcote Lane, off Kirkstall Road, Leeds; Soccer City, Benyon Park Way, Leeds (after-work 5-a-side emporium)

Golf Courses

Any urban golfer desirous of water obstacles might find nirvana in the Lee Valley. The WaterWorks Golf Complex, once the Essex filter beds, is now home to rare plants and wildfowl; a misfired ball might be lost in the radial beds or the River Lea itself, but a swift toddy supped in the lake's hide will restore all hope. Hemmed in on all sides by remnants of the area's industry the (compact) 18-hole course makes up in views for what it lacks in space.

Lee Valley Golf Course, London

The fairways, greens and roughs, and the wooded, boggy and sandy traps of England's hundreds of golf courses, evolved out of a game in which man, club and ball challenged the coarser elements of nature: heathland, commons, dunes, heather and gorse. Traditionally associated with Scottish aristocrats, golf was an aspirational sport that signified wealth. The post-war rise in affluence and delineated periods of free time (weekends, evenings), together with the avid study of American leisure trends, encouraged the bulging middle classes to take to the greens.

With redundant industrial land or 'unused' parkland to hand, and the perception of golf as a lucrative land use, many councils laid out municipal golf courses in the 1960s and 1970s. A counterpane of stripes and ovoid patches was draped over parks, battlefields and even world heritage sites, rutted by trolleys and the march of caddies. Hedges, trees and water hazards became the new sporting foe. At the other end of the market, golf remained intimately linked with the tradition of 'landscape' as nature created by man, which had been the basis of the aristocratic estate from the 17th century onwards. Many of these estates were redesigned in the pursuit of golf, and historic houses became country clubs, as at Hanbury Manor in Hertfordshire.

A second, and torrential, wave of course construction came in the late 1980s after the Royal and Ancient Golf Club of St Andrews (golf's governing body) announced an unfulfilled demand. Courses mushroomed, particularly in the south-east, as landfill and brownfield were turfed and dressed up, but many courses were condemned without trial as boring by old-school golfers and remain under-used. Almost 1% of Britain's landscape is given over to golf.

In the 1990s, golf courses were identified as pilferers and polluters of water supplies. The ensuing clean-up saw course designers and managers join forces with conservationists to create in-course reserves for wildlife and plants. For the golfer, these features offered diverse and interesting terrain and countered the reputations that many post-war efforts had acquired; the good walk ruined was enhanced. But England has yet to fully embed golf into its cultural landscape. Although the perennial seaside pastime of mini-golf became a recognised sport in the 1960s, Britain has still to offer the international circuit an official venue that conforms to the authorised design of the World Minigolf Sports Federation.

Where to see them:
Water Works Golf Complex (good filter beds ruined); Lee Valley Golf Course (river- and sewage works-side, lake-centred Jacobs-designed 18-hole course); Feltwell Golf Course, Feltwell, Norfolk (former THOR nuclear missile launch site); Chapel-en-le-Frith Golf Course (valley floor, High Peak views)

WaterWorks Golf Complex, Lea Valley, London

Cultural Centres

On the banks of the River Thames – the capital's gateway to the rest of the world – cultural celebration, departure from war and the arrival of a global future was announced through the Festival of Britain. The Lion's Brewery site was torn down and the Royal Festival Hall erected in its place. The Dome of Discovery became an iconic microcosm of the world. A flagged walkway was laid along the still-working river and the space filled with cultural exhibits, sculpture and performances. Gradually the site was extended through the Hayward Gallery, the National Theatre, and the small, dynamic and ergonomic Kino of 1951 (an early incarnation of the National Film Theatre), all linked by elevated concrete walkways. The South Bank Centre became an integrated arts complex that looked forward to the future of culture as a permanent fixture.

Gateshead Millennium Bridge and the Baltic Centre

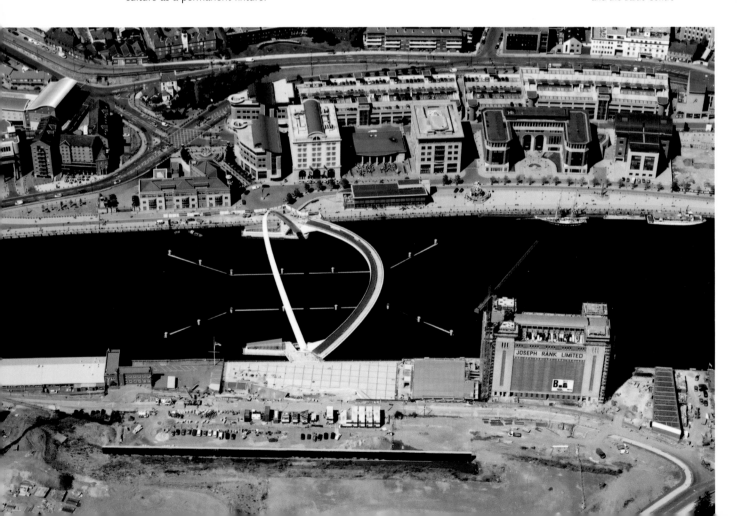

The Phoenix Arts Centre,
Leicester

Across the country, this approach to art began to leak into local plans. The formation of the
Arts Council as a government-funded but independent arts body infused the cultural boom.
New town centres were incomplete without a complex that brought art and theatre to the
centre of community, and often tied it to other infrastructure such as the town hall, sports
hall and library. These complexes used modern materials and designs and became daring
suggestions that cultural life was essential to everyone's well being. Far from being lofty
plans, they offered affordable access to the arts in the heart of town.

Typically, however, the great housing drive of the 1950s was not matched by amenity
provision until much later. At Billingham, Teesside, erstwhile home of the sizzling and
bubbling factories of ICI, the residential estates that had doubled the size of the town were

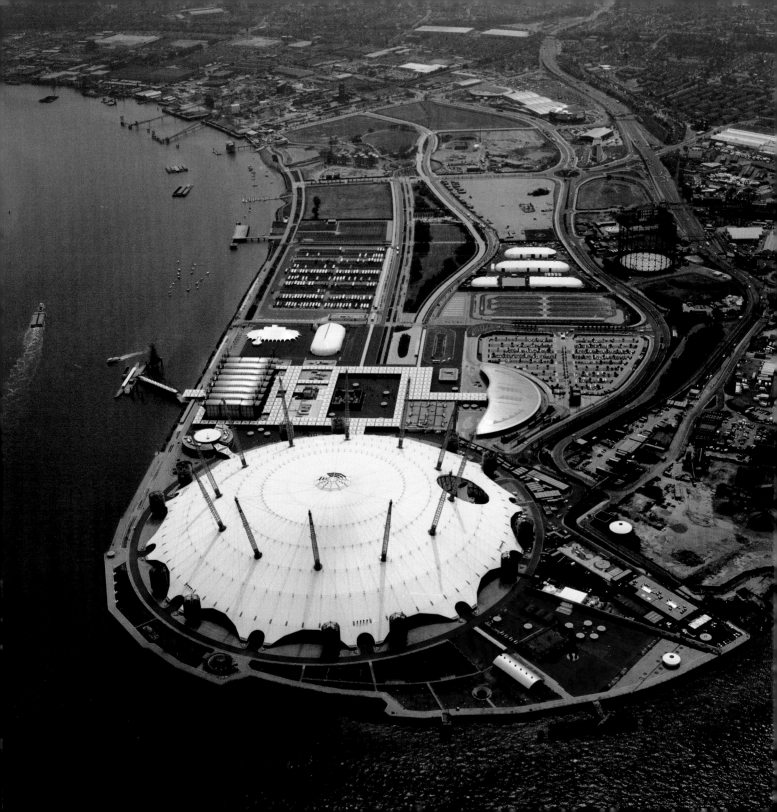

eventually rewarded with the Billingham Forum in 1967. The centrepiece of the new town centre, the Forum provided food for the soul and body – sport, theatre, community meeting space and library – all under one roof. Likewise at Wythenshawe (intended in the 1930s to be Manchester's garden suburb) where the Forum was not built until 1971 when the town's projected population of 90,000 had already been exceeded. There were problems at London's flagship complex too, which were reflected across the country; the early post-war promise for reconstructed cultural England was the first to be strangled by funding cuts. Both Wythenshawe (a red-brick block atop low-rise steel cladding) and Billingham (a similar imposing concrete-and-steel affair) suffered from 1980s funding cuts. In Leicester, the council's 1963 theatre was forced to close in 1987.

The end-of-century resurrection was driven by a renewed recognition of culture as a necessity for urban life. A government sympathetic to the arts and more incentive for private donors has led to greater arts provision, often daubed in the liveries of commercial sponsorship but as often driven by community and charity. Leicester's Phoenix, risen from the ashes in 1988 due to the intervention of the Polytechnic, offers an innovative and energetic mix of cinema, theatre, film and dance.

In an attempt to repeat the success of the Festival of Britain and to herald an era of growth and regeneration, New Labour commissioned the Millennium Dome, a vast white membrane descended from the Dome of Discovery, pegged to a promontory of industrial wasteland and flood-prone marsh, again on the south bank of the Thames. The Dome, beset by latecomings, shortcomings, and a cynical press pack, became a national joke and the capital's largest white elephant, despite a plug of James Bond cool and a purpose-built tube extension. Its cultural credentials seemed set at half-mast, neither high enough to attain the respect that the South Bank achieved nor popular enough to achieve the attendance figures of other, more adrenalin-fuelled, days out. Elsewhere, the transformation of industrial landscapes into cultural complexes involved the conversion of large spaces abandoned by industry, such as the former Baltic Flour Mill in Gateshead, into centres for contemporary arts; or the Arnolfini and the Watershed – arts and film centres in former warehouses that transformed Bristol's harbourside into an area dominated by the creative arts.

Since the turn of the century, both Wythenshawe (with a total refurbishment and facelift) and Billingham (its theatre given listed status and an ice rink added) have been saved to weather another century's arts funding.

Where to see them:
Wythenshawe Forum, Greater Manchester; Huddersfield Civic Centre (three of them); Billingham Forum, Stockton-on-Tees; riverside arts complex (Baltic, SAGE), Gateshead; Phoenix Arts Centre, Newarke Road (soon to be re-housed), Leicester; Bristol's Floating Harbour

Art and Place

On the A1 at Gateshead, or from the east-coast mainline, there is no mistaking the enormity of hope and pride encapsulated in the *Angel of the North*. In *Another Place*, the movement of Antony Gormley's travelling artwork – from Norway and Belgium en route to New York – has permanently stopped its westward journey and 100 iron men remain embedded in the seascape of Crosby near Liverpool. The artist describes the installation as 'a kind of acupuncture of the landscape': canvases, as the sea often is, for the transference of the thoughts and observations of the onlooker.

Although art for edification's sake had been incised on England's landscape for centuries in the form of architectural carvings and statuary, the ethos of socialistic endeavours meant public artworks became the centre-piece of the neat grassy space archetypal of post-war development. New town development corporations commissioned artists like Lynn Chadwick, Barbara Hepworth and Henry Moore to create uplifting and spirited statements that were rounded, questioning, elemental forms in a landscape of blocks and angles. Moore's *Family Group* became the heartstone of Harlow's town centre.

Comprehensive and distinctive, William Reid-Dick's equestrian *Lady Godiva* (1949) and Jacob Epstein's *St Michael's Victory over the Devil* (mounted on the new cathedral in 1960) symbolised Coventry's recovery from the Blitz. *Lady Godiva* was raised in a cleared square and stood, upright, as Coventry's post-war shape evolved around her. Now covered by a canopy, her square curtailed by a 1990s shopping centre, *Lady Godiva* joins the slender ranks of England's listed post-war statuary.

In the industrial New Town of Peterlee, the more ambitious and less figurative Apollo Pavilion (1970) by Victor Pasmore highlighted landscape as a bridge between indoors and outdoors. The angled concrete form spanned a lake, a place for lingering and playing. Inevitably, the pavilion appealed to the disenfranchised young, and was left to rot. Finally its steps were removed. Moore's *Family Group* was retired indoors, away from vandals and the weather. However, art's rebirth stemmed from its ability to 'speak' the landscape, to show its grain and explore memories. The abstraction of post-war public art gave way to private and publicly funded site-specific comments on place. Works such as David Mach's *Train* (1997) – a brick working of the Mallard locomotive at a supermarket close to the former Stockton–Darlington railway – were popular narratives of civic pride in former industrial areas. Guerilla art, graffiti works by artists such as Banksy, as well as the unsung taggers of the city, took on artful nuances and became popular with locals and critics alike but – alongside other controversial

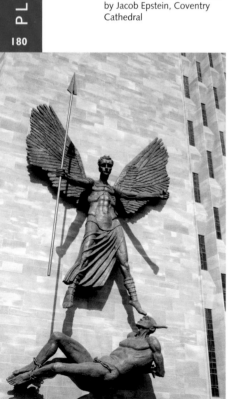

St Michael Defeats the Devil, by Jacob Epstein, Coventry Cathedral

works – not with the authorities. In Crosby, Antony Gormley's 100 sea-gazing iron men fought to keep their place in the Merseyside seascape.

Meanwhile, in Trafalgar Square, the 'fourth plinth' became a barometer of post-modern statuary: a waxwork of David Beckham; perspex bird houses; *Alison Lapper, Pregnant*; and a transparent resin cast of the plinth itself, all caused consternation in traditionalists and delight in the capital's quirk-followers.

Another Place, Crosby Beach, Liverpool

Where to see them:
Another Place, Crosby Beach, Liverpool; Harlow new town (sculpture capital); Yorkshire Sculpture Park, West Bretton, Wakefield (500 acres of sculpture-populated 18th-century parkland); fourth plinth, Trafalgar Square, London (public art zeitgeist); *Willow Man*, the M5 at Bridgwater, Somerset (Serena De Le Hey's 'Angel of the South' bent out of the industrious twigs of Somerset's flatlands)

Holiday Camps

The heyday of Pontin's holiday camps was also their waning. Pontin's Southport opened in 1970, unusually built on unused land in the dunes beyond Ainsdale Beach in Southport, Lancashire. The army barracks that had provided the basis for the original Pontin's camps heavily influenced the new design of 700 breezeblock chalet blocks arranged in circles, which became known to the locals as Colditz due to its resemblance to another form of camp. A mini racecourse near the entrance vies with crazy golf, while a large multi-purpose block houses indoor activities – a pool, bar games, arcade machines, a pub-restaurant and, inspired by the moon landing, the Lunar Bar. Self-contained, with all facilities onsite – an all-inclusive holiday experience for adults and children alike – the circular form assumes a defensible aspect that excludes outsiders and fences in residents. The Bluecoats who used to provide a warm welcome at the gate have been replaced by security guards.

Fairground man turned holiday entrepreneur, Billy Butlin, was co-opted by the wartime government to help improve the morale of female munitions workers billeted in a camp in Oxfordshire. Coloured paint and a weekly dance did the trick, and the format for the post-war camps was set. Butlin and Pontin bought up military camps and admitted a holidaying public and instead of a barbed-wire checkpoint, a smiling Redcoat welcomed all comers at the pink gates.

The known (the camp) and the unknown (the exotic) were fused with dripping glitter and gold, explosions of colour and bars named Fantasia and Lunar. Campers ingested the illusion, even when the lights were up and the paint had begun to crack. The enclosed space of the camp provided the 'otherness' that holidays need, away from the workday (but still ruled by the clock). Inside the camp walls the foremen and women – good-looking and approachable – happily sat down for a drink and a chat at the end of the day.

In 1960, Butlin's flagship camp at Bognor was a departure, with two-storey concrete accommodation blocks housing up to 2,000 people per week. Butlin sold his interests in the cheap arcades of the town to satisfy objections, but the giant stuccoed walls of the holiday camp nevertheless permanently altered the town's status. Uneconomic and expensive to refurbish, the big camps declined in the face of the Mediterranean and its guaranteed sun. Increased mobility, even in family life, has condemned the bigger camps to the stag weekend, oblivious to the all-in attitude of wartime or the sheer novelty of paid holidays and the 'week off work'. All the big-name camps have been taken over by investment companies. Refurbishment has once again changed the Bognor beachfront with the white peaks and all-year-round entertainment of the Skyline Pavilion.

Where to see them:
Pontin's Southport (Colditz of the north-west); Butlin's Bognor Regis (refurbished Southcoast World); Perran Sands Holiday Village, Perranporth, Cornwall (self-contained site safeguarding lost church of St Piran in the Sands)

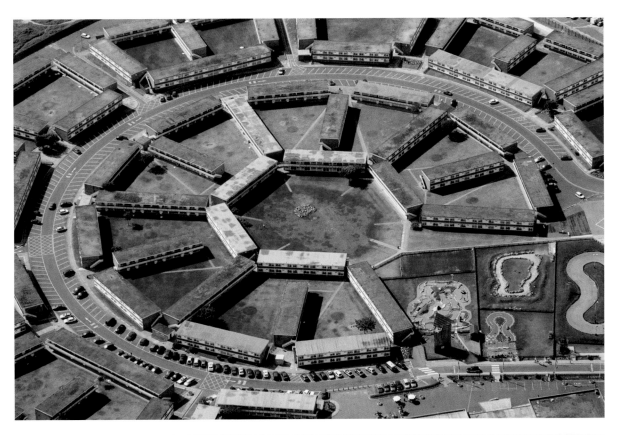

Pontins, Southport

Timber Vale Caravan Park,
Lyme Regis, Dorset

The Seaside

At the turn of the 19th century the harbour village of Newquay could still hear the cry raised from a whitewashed hut above, on Towan Head, when the pilchards were spotted offshore. At the turn of the 20th century, the town has built a new mythology under the cry of 'surf's up!' Seven miles of Atlantic beach, carved and warmed by the gulf stream, heave with tourism's success. Surf schools seduce tired city dwellers to the ends of the country, often along the former line of a mineral railway, to experience a little of nature's vigour and a lot of the traditional tack of the seaside town. Newquay's status as a resort town grew steadily in the first half of the 20th century and boomed in the second, as new estates expanded its boundaries south and eastwards. With international surf events and the annual Volkswagen avalanche that arrives with the Run to the Sun weekend, Newquay has survived centuries of changing industry intact.

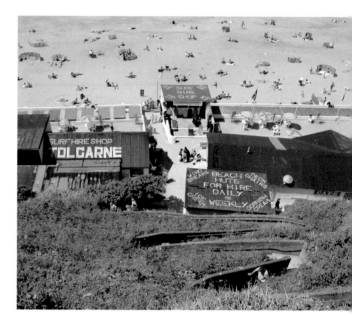

Tolcarne Beach, Newquay, Cornwall

Holidaymaking in England declined steeply from the mid-1970s to the mid-1980s, when England's day-trippers forsook crumbling piers, arcade-strewn promenades, miniature train tracks, peeling crazy golf, the detritus of fast-food stands and underused ballrooms. Rain-soaked families no longer wanted the B&B, closed between breakfast and tea. *This is the coastal town that they forgot to shut down*, Morrissey sang of the former middle-class resort of Southport, with an invitation to share greased tea and await the nuclear bomb. New Brighton died and England's holiday landscape moved abroad. The first package tour left for Corsica in 1950 and holidaymakers basked in guaranteed sun, cheap beer, and smart self-catering apartments. Sun-seeking migrant workers and cheap developments allowed the Costa del Sol to outshine chintzy family-run English resorts.

While expansive low-cost housing estates sprawled out from towns like Worthing and Bexhill in Sussex, other towns chose to reinvigorate the tourism trail: St Ives in Cornwall successfully trades on its artistic connections, while Whitby in Yorkshire thrives on Dracula.

The car and the caravan invented self catering. The privacy of static caravans within a self-sufficient fenced site, such as Perran Sands Holiday Village in the dunes at Perranporth,

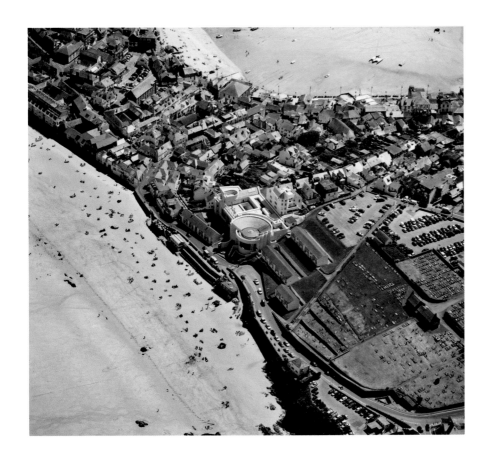

Tate St Ives, on the site of a former gasholder, Cornwall

became a neat, familiar site, sprinkled across the coastal edges of England. It was replicated upmarket by holiday lets–a remote cottage in Cornwall or the Lake District had the appeal of privacy, fridges and freedom–and was part of a new movement in taste: the country kitchen and back-to-basics lifestyle. Low house prices offset against high city wages created seasonal ghost towns, as properties were bought up as second homes and lay vacant for much of the year.

But the 1990s reinvented the seaside for the young: an affordable and accessible landscape in which to see and be seen. Brighton's all-embracing queer identity and Newquay's beach-bleached surfers reinvented the Californian body beautiful for Cool Britannia, worthy successors to the mods and rockers who battled over the beaches of the south coast in 1964. Young England reconnected with seaside kitsch. More sophisticated attractions, seaworlds and sports centres, beach volley courts and Jamie Oliver restaurants, are testament to the undying lure of the seaside. In the new millennium California comes to Brighton.

Where to see them:
Newquay, Cornwall (surf city); Brighton, Sussex (Regency to 'Naughties camp and cool); Whitby, North Yorkshire (seaside Gothic allure); Dungeness, Romney Marsh, Kent (shingle beach, Derek Jarman's cottage, nuclear power station)

Afterword

Janet Miller

Sex was invented in 1963, according to Philip Larkin and, I guess, that was a good thing. Of course the late 20th century couldn't take a patent out on the act itself. Just the attitude.

The point about archaeology isn't to dig up or even discover things; these are just means to an end. What archaeologists do is look at people's stuff and think about it. We try to say something enlightening about how people live and work and think, through looking at how they design and use their pots, houses, spaces and landscapes. So an archaeologist, like an artist or an historian, never simply describes. With a varying mixture of our own world view and attempts at professional dispassion, we analyse, create and present. Then we try to persuade others to look at things in an archaeological way too. Most of the time, because we are dealing with times and people that are long gone and of which we have no direct experience, we have to work back from the often limited stuff that we find to think about past beliefs and attitudes. The great thing about looking at the late 20th century from a landscape-archaeology perspective is that we can reverse the usual process. We can ask, of ourselves and others, what characterised life in late 20th-century England and then see how it is expressed in the landscape. There are plenty of people to ask and plenty of landscapes to see.

Let's not forget that the late 20th century, like any other era, was itself a journey. On any trip it's hard to make sense of the landscape as you pass through it. It is difficult to categorise it or carve it into chapters. As we travelled through the last half century we carried our baggage, dropped some things along the way, sent back for forgotten valuables, phoned home now and then, and arrived with part of us still back at home and part of us already planning the next trip. The landscapes that we read about in this book – the features and elements retained from earlier times as well as the new creations – are all physical manifestations of this journey, the twists and turns in attitudes, beliefs and values. We can see the collective sigh of post-war relief in the welfare state hospitals, housing and schools; confidence in the plate-glass universities; relations with other countries in Cold War compounds; an urge to curate for future generations in World Heritage Sites and fenced-off natural habitats; ingratitude in the landfill disposal sites; as well as individualism in urban back-garden fences which – almost universally – have risen over the last 50 years from three to six feet high.

The defining characteristics of the late 20th century might include the rapidity of the journey and the bell curve in fortune. Historically, the two post-war generations may be regarded as

the most blessed in many, many a century. They – we – prospered, were loved and cared for by the State throughout extended lives and were unashamed in displaying self love through conspicuous consumption. Before the end of the century the bells began to toll; the pollution, the congestion, the climate change, the obesity. It's tempting to speak of how features and places were characterised by optimism at the beginning of the period, only to end the century in decay, anonymity, commercial cynicism or nostalgic buffoonery. But is this all there is to say about the paths taken towards the new millennium? Would we enlighten anyone, encourage anyone to think in an archaeological way, if we let our 21st-century jealousy of the blessed generations lead us to uncritical pessimism about our past? The fact is, in every age there has been cheap architecture, cold and faceless spaces, excluding monuments and exploiting workplaces. Conflict between rich and poor, State and individual, and the uneasy negotiation between tradition and modernity have always been played out in our landscapes and townscapes. Every period has and will have its dark side, its self delusion and its failure to realise its lofty ideals. The landscape at the end of the 20th century does not reflect a collective sickness or badness, any more than would any other panoramic snapshot of another time. It simply reflects what the times were. We should simply reflect on what the times were.

Take shopping. For archaeologists, shopping is a thing which is never discussed. As members of the bookish segment of the middle classes we must share in the fashionable disdain. We must groan and raise our eyes skyward when someone demands a trip to the mall and we must express proudly our pitying contempt for the drones who travel simply to browse and buy. We think we are immune and we delude ourselves that our shelves of books, cameras and hand-thrown moss-coloured true-to-the-material stoneware mugs are not patterns of consumption, not reflections of our desire for status. Yet, as we tell others, all our material culture – landscapes as well as artefacts – is but a reflection of ourselves and our attitudes, our relationships, values, aspirations, conflicts and negotiations. And at the mall, the very things we would want to study and reflect on about any period or time are brought together and laid out, like wares for all to see: trade routes, technology, building styles, food consumption, domestic and ritual material culture, coinage, discard patterns, kinship arrangements, social stratification and the conflict between public and private space. Handy for archaeologists. Handy for encouraging others to think in an archaeological way. So instead of condemning shopping malls as unpleasant newcomers to the landscape, I suggest we should celebrate them, even see them as places where people are at their best. Because they are one of the places where modern people are at their most honest and self-knowing.

188

The Trafford Centre,
Manchester

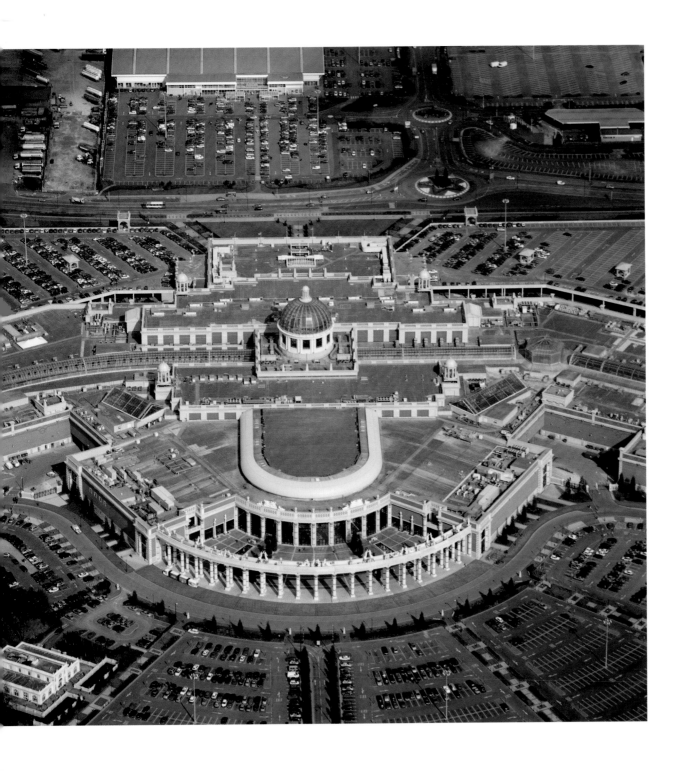

189

It is when shopping in the bright, interior-designed lights, that the relationship between our vanities and aspirations and our material culture is crystal clear.

The question is, is there anything that helped to define late 20th-century life that isn't reflected in the landscape? Perhaps it is the most basic, all-pervasive and most significant of things: personal relationships – the family, gender relations, sex. The shape and composition of the family has certainly changed in 50 years. It is smaller and undoubtedly more fluid and less dependant on marriage. Certainly, this might just be discernable in the two-up-two-down starter homes of our estates and infills, but some Victorian and Georgian workers' terraces were also very tiny. What about the transformed life experiences of women and the progress towards equality with men in the workplace and at home? The progress might not be as rapid as some would like, but few would deny the significant shift between 1950 and the year 2000 and its wide consequences. These changes seem to be even less visible in our buildings and spaces. And sex. Without a doubt, the average late 20th-century English person has more, and more varied, partners, and talks about it more, than someone of the 1950s. It's a good thing. It reflects an attitude characteristic of current modernity, certainly when compared with the mid-20th century. It is tolerance of difference, in sexuality and other lifestyles. Yet, other than the shopfronts of Soho in London (which is anyway already becoming gentrified), this most fundamental of changes, which affects almost everyone in modern society, has virtually no material expression in the landscape. But perhaps there is one last surprise. When we look at the biggest and most modern of landscapes – the internet – with its invisible superhighways carrying traffic and communications across all terrains, what do we find? We find that most transactions are about retail, pornography and dating.

So, late 20th century, sex and shopping, perhaps, is what you were. At your best. Come to think of it, if I'm on, say, a bus journey through the landscape of New England next to the driver who has just given the usual long American 'wow' after learning that I'm an archaeologist from Britland, and he asks me what my favourite archaeological site is, I always say 'Harvey Nick's darling! Every time'.

Further reading

Dan Hicks

The reader wanting to explore further the material introduced in this book can turn to a wide range of other studies. Work in historical and cultural geography provides much inspiration: David Matless' landmark study of *Landscape and Englishness* in the 20th century is an excellent point of departure, while Dolores Hayden's *Field Guide to Sprawl* provides a stunning, alphabetical journey around the built environment of later 20th-century America. There is also, however, a fast-growing body of archaeological studies of the recent past, both in the United Kingdom and around the world. Much of the archaeological work has been pioneered by industrial archaeologists, and Michael Stratton and Barrie Trinder's book *Twentieth Century Industrial Archaeology* provides a good introduction. Beyond industrial archaeology, a range of studies of 20th-century material have been carried out in Australia and the United States over the past 30 years, most notably in William Hampton Adams' excavations of the town of Silcott in Washington State during the 1970s. Scientific archaeologists increasingly work on 20th- and 21st-century material with the development of forensic archaeology. The great potential of the archaeological study of the recent past has led to a growing range of archaeological approaches, summarised by Victor Buchli and Gavin Lucas in their collection *Archaeologies of the Contemporary Past*, and more recently in *The Cambridge Companion to Historical Archaeology*. In the United Kingdom a wide range of continuing education and postgraduate courses now introduce the field of historical archaeology.

Beyond archaeology and geography, sociologists, artists, writers and many others have increasingly found inspiration in the material remains of the recent past. Here, clearly, any further reading will be led by the reader's particular interests in the 20th century, but can be guided by a first-hand engagement with these landscapes. Indeed, the way in which walking, visiting or studying the relict landscapes of the 20th century brings multiple readings of the recent past is the central argument of the present volume. The book challenges us to think through the idea of treating these landscapes as heritage: to seek them out and explore and study them; to debate their values as archaeological and historical resources; and to consider how they can reorient our vision of 'English heritage'. In beginning this task, *Images of Change* underlines how the value of the landscapes of England's recent past – perhaps like all archaeological heritage – lies in their role as contemporary places from which we can tell a diversity of stories.

Further reading

General

Adams, W H 1977 *Silcott, Washington: Ethnoarchaeology of a rural American community.* Pullman, WA: Laboratory of Archaeology, Washington State University (Reports of Investigations **54**)

Beaudry, M C 2007 'Historical Archaeology with Canon on the Side, Please' in L McAtackney, M Palus and A Piccini (eds) *Contemporary and Historical Archaeology in Theory: Papers from the CHAT 2003 and CHAT 2004 Conferences.* Oxford: Archaeopress (Studies in Contemporary and Historical Archaeology **4**)

Bradley, A, Buchli, V, Fairclough, G, Hicks, D, Miller J and Schofield, J 2004 *Change and Creation: Historic Landscape Character, 1950–-2000.* London: English Heritage.

Buchli, V and Lucas, G (eds) 2001 *Archaeologies of the Contemporary Past.* London: Routledge

Cossons, N (ed) 2000 *Perspectives on Industrial Archaeology.* London: Science Museum

Hall, M and Silliman, S 2006 *Historical Archaeology.* Oxford: Blackwell.

Hawkes, J 1951 *A Land.* London: Cresset Press

Hayden, D (with aerial photographs by Jim Wark) 2004 *A Field Guide to Sprawl.* New York: W W Norton

Hicks, D and Beaudry, M C (eds) 2006 *The Cambridge Companion to Historical Archaeology.* Cambridge: Cambridge University Press

Hicks, D 2007 'Historical Archaeology in Britain' in D Pearsall (ed) *Encyclopedia of Archaeology.* London: Elsevier

Jones, D (ed) 2002 *Twentieth-century heritage: our recent cultural legacy.* Proceedings of the Australia ICOMOS National Conference 2001 School of Architecture, Landscape Architecture and Urban Design, University of Adelaide, and Australia ICOMOS Secretariat

Matless, D 1998 *Landscape and Englishness.* London: Reaktion

Muir, R 1981 *The Shell Guide to Reading the Landscape.* London: Michael Joseph

Muir, R 1998 Reading the Landscape, Rejecting the Present. Landscape Research **23**(1), 71–82

Rowley, T 2006 *The English Landscape in the 20th Century.* London: Hambledon Continuum

Stratton, M and Trinder, B 2000 *Twentieth Century Industrial Archaeology.* London: Spon Press

People

Addison, P and Jones, Harriet (eds) 2005 *A Companion to Contemporary Britain 1939–2000*. Oxford: Blackwells

Cherry, Gordon E 1996 *Town Planning in Britain Since 1900*. Oxford: Blackwells

Cresswell, Tim 2004 *Place: A short introduction*. Oxford: Blackwell

Gilbert, David, Matless, David and Short, Brian (eds) 1998 *Geographies of British Modernity: Space and Society in the Twentieth Century*. Oxford: Blackwell

Matless, D 1998 *Landscape and Englishness*. London: Routledge

Pile, Stephen and Thrift, Nigel (eds) 2000 *City A–Z*. London: Routledge

Pile, Stephen and Thrift, Nigel (eds) 1995 *Mapping the Subject: geographies of transformation*. London: Routledge

Relph, Edward 1987 *The Modern Urban Landscape*. Beckenham: Croom Helm

Tuan, Yi-Fu 1991 'Language and the Making of Place: A Narrative-Descriptive Approach', *Annals of the Association of American Geographers* **81**(4)

Waller, Philip (ed) 2000 *The English Urban Landscape*. Oxford: OUP

Politics

Gold, John R 1997 *The Experience of Modernism: Modern architecture and the future city 1928–1953*. London: E&F Spon

Gladstone, David 1999 *The Twentieth-Century Welfare State*. Basingstoke: Macmillan

Gorst, Thom 1995 *The Buildings Around Us*. London: E&F Spon

Marwick, Arthur 2003 *British Culture Since 1945*. London: Penguin

Smith, Adam T 2003 *The Political Landscape Constellation of Authority in Early Complex Polities*. London: University of California Press

Profit

Barrett, Anthony and Scruton, Roger (eds) 1998 *Town and Country*. London: Jonathan Cape

Hayes, Brian 2005 *Infrastructure: A Field Guide to the Industrial Landscape*. New York: W W Norton & Co

Pleasure

Gershuny, Jonathan and Fisher, Kimberly 2000 'Leisure' in Halsey, A H with Webb, J (ed) *Twentieth-Century British Social Trends*. London: Macmillan Publishers 3 edn

Hill, Jeffrey 2002 *Sport, Leisure and Culture in Twentieth-Century Britain*. Basingstoke: Palgrave

Bibliography

People

Appleby, Sam 1990 'Crawley: A Space Mythology' in *New Formations* **11**, Summer 1990, 19–45

Clapson, Mark 2004 *A Social History of Milton Keynes: Middle England Edge City*. London: Cass

Davies, Colin 2005 *The Prefabricated Home*. London: Reaktion

Davies, Colin 2004 'The British Airport at the Turn of the Century' in Holder, Julian and Parissien, Steven (eds) *The Architecture of British Transport in the 20th Century*. London: Yale UP, 133–58

Edwards, Brian 1997 *The Modern Station: New approaches to railway architecture*. London: E&F Spon

Glendenning, Miles and Muthesius, Stefan 1994 *Tower Block: Modern Public Housing in England, Scotland, Wales and Northern Ireland*. London: Yale UP

Harwood, Elain and Power, Alan (eds) 2002 *The Sixties – Twentieth Century Architecture 6: life:style:architecture*. London: The Twentieth Century Society

Holder, Julian and Parissien, Steven 2004 *The Architecture of British Transport in the 20th Century*. London: Yale UP

Lawrence, David 1999 *Always a Welcome: the glove compartment history of the motorway service area*. Twickenham: Between Books, 219–44

Matless, David and Short, Brian (eds) 1998 *Geographies of British Modernity: Space and Society in the Twentieth Century*. Oxford: Blackwell

Merriman, Peter 1998 '"A Power for Good and Evil": Geographies of the M1 in Late Fifties Britain' in Gilbert, David, Matless, David and Short, Brian (eds) *Geographies of British Modernity: Space and Society in the Twentieth Century*. Oxford: Blackwell, 115–131

Naylor, Simon and Ryan, James R 1998 'Mosques, Temples and Gurdwaras: New Sites of Religion in Twentieth-Century Britain' in Gilbert, David, Matless, David and Short, Brian (eds) *Geographies of British Modernity: Space and Society in the Twentieth Century*. Oxford: Blackwell

Pascoe, David 2001 *Airspaces*. London: Reaktion

Ravetz, Alison 2001 *Council Housing and Culture: the History of a Social Experiment*. London: Routledge

Shaw, Frederick 1985 *The Homes and Homeless of Postwar Britain*. Totowa, New Jersey: Barnes & Noble

Stevenson, Greg 2003 *Palaces for the People/ prefabs in post-war Britain*. London: Batsford

Vale, Brenda 1995 *Prefabs: A History of the UK Temporary Housing Program*. London: E&F Spon

Watson, Sophie with Armstrong, Helen 1986 *Housing and Homelessness: A Feminist Perspective*. London: Routledge & Kegan Paul

Webster, Roger (ed) 2000 *Expanding Suburbia: Reviewing Suburban Narratives*. London: Berghahn Books

www.c20society.org.uk/docs/casework/pasmore.html (Peterlee)
Accessed 07/06/2007

www.bbc.co.uk/legacies/heritage/england/birmingham/article_2.shtml (Spaghetti Junction)
Accessed 04/04/2006

195

www.carparkstars.co.uk (Car Parks)
Accessed 04/04/2006

www.cbrd.co.uk (Roads)
Accessed 04/04/2006

www.croydon-tramlink.co.uk (Croydon Tramlink)
Accessed 04/04/2006

www.dft.gov.uktranstat (Transport)
Accessed 04/04/2006

www.msatrivia.co.uk (Motorway Service Stations)
Accessed 04/04/2006

www.peterlee.gov.uk/about/ (Peterlee)
Accessed 06/06/2007

Politics

Brodie, Allan, Croom, Jane and Davies, James O 2002 *English Prisons: An Architectural History*. Swindon: English Heritage

Cocroft W D and Thomas, R J C 2004 *Cold war: building for nuclear confrontation*. London: English Heritage

Francis, Susan, Glanville, Rosemary, Noble, Ann and Seher, Peter 1999 *50 Years of Ideas in Health Care Buildings*. London: The Nuffield Trust

Grainger, Hilary J 2005 *Death Redesigned: British Crematoria: History, Architecture and Landscape*. Reading: Spire Books

James, W Paul and Tatton-Brown, William 1986 *Hospitals; Design and Development*. London: The Architectural Press

Jetts, Tony 1998 *Henry Morris's Village Colleges, Community Education and the Ideal Order*. Nottingham: Educational Heretics Press

Jones, Kathleen 1993 *Asylums and After: A Revised History of the Mental Health Service from the Early 18th Century to the 1990s*. London: The Athlone Press

Jupp, Peter C and Gittings, Clare 1999 *Death in England: An Illustrated History*. Manchester: Manchester University Press

Saint, Andrew 1987 *Towards a Social Architecture: The Role of School-Building in Post-War England*. London: Yale University Press

Schofield, J (with contributors) 2004 *Modern military matters: studying and managing the twentieth-century defence heritage in Britain – a discussion document*. London: Council for British Archaeology

Thompson, John D and Goldin, Grace *The Hospital: A Social and Architectural History*. London: Yale University Press

Profit

AlNaib, S K, nd, *London Water Heritage*. London: University of East London

Ashworth, W 1986 *The History of the British Coal Industry, Vol 5*. Oxford: OUP

Barton, Barry 2003 *Water Towers of Britain*. London: The Newcomen Society

Fairclough, Graham 2002a 'Europe's Landscape: archaeology, sustainability and agriculture' in Fairclough, G and Rippon, S (eds) 2002 *Europe's Cultural Landscape: archaeologists and the management of change*. Brussels: Europae Archaeologiae Consilium

Gaskell, P and Owen, S 2005 *Historic Farm Buildings: Building the Evidence Base*. Cheltenham: University of Gloucestershire

Mingay, G E (ed) 1989 *The Agrarian History of England and Wales, VI (1750–1850)*. Cambridge: Cambridge University Press

Roberts, B K and Wrathmell, S 2002 *Region and Place: A study of English rural settlement*. London: English Heritage

Mabey, Richard 1999 *The Unofficial Countryside*. London: Pimlico

Ministry of Power, annual, *Statistical Digest*. London: HMSO

Rural Strategy 2004. London: Defra

Stoyel, A and Williams, Peter 2001 *Images of Tin*. London: English Heritage

Thornes, R 1994 *Images of Industry: Coal*. London: HMSO

Thurlow, C 2001 *China Clay from Cornwall and Devon*. St Austell: Hillside, 3 edn

Vernon, R W 2006 *Mining Heritage Guide*. Matlock Bath: National Association of Mining History Organisations

http://www.communities.gov.uk/index.asp?id=1143572
Accessed 5/6/07

Countryside Agency. Agricultural Landscapes: 33 years of change
http://www.countryside.gov.uk/Publications/articles/Publication_tcm2-29715.asp
Accessed 26-09-2006.

www.forestry.gov.uk (The Forestry Commission)

Pleasure

Aitchison, Cara, MacLeod, Nicola E and Shaw, Stephen J 2000 *Leisure and Tourism Landscapes: Social and Cultural Geographies*. London: Routledge

Bale, John 1993 *Sport, Space and the City*. London: Routledge

Bale, John and Moen, Olaf (eds) 1995 *The Stadium and the City*. Keele: Keele University Press

Bale, John 1999 'Parks and Gardens: Metaphors for the Modern Places of Sport' in Hill, Jeffrey *Sport, Leisure and Culture in Twentieth-Century Britain*. Basingstoke: Palgrave, 91–108

Canter, David, Comber, Miriam and Uzzell, David L 1989 *Football in its Place: An Environmental Psychology of Football Grounds*. London: Routledge

Crouch, David (ed) 1999 *Leisure/tourism geographies*. London: Routledge

Nielson, Niels Kayser 1995 'The Stadium and the City' in Bale, John and Moen, Olaf (eds) *The Stadium and the City*. Keele: Keele University Press, 21–31

Ravetz, Alison with Turkington, Richard 1995 *The Place of Home: English Domestic Environments, 1914–2000*. London: E&F Spon

Schofield, Peter 1996 'Cinematographic images of a city: Alternative heritage tourism in Manchester' in *Tourism Management* **17**(5), 333–40

Shaw, Gareth and Williams, Allan 1991 'From Bathing Hut to Theme Park: Tourism Development in South West England' in *The Journal of Regional and Local Studies* **11**, 182

Shaw, Gareth and Williams, Allan 1997 *The Rise and Fall of British Coastal Resorts: Cultural and economic perspectives*. London: Pinter (Cassell)

Smith, Janet 2005 *Liquid Assets: the lidos and open air swimming pools of Britain*. London: English Heritage

Taylor, Harriet 1997 *A Claim on the Countryside: A History of the British Outdoor Movement*. Edinburgh: Keele University Press

Williams, John 1995 'English Football Stadiums after Hillsborough' in Bale, John and Moen, Olaf (eds) *The Stadium and the City*. Keele: Keele University Press, 219–53

Wylson, Anthony and Wylson, Patricia 1994 *Theme Parks, Leisure Centres, Zoos and Aquaria*. Harlow: Longman

http://clutch.open.ac.uk/schools/eaton-overspill00/home.html (Bletchley Leisure Centre) Accessed 27/6/2006

http://homepage.ntlworld.com/alan-turnbull/emmerdale.htm (Television landscapes) Accessed 12/10/2006

www.the-hta.org.uk/trade/index.asp (The Horticultural Trade Association) Accessed 25/8/2006

http://www.vornster.co.uk/AIW/pages/pool/pool1.html (Coventry Swimming Baths) Accessed 13/9/2006